Utopian Pulse — Flares in the Darkroom

Ines Donjak & Oliver Ressler (eds.)

PlutoPress
www.plutobooks.com

# Chronology

# SALON PUBLIC HAPPINESS

Curated by Christoph Schäfer

with
Videoccupy; PlanBude St.Pauli (Margit Czenki, Renée Tribble); Esso-Häuser Filmteam (Irene Bude, Steffen Jörg); Echohäuser (The Good The Bad and The Ugly, Frank Egel, Julia Priani, Thomas Wenzel, Ømmes Andreas Fröhling, Mense Reents, Ted Gaier, Oxana Smakova, Der Buttclubchor); Esso-Häuser Echo (Megafonchor/Sylvi Kretzschmar, Svenja Baumgart), Der Investor (Die Goldenen Zitronen, Gaier, Duve, Schierhorn), Wien TV.

17 – 23 September 2014

# SALON-E-GIRDBAD (Salon of the Whirlwind)

Curated by Mariam Ghani

with
4 States Sessions, Afghan Films Archive (Juwansher Haidary, Abdul Khalek Halil, Nassima Jalal, Faqir Nabi, Eng. Latif Ahmadi, assorted newsreels & photographs), Afghanistan Center at Kabul University (Louis Dupree, Nancy Hatch Dupree, Jean Stewart), Emil Gross, Igor Gross, Nabila Horaksh, Luca Kezdy, Dr. Zamiruddin Mihanpoor, Dr. Parwin Zaher-Mihanpoor, Abassin Nessar, Edith Poirier & Daniele Rossi, Peter Taylor, Arzoo Waseeq.

24 – 30 September 2014

# SALON ORIZZONTI OCCUPATI

Curated by Bert Theis

with
Isola Art Center collective and friends: Luca Andreolli, Aufo, Aviosuperficie del Sole, Bad Museum, Roberto Balletti, Emanuel Balbinot, Zanny Begg, Kristina Borg, Antonio Brizioli, Tania Bruguera, Angelo Castucci, Cooperativa Nuovo Cilento, Antonio Cipriani, Comune di San Mauro Cilento, Irene Coppola, Creative Olive, Paola Di Bello, Fornace Falcone, Maddalena Fragnito, Mariam Ghani, Edna Gee, Etcétera, Isola Art's Club Band, Heinz-Norbert Jocks, Isabell Lorey, Gianfranco Marelli, Orestis Mavroudis, Valentina Montisci, Philippe Nathan /2001, Nikolay Oleynikov, Maria Papadimitriou, Dan Perjovschi, Steve Piccolo, Edith Poirier, Gerald Raunig, Oliver Ressler & Dario Azzellini, Daniele Rossi, Gak Sato, Milena Steinmetzer, Christoph Schäfer, Mariette Schiltz, Serio Collective, Superstudio, Stefano Taccone, Camilla Topuntoli, Transdisziplinäres Planungsteam Milliardenstadt, Utopia Urbis, Nikola Uzunowski, Flora Vannini, Jiang Zhi.

01 – 07 October 2014

# SALON FLUCHTHILFE

Curated by Zanny Begg

with
Khan Adalat, Ilker Ataç, Sherko Jahani Asl, Katherine Ball, Barat Ali Batoor, Imayna Caceres, Libia Castro and Ólafur Ólafsson, Pilar Mata Dupont, Clifford A. Erinmwionghae, Escape from Woomera, Fluchthilfe & Du, Mariam Ghani, Marina Gržinić, Yusuf Haibeh, Njideka Stephanie Iroh, Marissa Lôbo, Ines Mahmoud, Gin Müller, Mindj Panther, Prozess.report, Refugee Protest Vienna, Firas Shehadeh, Solidarityagainstrepression, The Silent University, Undrawing the Line, Katarzyna Winiecka, Maria Zimmermann

08 – 14 October 2014

# SALON DADADA

AND AND AND

with
Ben Morea, Emilio Fantin, Sherry Millner, Ernie
Larsen, Ayreen Anastas, Rene Gabri, Harout
Simonian, Karen Hakobian, Giulia Gabrielli, Andrea
Fabbro, Luca Musacchio, Mattia Pellegrini, Annette
Krauss, Miklos Erhardt, Elske Rosenfeld, Keiko
Uenishi, Virag Major and guests.

15 – 21 October 2014

# CUARTOS DE UTOPÍA

Curated by Pedro G. Romero/Máquina P.H.

with
María García Ruiz, Antonio Marín Márquez. Marco
de Ana, Javiera de la Fuente, Stefan Voglsinger.
Introducing: Tomás de Perrate & Amador Gabarri.
Ocaña, Charo Martín, Israel Galván, Rocío
Márquez, Rudolf Rostas, La Esmeralda de Triana.
Pie Flamenca, LaFundició, 4Taxis, Los Flamencos,
flo6x8, Ketani, Wein Klub, Zikkurat.

22 October –
02 November 2014

# SALÓN DE BELLEZA

Curated by Miguel A. López

with
Carlos Motta, Sandra Monterroso, Giuseppe
Campuzano, André Masseno, Sergio Zevallos,
Virginia de Medeiros, Jaume Ferrete, Open
Barbers (Greygory Vass and Felix Lane).

# CONTENTS

# FOREWORD

Ines Doujak and
Oliver Ressler

1
The Secession was an ideal location in that it was founded as an association by a group of artists in 1897. They wished to present their works independently from the academic art of their time. It remains as an artist-run exhibition space.

After two years of preparation, a fund was granted by the Austrian Science Fund (FWF) for an artistic research project on the theme of the terms and conditions of artists who conceive curating as part of their practice. It aimed to analyse and subvert the hierarchical division of labour between curator and artist. In the course of the research we decided to specify our undertaking by introducing a theme which seemed to be urgent in the given political situation, the discredited concept of utopia. We felt that there are many social groups, ourselves included, that are in no position to give up hope. Our aim was then to liberate utopia from its totalitarian undertone and give it a fresh direction. This meant talking about temporalities, about endings, about new forms of alliances. It meant relying on concepts developed by '2nd wave' feminism's emphasis on the relationship between process and intentions.

That it should take place at all and in such a public space as the Secession in Vienna was and is, timely. The neoliberal mantra of 'There is No Alternative' has more recently lost the triumphal air of 1989. In such a climate the desire for and articulation of other potential futures grounded in the oppositional practices of the present are flaring up across boundaries.

In January 2014 a four-day meeting took place at the Secession with the involved artists/groups we invited to collaborate. On the fourth day this led to the first public appearance, the *Salon Klimbim*.

We chose the Salon as a structuring element in reference to its link with feminist history, and with the foundation of the Secession itself.

From February to August 2014 *Salon Klimbim* was followed by the exhibition of a series of banners, for which we invited further artists, under the subtitle *Urgent Alternatives: Utopian Moments*, to produce banners for display on the façade of the Secession, each for one month.[1] They dealt with the uprisings, occupations and social movements that have emerged in recent years, or were poetic references to the feeling that 'something is missing'.

In September 2014 the research exhibition started in which each of the other seven co-researchers elaborated and established a week-long salon with related programmes and events.

This book is now a reflection on what happened and what still needs to be done, and tries to inspire an outreach to the public, which will endure beyond the limits of the exhibition's specific time and place. It is not a final step. One hundred and sixty people have participated in the exhibition and in the making of this book. In addition there were all the technicians and staff at the Secession, the installation teams and of course the diverse audiences who were part of its unfolding.

The four-day meeting of the artist–curators in January 2014 developed a common view that what we were *not* doing, that is not to display or celebrate 'utopias'. In this we were helped through our correspondence with the writer Matthew Hyland.

*We understand 'utopia' as an always incomplete alternative, the invocation within the given world of something incompatible with, and hostile to, given conditions. It is a negation of the given and a recognition of 'something missing', but also a necessarily imperfect assertion of that which is not – yet.*[2]

The work we would help to produce would follow utopian projections that serve the purposes of secession from and resistance to our particular present. Neither was it a matter of 'listing what's wrong with the world as though listing it could change it.' Utopia is, we agreed, 'the assertion of the unrealized *in and against* the real.'

The meeting was followed by our first public appearance on the fourth day with *Salon Klimbim*, orchestrated by the artist–curator Fahim Amir and ourselves on 23 January 2014. True to its name, it was a variety show set under a huge and beautiful tent of many colours set up in the Secession's main space with a bar included. The tent itself – requiring a lot of work, with much help from people outside the art world, especially Hermann Seiwald – which was created for just the one

3
This had some precedent in that
the façade of the Secession in
2000 had been used to display a
protest against the inclusion of
the FPÖ, a racist neoliberal party,
in the governing coalition.

night, was itself a proclamation of utopian
abundance. In addition to preliminary works by
the seven artist–curators of the upcoming salons –
in the form of short films, talks and performances –
other artists, musicians, performers and drag
queens all had their moment in the lights. It achieved
a breakthrough in one aim, bringing in a variety of
audience who were able to move from one 'show'
to another, party and dance during the evening
and night.

In the following weeks, the first of the series
of seven banners was installed.[3] What these works
shared in common, was a sense of the utopian
pulse as an integration of *how* and *what* was being
fought for, a clear break with the ends-justify-the-
means politics.

The first of these banners by Katarzyna Winiecka's
*Fluchthilfe & Du?* is a good example of what Matthew
Hyland called 'the monstrous birth of new alliances',
and what we had hoped for. It directly influenced
the Australian artist Zanny Begg's decision, to
name her week of exhibition *Salon Fluchthilfe*. The
main reason for Begg's decision to pick up German
vocabulary was the lack of wording in English that
describes 'human smuggling' in a positive way (as
the German term *Fluchthilfe* does).

While Mariam Ghani focused in her *Salon-e-
Girdbad* (Salon of the Whirlwind) on unfinished
Afghan feature films from the Communist period,
the Hazara Afghani refugee and artist Barat Ali
Batoor documented his own modern day month-
long refuge-seeking journey from Afghanistan to
Australia through a photographic work in *Salon
Fluchthilfe*, that documents this dangerous trip.

Similarly while Halil Altindere in *Urgent Alterna-
tives: Utopian Moments* had presented a banner
showing the façade of AKM Cultural Centre
in Istanbul that became a canvas for protesters'
banners and posters in the Taksim Square Protests,
Christoph Schäfer in *Salon Public Happiness*, picked
up the issue of the Gezi-Taksim movement. This
was done by including videos in three sections by
Videoccupy as a central focal point in his salon.
Some visitors objected that the protesters' views

would be silenced because the video was in Turkish with no subtitles, but the opposite was the case as two activists from Videoccupy itself accepted the invitation to present their strategies and political interventions in one of the salon's events.

The exhibition stage of the process was divided into seven salons. It seemed appropriate when the potential imperfectly expressed in the *salon* is seen as *neither* a proto-public sphere – that is, one stage in an orderly evolution towards universal convivial-conversation – *nor* pure 'courtly' proprietorship, but rather as a partial breach of the prevailing order of class and gender, a disruption that cannot become the public norm because it prefigures a total upheaval of what constitutes the 'public'.

We were given free rein with the whole basement area of the Secession where a modular and easily adaptable display system was developed, consisting of beige and silver curtains and a set of tables and benches that could easily be transformed as a space for each salon. Most importantly, we were given keys to this area, so that we were able to keep the doors open to the public at irregular hours, often late into the evening. This created the possibility for that new and mixed audience we were hoping for.

There were 'unscripted' moments of fun, emotion and provocation. In the last week of the exhibition during the 'queer' *Salón de Belleza,* the Open Barbers, Felix Vass and Greygory Lane, were giving free haircuts with conversation. At one point a visitor to the Secession eventually found his wife having a pleasurable hair cut. His response was somewhat irate: 'I thought we were going to a museum and now I find you at the hairdressers.'

The week before, during *Cuartos de Utopía*, one of the Flamenco performers in the middle of a performance started to spontaneously sing a song in Romani that brought his sisters to tears. We later learned that it was a song about the road to Auschwitz. Somehow he then changed the mood by entering a joyous dance with another sister.

The pace of the exhibition was relentless, seeming to accelerate. Every week the shows of

each artist–curator had to be installed or
un-installed. They had also created their own
banners for the façade which now, unlike the
earlier monthly sequence, were erected weekly.

   To do justice to that and for a wider perspec-
tive, we invited the artists themselves and other
artists and writers to contribute to this book. We
are pleased that, as with the salons themselves,
there is a wide range not just of the touch of the
utopian pulse, but also of the style. These vary
from Marina Vishmidt and Antke Engels' tightly
argued analyses, the poetic wit of Pedro G. Romero,
to the coiled anger of Alice Creischer. Utopia is
*secession* without instructions.

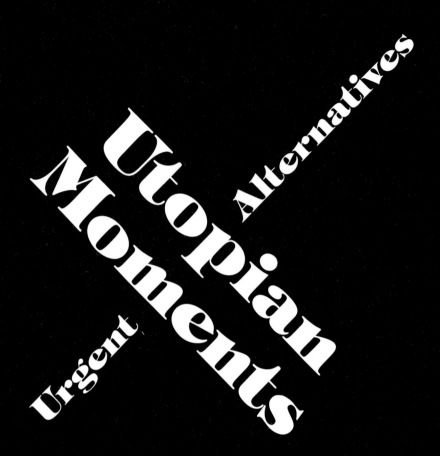

Urgent Alternatives: Utopian Moments

Between February and September 2014 a series of
seven large-scale banners (9 x 3.4 metres) were
presented on the façade of the Secession, the exhi-
bition hall for contemporary art in Vienna. They
related to the uprisings, occupations and social
movements that have emerged in recent years.
The artists were invited to focus on the utopian
pulse in these actions and movements. This is
most clearly manifested in the integration of how
and what was being fought for. During the period
when Syntagma Square in Athens was occupied
in active opposition to the self-defeating austerity
policies, the principles of true democracy were
evident throughout. Debates as to actions, methods
and alternatives were open and respectful, and
decisions were made on this basis. They included
who would speak and what would be spoken about
to a wider public. In Tahrir Square, Cairo in 2011 a
determination that the machinery of state violence
could be overcome by surrounding tanks was
crucial in the early victories of the movement. This
should not be forgotten in its defeat by rival forms
of authoritarian politics. Part of the failure by the
initial movement was its incapacity to build *durable*
democratic structures. In Istanbul the determi-
nation was to hold the common property of a park
that made life bearable in the city, an action with a
global resonance of defending the commons against
the many forms of predatory enclosure. All the
artists in the *Urgent Alternatives: Utopian Moments*
had in common that they were directly involved in
the protests which they had focused on in their
banner, or that they talked from a clear, unequivocal
position of solidarity with the protests. This series
of banners can be seen as symptomatic of how
utopian thinking, which seemed to have been
buried for years, has revived with a sense of urgency.
It is the idea that things can carry on as they are
which is really just wishful thinking.

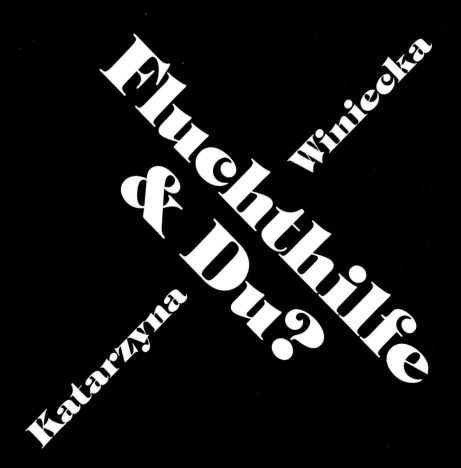

Katarzyna Winiecka

Fluchthilfe & Du?

*Urgent Alternatives: Utopian Moments*
**February 2014**

*Fluchthilfe & Du* addresses the critique of the EU border regime and its migration policies expressed by the self-organised refugee protest movement in Vienna. The design of the banner, titled *Flucht-hilfe & Du? (Escape Aid & You?)*, echoes a current campaign by Caritas, an organisation which collects donations with an appeal to charity while distancing itself from those it denounces as 'human smugglers': people whose assistance to refugees made it possible for them to come to Austria and apply for asylum in the first place. *Fluchthilfe & Du* envisions aid to refugees as a service and publicly solicits support for their struggle for freedom of movement.

The work was created as an act of solidarity with those eight activists of the refugee movement who were held in custody from July 2013 to January–March 2014 and accused of being members of an international human smuggling organisation. The charges – they supposedly made millions and endangered the lives of refugees in transit – were rebutted immediately, but the Austrian state continued to criminalise them.

On 4 December 2014, after 43 days of trial in Wiener Neustadt, under media attention as well as being monitoring by civil society, seven of the eight defendants were found guilty under paragraph 114 FPG 'human smuggling – within a criminal association'. The judgement is not final; the decision was appealed by all the accused. Paragraph 114 FPG, which is in dire need of reform, criminalises help (food, shelter, information, buying a ticket) given to undocumented refugees/to be asylum seekers, who try to come to, pass, or leave Austria, with the aim of arriving to ask for protection in a destination of choice within the alleged border-free European Union – as is clearly shown in this so called Fluchthilfeprozess.

www.fluchthilfe.at

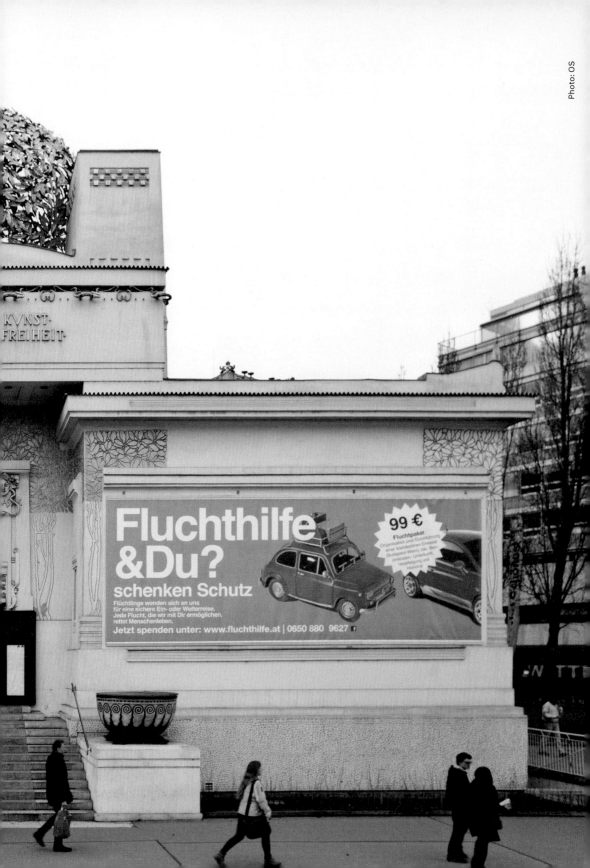

# DRIVEN INTO CONFLICT BY UTOPIA

## Antke Engel

Pauline Boudry/Renate Lorenz: *Opaque* (2014),
a film installation, 10 mins. Performers: Werner
Hirsch and Ginger Brooks Takahashi. Courtesy:
Ellen de Bruijne Projects and the artists, film still

1
Renate Lorenz (ed.), *Not Now!
Now! Chronopolitics, Art &
Research*. Berlin: Sternberg, 2014.

2
Ernst Bloch, *Das Prinzip Hoffnung*.
Band 1–3 (1954–59), Frankfurt:
Suhrkamp, 1982; *The Principle
of Hope*, Neville Plaice, Stephen
Plaice, and Paul Knight (trans.),
3 vols, Cambridge, MA: MIT
Press, 1995.

3
Michel Foucault, *Of Other Spaces:
Utopias and Heterotopias* [1967].
Jay Miscoviec (trans), in *Diacritics*
16 (1), 1984: 22–27.

4
Barbara Holland-Cunz, *Utopien
der Neuen Frauenbewegung.
Gesellschaftsentwürfe im Kontext
feministischer Theorie und Praxis*.
Meitingen: Corian, 1988. See
also, Barbara Holland-Cunz (ed.),
*Feministische Utopien – Aufbruch
in die postpatriarchale Gesell-
schaft*. (2nd edn) Meitingen:
Corian, 1990.

5
María do Mar Castro Varela,
*Unzeitgemäße Utopien: Migran-
tinnen zwischen Selbsterfindung
und gelehrter Hoffnung*, Bielefeld:
transcript, 2007.

6
Karin Schönpflug, *Feminism,
Economics, and Utopia: Time
Traveling Through Paradigms*.
London: Routledge, 2008.

7
Helga Haberler, 'Des-Integration
im Kontext moderner Staatlich-
keit. Utopische Wirklichkeiten in
Auszügen queeren Dissenses',
in Helga Haberler, Katharina
Hajek, Gundula Ludwig and Sara
Paloni (eds), *Que(e)r zum Staat,
Heteronormativitätskritische
Perspektiven auf Staat, Macht und
Gesellschaft*. Berlin: Querverlag,
2012: 208–27.

*Utopian Pulse – Flares in the Darkroom* offered
a programme of confrontation with utopian
pleasure, pain, handicraft and brain, a variety show
of utopian visions. Yet, what if utopia prefers to
unfold in the untimely 'Not Now! Now!'.[1] The
not-moment of midnights, which is neither today
nor tomorrow, may activate the conflicts that are
implied by the different, contradictory and
competing visions. What is utopia in a geo-histor-
ical-political constellation that presumably strives
to acknowledge the interplay of a complexity of
relations of power and domination – not in order to
affirm, but to transform the asymmetries, injus-
tices and violences that organise it?

'Utopia is ... the assertion of the unrealized *in
and against* the real,' declares the announcement
of *Utopian Pulse – Flares in the Darkroom*, 'the
invocation *within* the given world of something
incompatible with, and hostile to, given condi-
tions.' While philosophers like Ernst Bloch[2] or
Michel Foucault,[3] and feminist theoreticians like
Barbara Holland-Cunz,[4] María do Mar Castro
Varela[5] or Karin Schönpflug[6] point out the impact
of utopia as a form of *critique*, the above formula-
tions signal something like an open *conflict*
between the utopian and the existing, a conflict,
which is by no means virtual, but unfolds within the
existing, the real or reality. It produces what Helga
Haberler[7] calls a lived dissent with the hegemonic
order. For her, the utopian vision lies in learning to
enjoy and gain pleasure from experiences of disinte-
gration, thus overcoming the longing for recognition
and integration.

Yet, a couple of questions are left open by
pushing utopia into an antagonistic relationship
with reality: Can one still speak about a conflict
*between* utopia and reality, once utopia appears as
part of or is interpolated by reality? What are the
modes and means conflict takes on, when it is
expected to articulate itself in a heterotopian
space like an exhibition? Instead of looking for
conflict in the relationship between utopia and
reality my suggestion is to search for a utopian
moment in conflict itself, namely a moment that

8
Dagmar Fink, 'Cherished As Well
As Suspicious: Femme Femi-
ninities', in Walter W. Höbling *et
al. (eds), US Icons and Iconicity*.
Vienna: LIT Verlag, 2006, 167–85.

derives from utopias as machines producing conflicts. Utopia drives into conflict! Utopia is conflict! At least potentially – then and there.

What seems interesting to me are two moments. One where utopia effects changes in the existing power relations through pushing well-known antagonisms into paradoxes, ambiguities and new, unexpected constellations. For example, when Dagmar Fink[8] introduces to her readers a whole range of femme genders or *femme*ninities, which undermine simultaneously the male/female binary as well as sexual differences within homosexualities. The other, those moments when one understands why the utopian potential of a certain conflict cannot realize itself due to desire, power or habit. To stick with the same example, femme is often not acknowledged as a transgression of heteronor-mative gender, because, according to Fink, it is habitually misconceived as escaping a proper *oppositional* performance. To say that utopia is conflict does not mean that utopian visions consist of representations of conflict, but that an experi-ence of conflict is invoked in between the recipient, the utopian work and a wider social world.

Feminist utopia and science fiction – Christine de Pizan's *Le Livre de la Cité des Dames (The Book of the City of Ladies*, originally 1405), Joanna Russ' *Female Man*, Marge Piercy's *He, She and It*, Octavia E. Butler's *Lilith's Brood* and Ursula K. Le Guin's *The Left Hand of Darkness* – not only shift attention to such conflicts and their socio-historical origin, but also develop complex nets of future genealogies – not in order to provide solutions, but to lay out the impossibilities of various alternatives. These authors make clear that any conflict is complex, and also always holds psychic, communal and external dimensions simultaneously. There is not simply 'the enemy', and it is not always 'over there'. Rather, the enemy might be a lover, a friend; it might dwell in the heart, and resist being pinned down to the position of perpetrator – or victim; and named war, or capitalism, or patriarchy which one might like to fight over there, while enjoying its profits right here. Cutting out one of these (psychic, communal,

external) dimensions, which are obviously also contradictory in themselves, would simplify the complexity of a conflict and undermine the chance of activating its utopian potential. Yet, my point here is a different one. Instead of looking for analytical-diagnostic or speculative-utopian representations of conflicts, I would like to shift the focus to the moment where the social existence of a utopia drives its recipients into conflict.

Take, for example, Tejal Shah's five-channel video installation *Between the Waves* (2012). The different episodes do not depict any conflict at all. On the contrary, the bare-breasted, harnessed unicorns who inhabit a fictional world that merges ancient excavations and mythological sites with futuristic design, natural landscapes and urban metropolitan settlements, are engaged in caring and erotic practices, in cleaning up, caressing, and healing, as well as with forms of symbolising and knowledge production. What is going on appears to be significant, but remains cryptic to the viewer. Intimate procedures signify an embodied knowledge that draws connections between those involved, while keeping their meaning opaque.

Conflicts may arise, because traditional hierarchies of perception and articulation are undermined: touch seems to be more important than vision; cosmic sounds or the loud smack of pomegranates smashed to pieces supplement composed music and spoken language; a trash heap is not an environmental problem, but the site for a collective dance; and pleasures are not defined by the phallus when unicorns have sex and species meet. *Between the Waves* knows about racist, sexist, heteronormative, geopolitical and neocolonial hierarchies. Yet, it does not operate through antagonising, but through creating possibilities for accepting a not-knowing and learning to listen.

Learning to listen in itself, may also activate inner conflicts, repulsions or ambiguities in the beholder. It may, for example, draw attention to the traces of global environmental pollution and the circuit of capitalist industrial production;

9
Elizabeth Povinelli, *Economies of Abandonment: Social Belonging and Endurance in Late Liberalism.* Durham, NC: Duke University Press, 2011.

10
Ibid.

exploitative production in the global South for consumption in the global North returning as trash from the North to the beaches and dumps of the South. Plastic netting, shiny DVDs, foil, bags, bottles inhabit the fantastic world. They could be read as signs of pollution, global exploitation and colonial heritage. Yet, this relies on the labour of the recipient. The film, in contrast, depicts these objects as curious and colourful, sometimes dangerous, sometimes as astonishing instances of new assemblages. In the film they function as inspirations and accessories of erotic, caring and creative practices, whereas for the beholder they may strengthen feelings of displacement or dispossession in the face of a 'tribe of aliens' who seem to know and to act as an integral part of a cosmic whole and post-human sociality.

In a very different way, yet with similar effect, queer theoretician Elizabeth Povinelli invites Ursula K. Le Guin's short story 'The Ones who Walk Away from Omelas' to do the work of deconstructing the liberal, occidental subject. In her book *Economies of Abandonment*,[9] Povinelli lays bare the ethical dilemma that haunts late liberalism: that the happiness and freedom of those enjoying the liberal regime depend on the continuous suffering of some others, on 'forms of suffering and dying, enduring and expiring that are ordinary, chronic, and cruddy rather than catastrophic, crisis laden, and sublime.'[10] Those who profit from the system know about this dilemma, know about 'the child in the broom closet' as figured in Le Guin's story, and the cheap attempts at justification, like seeing the child as a degraded being, less than human, or hopelessly lost, of calling its fate a necessary sacrifice, or soothing the effects through social technologies.

In the face of this dilemma in Le Guin's story some citizens decide to leave 'the city of happiness', and while the author would not say where they were going, one could read Povinelli's book as an attempt to open up similar passages into unknown worlds. What's important about these worlds, which Povinelli calls 'spaces of otherwise'[11] and

11
Ibid.

which she finds in certain social projects and forms of embodied sociality, is that they are neither positioned in the future nor dependent on the past perfect of the former regime, but instead acknowledge the enduring present tense of histories of violence. Reflecting on twenty years of friendship with Ruby Yarrowin, an elder indigenous women and her kin from the Northern Territory in Australia, Povinelli develops the term 'queer socialities'. It names a loving and laughing and caring relationship built on *jouissance*, a simultaneity of pleasure and pain; painful, because it is again and again ruptured by the asymmetric positioning defined by the regime of settler colonialism.

Queer sociality carries a utopian potential exactly because of its shared *jouissance*. It suggests understanding *jouissance* not as a paradoxical experiences that drives the one who experiences into asocial isolation, but insists that it is possible to share the inseparable pleasure–pain, though one will never overcome the limits of understanding that are due to an unbridgeable difference in the way both friends are implicated in late liberalism. In the text, the limits of understanding are demonstrated quite literally in presenting the joy and the agony of learning and teaching Emmiyengal, Ruby's native language. The reader follows conversations between Ruby and Liz in Emmiyengal, which is transferred into English, yet in a quite surprising way, since certain idioms and grammar are upheld, and their meaning is discussed in the exchange. Conflict between Ruby and Liz lures on the threshold between limits of understanding, lack of understanding, and misunderstanding, but is sustained by practices of friendship. For me as a reader my pleasure–pain arises thanks to the aesthetic form of the text. The poetics help one to endure the experience of not-knowing and the limits of understanding, but are simultaneously pushing me into conflict. Am I going to hold on to the privileges and resources of my Occidentalist self and my late liberal resources? Or am I opening up to queer sociality?

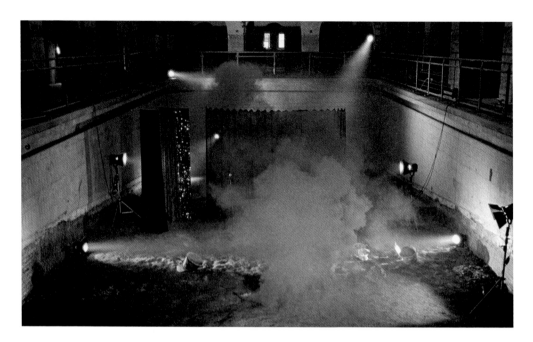

Pauline Boudry/Renate Lorenz: *Opaque*
(2014), a film installation, 10 mins.
Performers: Werner Hirsch and Ginger
Brooks Takahashi. Courtesy: Ellen de
Bruijne Projects and the artists, film still

Povinelli's 'spaces of otherwise' remind one of
Michel Foucault's 'heterotopias' – spaces within
the given order that do not follow the rules of this
order.[12] While enacting diverging norms and
relationships, heterotopias are not automatically
critical or resistant. They may sustain the undis-
turbed functioning of the dominant order as well
as they may inspire the questioning of truth claims
and historical power relations. María do Mar Castro
Varela[13] activates Foucault's notion of heterotopia
together with Ernst Bloch's *Das Prinzip Hoffnung*
(*The Principle of Hope*) in order to underline the
concreteness and present tense of utopia as a form
of political critique. Bloch distinguishes between
abstract and concrete utopia, where the latter is a
form of critique which translates hope into an
intervention into given social relations. He under-
stands utopia as a mode of historical practice
(*geschichtliches Handeln*). As such it is neither
illusionary nor teleological, but driven by a wishing
that takes place here and now.

12
Foucault, *Of Other Spaces*.

13
Castro Varela, *Unzeitgemäße
Utopien*.

This is why Castro Varela calls utopia a discourse of longing (*Sehnsuchtsdiskurs*), and carves out similarities between utopia and migration. She reflects and deflects utopias through the lens of migration, but makes sure that longing is understood as neither nostalgic nor escapist. Migrating for her means living an ambiguous simultaneity of longing for belonging and longing for emigration. It may carry a wish for *Heimat*, yet this Heimat is deferred and always to come, built on the pleasures and dangers of giving in to one's curiosity and one's hope of building a better future. As a form of lived critique, this simultaneity undermines historical and epistemic regimes of truth, and as such it is utopian vision which helps to make sense of the concrete here and now, and answer to concrete experiences of social conflict.

Castro Varela presents utopian visions as a form of virtual migration – a form of escape deployed by those who do not dare or lack capacities and resources to actually get on the move. Furthermore, those who in fact have migrated might need and do cultivate utopian thinking artfully as a collective practice of coping with the hardships of migrant everyday life. Castro Varela has developed her contribution to theories of utopia in exchange with migrant women, who during group interviews reveal their capacity for and the potentials of utopian thinking. They invite Castro Varela to listen to their communication and laughter, and thus let her understand how utopian thinking allows for analysing, criticising and politicising, for enduring and overcoming racist, sexist and classist experiences. I would argue that it is at this untimely moment when conflicts – diverging opinions, values, wishes or interests organised along unequal relations of power and desire – shift the current layout of space-time, that historically concrete critique is moved by a utopian pulse.

It is José Esteban Muñoz, who like Castro Varela combines the Foucaultian vision of resistance as desubjugation with Bloch's principle of hope, but actually specifies how utopia develops its political impulse. For Muñoz there is no such

14
José Esteban Muñoz, *Cruising Utopia: The Then and There of Queer Futurity*. New York and London: New York University Press, 2009, p. 9. See also José Esteban Muñoz, *Disidentifications: Queers of Color and the Performance of Politics*. Minneapolis, MN: University of Minnesota Press, 1999.

15
Ibid.

16
Lee Edelman, *No Future. Queer Theory and the Death Drive*. Durham, NC: Duke University Press, 2004.

17
Fatima El-Tayeb, *European Others. Queering Ethnicity in Postnational Europe*. Minneapolis, MN: University of Minnesota Press, 2011.

thing as a lived utopia and no utopian vision functioning as the blueprint of a better world. However, there are aesthetic and political practices of potentiality that create 'a mode of being and feeling that was then not quite there but nonetheless an opening.'[14] He explains potentiality as a 'nonbeing that is eminent, a thing that is present but not really existing in the present tense.'[15] For Muñoz, queer aesthetics provide a space for this kind of potentiality. They invite the viewer to look out for the 'nonbeing' when they engage with art and/or politics; where queer aesthetics is fed by and feeding into today's collective practices such a kind of utopian 'there and then'.

Thus, for Muñoz queer aesthetics challenge what is enacted as the rational politics of the liberal political subject. In contrast, Lee Edelman with his book *No Future*,[16] promotes an antisocial turn, which avoids any kind of optimism or belief in futurity. Yet, for Muñoz it is hope, materialised in the aesthetic forms of queer potentiality, which allows the acknowledgement of identities that are multiple, contradictory and unstable, and social practices that transgress the normative and the intelligible. *Queer potentiality* does not connect queer immediately or necessarily to sexuality, but encompasses all power relations that are hooked up with naturalisations of difference, and which can never be separated out as either gendered, sexualised, racialised, ethnicised, classed but insist on contradictory simultaneities (El-Tayeb).[17] Thus, ironically it is not Edelman's claim of negativity, but the claim of utopia that provides space for handling conflicts arising from the complex intertwinement of power relations.

Why hook utopia up with conflict? Conflict is not promising in and of itself. It is of no use as long as the conflict only indicates fields of struggle and desires for change, but not how established hierarchies become reorganised, social positioning undermined, or power dynamics change exactly through handling the conflict. And what exactly is the role or relevance of individual or collective agents in upholding or transforming structural

18
Tom Holert (ed.), *Imagineering. Visuelle Kultur und Politik der Sichtbarkeit*. Köln: Oktagon, 2000.

dimensions of conflict? Of course, you can react to conflict with a will to power, thus expecting your adversary to submit. Yet, what does it do to your will to power, if you keep open – expect, acknowledge, desire – the possibility that the tables may be turned? You could also react to conflict with a search for compromise, ready to provide a calculated space for the other. Yet, what has been given up might return in various surprising forms from either side. Or conflict could effect the questioning of one's own position, actively dispossessing oneself in response to and empathy with an adversarial. Yet, again, one might need to accept the return of the repressed in oneself, or the turning up of hate or violence due to self-loss. What is interesting from a perspective of utopian thinking are not those different reactions to conflict, but the 'yets' – potentialities that are not simply a promise, but carry the conflict in their psychic, social and external dimension.

If, as Muñoz puts it, queer is always on the horizon, never realized but also never to be lost, utopia might pulse in between the salons of *Utopian Pulse – Flares in the Darkroom*, flaring at midnight, spinning out from then and there, that is, from aesthetic practices which acknowledge the working of utopian potentiality in concrete historical conflicts. Political utopia is not defined by content, but by its force of creating social constellations – between utopian visions and their recipients, or between authors (performers, inventors, discussants, imageneers: Holert[18]) of diverging visions – which trouble established positions, confuse norms-values-habits, redistribute power, and stage conflict in ways that undermine simple solutions, while insisting on change. Queer sociality in Povinelli's sense is always also queer potentiality: it remains on the horizon, even when the then and there of past and future unfolds here and now. Potentiality derives from aesthetic strategies of conflict, which do not present solutions but induce movement. Utopia is a discourse of desire and longing, which migrates from conflict to conflict.

# SALON FLUCHTHILFE

**Zanny Begg**

with
**Khan Adalat, Ilker Ataç, Sherko
Jahani Asl, Katherine Ball, Barat
Ali Batoor, Imayna Caceres,
Libia Castro and Ólafur Ólafsson,
Pilar Mata Dupont, Clifford A.
Erinmwionghae, Escape  from
Woomera, Fluchthilfe & Du,
Mariam Ghani, Marina Gržinić,
Yusuf Haibeh, Njideka Stephanie
Iroh, Marissa Lôbo, Ines Mahmoud,
Gin Müller, Mindj Panther,
Prozess.report, Refugee Protest
Vienna, Firas Shehadeh,
Solidarityagainstrepression,
The Silent University, Undrawing
the Line, Katarzyna Winiecka,
Maria Zimmermann,**

## Unthinking utopia – borderlessness as method

*We are here because
you were there*
Kwame Nimako[1]

During a drawing workshop in Western Sydney Mona tells me she had packed a Persian translation of George Orwell's *1984* to read on the way to Australia, but once on the boat she was told it was too heavy and she must throw it overboard. She complained that she hasn't been able to find another translation to finish the book. We joke she doesn't need it – her years in Australia being an ample introduction to the double-think of Orwellian dystopia.

We discuss the bird she is drawing. She tells me it is a Homa bird. We stumble through explanations, and with a little research, I start to understand. The Homa is a mythical Persian bird that, as Herman Melville briefly alludes to in *Moby-Dick*, 'never alights'. The Homa is impossible to catch but is said to bestow kingship or spiritual enlightenment on those it flies over. In some versions of the story this limitless nomad has shed its legs, unimportant appendages for a being always on the wing. As we talk the Homa bird begins to fill the room, and our drawings, with possibility. Between

Orwellian totalitarianism and the Homa bird emerges the terrible gaps between limits and limitlessness, between the *here* and the *there*. It is within these gaps I find a starting point for writing about utopia.

Thomas More described Utopia as a territory blessed with a narrow isthmus, sea lying rocky outcrops and other natural defences that protected it from external threats. It is a circumscribed space with all the negative dynamics that must entail, but it gave a name to a flourishing genre of literature, activism and political thought. Importantly, the contradiction he embedded in the term, between the Greek word *outopos* (no place) and its phonetic pronunciation as *eutopia* (the good place), continues to provide pertinent ways through which we can understand the politics of possibility. In the nineteenth century there was a flurry of utopian books and experiments inspired by them. In one example, a group of radicals fled the emerging Australian nation and set sail for Paraguay to found a New Australia. For these colonisers utopia was territorialised and More's concerns with defence were pertinent (although they discovered to their detriment that their enemies were themselves).

While many of the late nineteenth century movements had a spatialised approach to utopia, in the early twenty-first century an alternative discourse emerged from within globalisation theorists focused on the borderless non-place (very different versions, Hardt and Negri's *Empire* and Kenichi Ohmae's borderless world exemplify this trend).

1
Marina Gržinić and Šefik Tatlić, *Necropolitics, Racialization, and Global Capitalism: Historicization of Biopolitics and Forensics of Politics, Art, and Life*. Lanham, MD: Lexington Books, 2014, kindle edition.

Zanny Begg, *Duckrabbit*
(after Wittgenstein),
pen and ink drawing, 2014

Borderlessness promised a world of interconnectedness and flows, where global differences would be deterritorialised, like the flight of the Homa bird, into a non-place of potentiality.

Of course the borderlessness of globalisation was clearly 'utopian' in the incredulous understanding of the word. As Brian Holmes pointed out on the eve of the financial crash in 2008, it was an appealing fiction that justified post-Cold War neoliberal trade expansion. Sandro Mezzadra and Brett Neilson have expressed similar scepticism about the 'hydraulic' metaphor of 'flow' by highlighting the striated and complicated space of capitalist globalisation. '*Border as method* ... tries to make sense of the different kinds of mobilities that traverse and intersect in different spaces, making the very concept of space increasingly heterogeneous and complicated in its constitution.'[2] As Shahram Khosravi, from The Silent University, points out while global travel may have shrunk the world for a wealthy elite who fly by air, an underclass of paperless migrants and refugees have been shut out of this 'flow' and forced to use striated land and sea routes, often paying with their lives to cross a border.[3]

After the 2008 financial crash even the most enthusiastic neoliberal capitalists seem to have lost their 'flow': the globalised rhetoric of 'one world' has been replaced by regional and national power blocks, not unlike the superstates of George Orwell's *1984*, ones that circle the wagons behind trade wars, security measures and border police. The brief moment of capitalist victory after 1989 has been celebrated with a revival of imperialist interventions in the non-core economies (something considered too politically costly in the aftermath of the Vietnam war), escalating border controls and savage austerity measures.

For Marina Gržinić this shift marks a change from the biopolitical order that sought to regulate the 'good life' to a necropolitical order focused on the disposability of life. Foucault's biopolitics in her reading can be designated in an axiomatic way as 'make live and let die'.

2
Sandro Mezzadra and Brett Neilson, 'Border as Method, or, the Multiplication of Labor', *Transversal*, at: http://eipcp.net/transversal/0608/mezzadraneilson/en (accessed 13 November 2014).

3
Shahram Khosravi, 'Is a World without Borders Utopian?' in *The Silent University*, Tensta Konsthall, 2013.

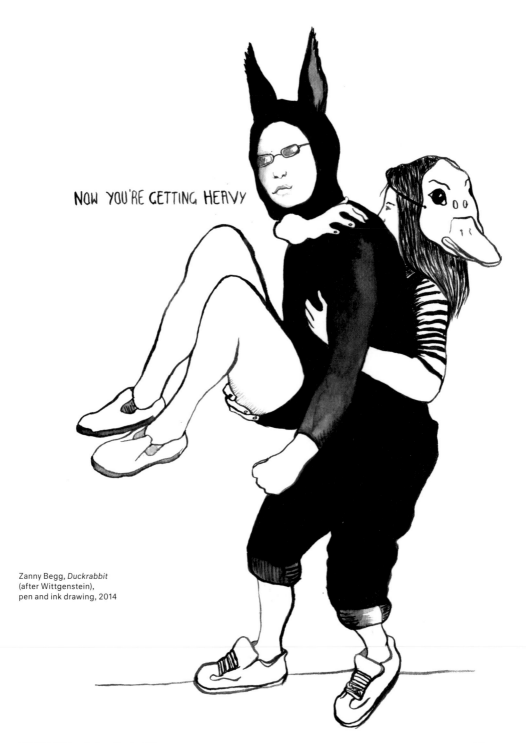

NOW YOU'RE GETTING HEAVY

Zanny Begg, *Duckrabbit*
(after Wittgenstein),
pen and ink drawing, 2014

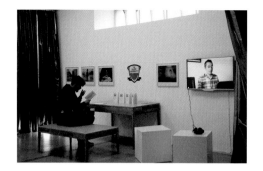

The Silent University, installation and photographs, 2014 and Noory Fakhry (Rebwar), *Grounds for Asylum According to the 1951 Convention*, 37 mins, 2013; photo: MP

Necropolitics regulates life through the perspective of death and can be summarised in an axiomatic way as 'let live and make die'.[4]

Central to Gržinić's work is the writing of Santiago López Petit who argues that in the first decade of the new millennium there was a 'great transformation' which resulted in the matching of global capitalism and reality: 'there is no outside'.[5] The claustrophobic fit between the two has released capitalist ideologies from any burden of justification for their system. This has freed capitalism from the softening and modifying impact of competition for its global dominance.

Nowhere is this more evident than in the discourse on human rights. As Gržinić points out, the international Human Rights regime was developed in Western Europe after World War II as a point of positive differentiation to the totalitarianism of the Soviet Block. The Convention relating to the Status of Refugees, for example, was signed in 1951, at the height of the Cold War, and sought to both resolve the aftermath of post-war displacements while recouping the moral high ground for capitalist 'humanism'. In the contemporary context, with an absence of the need for this differentiation, the global order of human rights is now, according to Gržinić, a dead end.[6]

Concurrent and central to this process are the links that she (after Achille Mbembe) draws between necropolitics and a 'racialisation' that enacts a:

*process of capital's differentiation between citizens (first and second grade citizens), non-citizens (refugees and asylum seekers), and migrants; they are all violently, but differently discriminated as the labour market under global capitalism imposes processes of racial, class and gender selection.*[7]

4
Gržinić and Tatlić, *Necropolitics, Racialization, and Global Capitalism*.

5
Santiago López Petit, 'Public Space or Spaces of Anonymity', *Barcelona Metropolis Archive*, at: http://w2.bcn.cat/bcnmetropolis/arxiu/en/page6ad2.html?id=23&ui=416 (accessed 13 November 2014).

6
Gržinić and Tatlić, *Necropolitics, Racialization, and Global Capitalism*.

7
Gržinić and Tatlić, *Necropolitics, Racialization, and Global Capitalism*, Chapter 5.

For example, as an exercise in doublethink, refugees are violently excluded from the 'official' labour market, yet surreptitiously included in the shadow economy as a vulnerable and super-exploitable workforce that can be drawn in and out of paid work at a whim.

During the process of writing this essay I catch a train from Redfern to Western Sydney with Murtaza. Murtaza came to Australia by boat, and has been in Australia for five years. He spent six months on Christmas Island, two years in detention and the remaining time in community detention. When released into the community he was initially granted the right to work, he got a job, got his licence, bought a car, paid his taxes and was sending money back home to his family to pay off debts they incurred helping him escape.

In September this year he was called into the immigration office and told, effective immediately, that his work rights had been taken away (with no reasons given). He was not granted any other form of financial assistance. When he asked what he was to do, he was told 'sleep on the streets or return to your own country'. Murtaza is a Hazara refugee from Afghanistan, a country he was forced to flee from with his family as a child. His family is in Pakistan, a place he cannot return to for fear of his life. As we talk it is obvious how trapped he feels, escaping death to be confronted by the living death of indefinite detention. He expressed his regret that Australia is an island: 'there is no way I will ever be allowed to stay, and I have no safe way to leave. It's like I am dead already.'

Murtaza had just received thunderous applause for speaking at a cultural event in the city. He has a headache and after a while we stop talking. What can I say? Sitting with my passport in the drawer at home, I am painfully aware of the privilege that 'citizenship' grants me, a category of belonging that has eluded my friend since birth. The next day the newspapers are full of the new legislation before the Australian parliament: the *Migration and Maritime Powers Legislation Amendment (Resolving the Asylum Legacy Caseload) Bill 2014*. Among other things the bill removes references to the UN Convention on Refugees and eliminates *refoulement* obligations. A subsidiary story, run in *The Guardian*,

Salon Fluchthilfe installation view with Barat Ali Batoor, *The Unseen Road to Asylum*, framed photographic prints, 2013; and Pilar Mata Dupont, *Purgatorio*, infinite loop, 2014; photo: ID

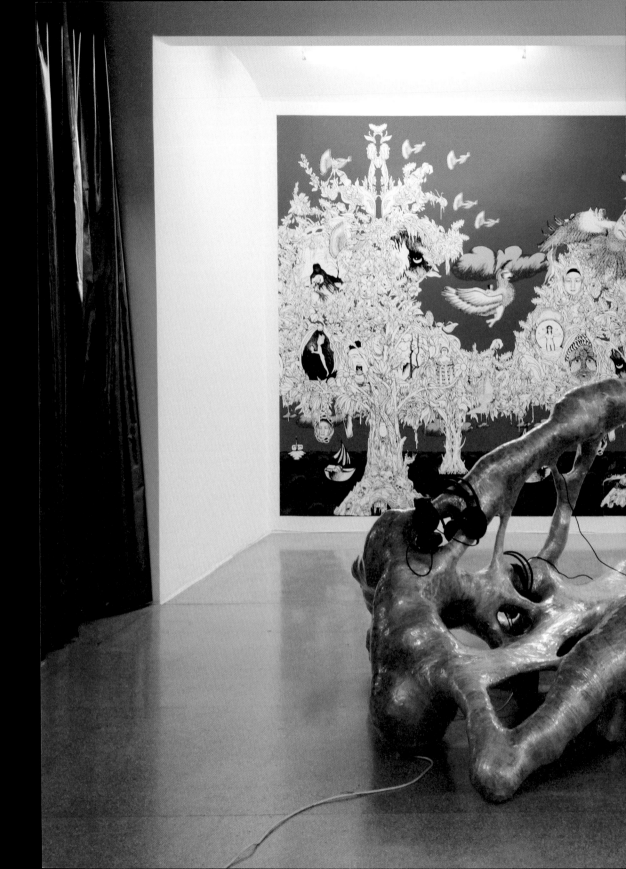

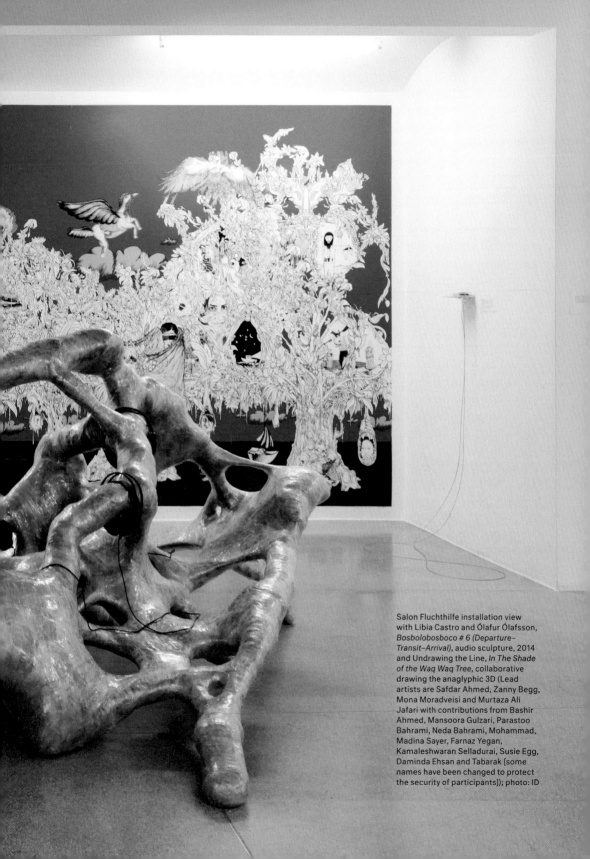

Salon Fluchthilfe installation view with Libia Castro and Ólafur Ólafsson, *Bosbolobosboco # 6 (Departure–Transit–Arrival)*, audio sculpture, 2014 and Undrawing the Line, *In The Shade of the Waq Waq Tree*, collaborative drawing the anaglyphic 3D (Lead artists are Safdar Ahmed, Zanny Begg, Mona Moradveisi and Murtaza Ali Jafari with contributions from Bashir Ahmed, Mansoora Gulzari, Parastoo Bahrami, Neda Bahrami, Mohammad, Madina Sayer, Farnaz Yegan, Kamaleshwaran Selladurai, Susie Egg, Daminda Ehsan and Tabarak [some names have been changed to protect the security of participants]); photo: ID

details how the Minister for Immigration Scott Morrison has been systematically breaking the law in his attempt to delay granting asylum to refugees currently in Australia, hoping to buy time until he can change the laws to deport them.[8]

In a 2003 article Angela Mitropoulos attempted to answer the question posed by refugees on a hunger strike in Curtin Detention Centre 'where is the human right?'[9] For her an answer to this question springs less from universalist or divine sources than it does from the law, specifically the power of nation-states to legislate for the protection of human rights based on the categories of citizen/non-citizen. The difficulty is that this division effectively eliminates the 'human' aspect of 'human rights' reserving them for the far more limited category of citizens. As Hannah Arendt argues:

*The conception of human rights, based upon the assumed existence of a human being as such, broke down at the very moment when those who professed to believe in it were for the first time confronted with people who had indeed lost all other qualities and specific relationships – except that they were human.*[10]

Popular anxiety over the collapse of the discourse on human rights can be found in a range of blockbuster science fiction films that have come out in the recent years. One particularly relevant for this discussion is Neill Blomkamp's 2013 film *Elysium*. Evocative of Thomas More's *Utopia*, *Elysium* is an attractive oasis,

protected by the distance of space, where a handful of citizens have built a biopolitical order that has, as Foucault predicted, offered its citizens a controlled 'good life' and eliminated death via Med-Bays that cure illness, restore the ravages of time and heal other defects. Trapped down on earth is the mass of the non-citizens forever cut off from the healing machines: forced to work or left to die.

Uniquely, *Elysium* includes a semi-sympathetic portrayal of a people smuggler, Spider, who makes a living out of selling dangerous passages into space with cracked codes to access the Med-Bays. In the inevitable confrontation between the main heroes of the film Matt Damon and Jodi Foster, Spider (played by Wagner Maniçoba de Moura) manages to crack open the entire programme running the Med-Bays making the whole of humanity 'citizens'. The film concludes with emissaries from *Elysium* heading to

8
Ben Doherty, 'Scott Morrison Ignored Departmental Advice on Visas for Boat Arrivals', *The Guardian*, at: www.theguardian. com/australia-news/2014/ oct/27/scott-morrison-ignored-department-advice-on-visas-for-boat-arrivals?CMP=share_btn_fb (accessed 13 November 2014).

9
Angela Mitropoulos, 'The Barbed End of Human Rights', *borderlands ejournal*, Vol. 2, No. 1, 2003, at: www.borderlands.net.au/ vol2no1_2003/mitropoulos_ barbed.html (accessed 13 November 2014).

10
H. Arendt, *The Origins of Totalitarianism*. New York: Harcourt Brace Jovanovich, 1979 p. 299.

earth with Med-Bays to begin curing the sick and extending the hand of citizenship to a polluted and over-crowded planet.

Elysium is animated by a deep-seated anxiety: the lush space outpost is home to the 1 per cent which ensures their survival at the expense of the teaming mass of humanity. Will we be the ones left behind on a ravaged earth? In a 2003 article about the infamous 'children overboard scandal' (where a govern-ment minister erroneously claimed that refugees had thrown their children overboard to flag down a ship) Ghassan Hage argued, 'what kind of people believe that a parent (even an animal parent let alone a human parent from another culture) could actually throw their child overboard? Perhaps only those who are unconsciously worried about being thrown overboard themselves by their own motherland?'[11] For Hage 'worrying' about one's nation has replaced 'caring' about it, indicating a slide from more comfortable ideas of citizenship, that denote access to the 'good life', to more insecure ones focused on maintaining one's position against others.

Sandro Mazzadra and Brett Neilson, who talked of 'border as method' to describe the constricted and fragmented spatial-temporal global order, argued that the border not only physically constrains the free movement of people around the globe but polices a global division of labour 'that serves to equilibrate, in the most violent of ways, the consti-tutive tensions that underlie the very existence of labour markets'.[12]

While the early days of globalisation produced a borderless fantasy for capitalism, to counteract a defunct fantasy with another fantasy might seem counter-intuitive and facile. But what if we posed borderlessness as method as a deconstructing device that challenges territorially inscribed notions of utopia by creating an endless line of flight (à la the Homa bird) out of the binary between citizen/non-citizen that has hitherto contained it? This is not to evict, even within our imaginations, connections between people and the land, but to disengage the human from geopolitically constituted notions of citizen/non-citizen. In this task we would sublate the territori-ally defined eutopia (the good place) into outopos a borderless non-place opening the potentiality of utopian thinking for contemporary realities.

Gavin Kendall and Mike Michael, when writing on 'the outside' in the thinking of Foucault (among other theorists) explain, 'we take it as a presupposition that this outside that impinges in order to instigate shattered thinking is an outside that is semiotically fecund: it is a (non) place of fluxes and shifts'. Foucault himself explains the unthought as

11
Ghassan Hage, 'On Worrying: the lost art of the well-administered national cuddle', borderlands e-journal, Vol. 2, No. 1, 2003, at: www.borderlands.net.au/vol2no1_2003/hage_worrying.html (accessed 13 November 2014).

12
Mezzadra and Neilson, 'Border as Method, or, the Multiplication of Labor'.

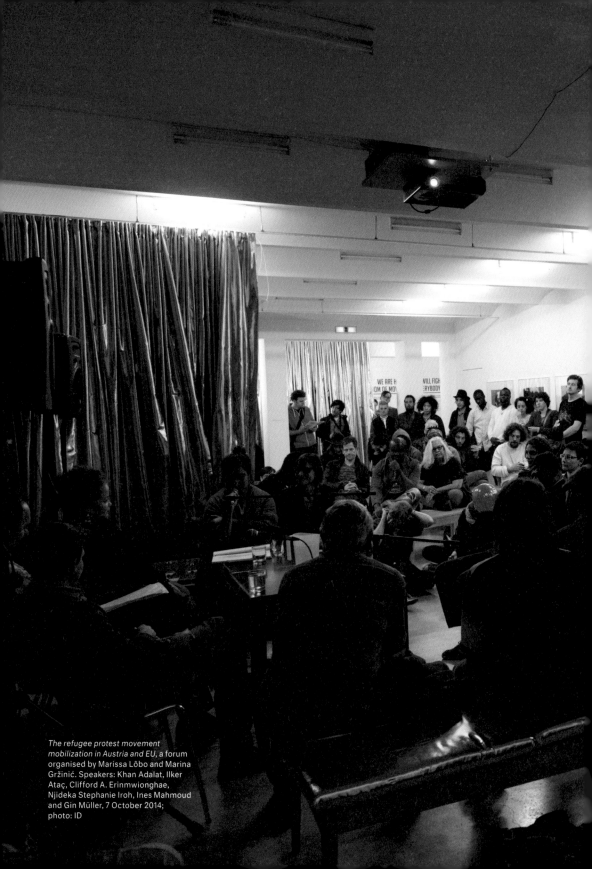

*The refugee protest movement mobilization in Austria and EU*, a forum organised by Marissa Lôbo and Marina Gržinić. Speakers: Khan Adalat, Ilker Ataç, Clifford A. Erinmwionghae, Njideka Stephanie Iroh, Ines Mahmoud and Gin Müller, 7 October 2014; photo: ID

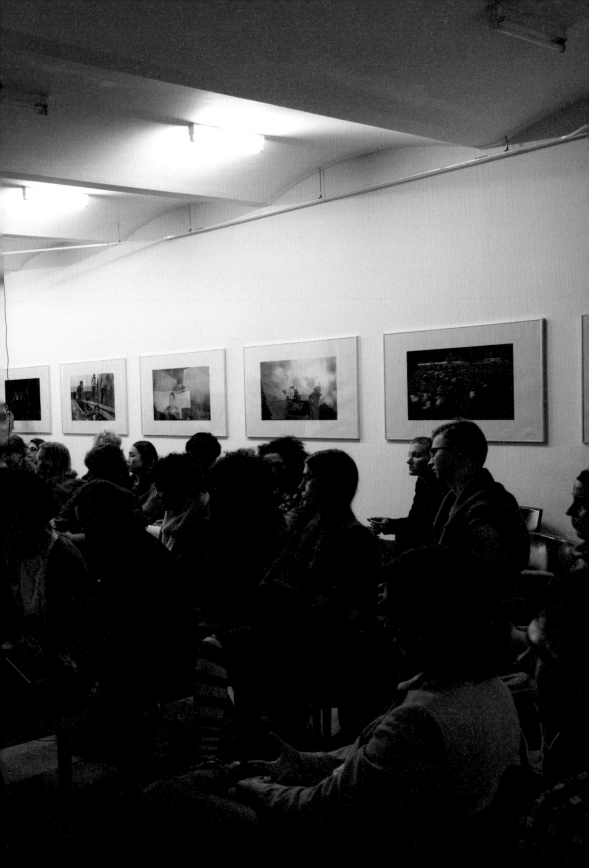

follows 'the whole of modern thought is imbued with the necessity of thinking the Unthought – of reflecting the contents of the *In-itself* in the form of the *For-itself*.'[13] It is worth noting that the outside proposed here is not an outside of capitalism, which as Santiago López Petit explains no longer exists, but an outside of known reality that acts as a destabilising challenge to the 'order of things'. If utopia is anything more than a literary amusement, it is in its possibilities of 'becoming', the not-yet of the unthought that might offer ways for social actors to act 'for themselves'.

In my contribution to *Utopian Pulse – Flares in the Darkroom* I tried to unthink utopia by using *borderlessness as a method*, an attempt admittedly caught in the contemporary realities of racism, border politics and refugee struggles. Salon Fluchthilfe draws its name from the German word *Fluchthilfe* a positive term used to describe those who help others cross borders to escape persecution (which in English has only derogatory translations, such as people smugglers or human traffickers). Salon Fluchthilfe included the work of Barat Ali Batoor, The Silent University, Undrawing the Line, Katarzyna Winiecka, Mindj Panther, Pilar Mata Dupont, Escape from Woomera, Libia Castro and Ólafur Ólafsson and Mariam Ghani with a

discussion forum organised by Marina Gržinić and Marissa Lôbo from Maiz (Self-organisation – Participation – Autonomy – Resistance – Transformation – Utopia), an independent organisation by and for migrant women.

For me, 'unthinking' borders began in the drawing workshops run by the Refugee Art Project in Villawood Detention Centre and with those in community detention in Sydney. Through these workshops the collective Undrawing the Line was formed (by Murtaza, Safdar Ahmed, Mona and myself) to imagine new possibilities beyond the 'shattered thinking' of borders. Using *borderlessness as method* we began working on an oversized drawing of the WaqWaq Tree with a series of birds, such as the Homa bird, in anaglyph 3D. In contrast to the Western tradition of utopia WaqWaqis a non-place from thirteenth-century Islamic maps that denoted the limits of the known world, it sits outside the Western tradition of utopia and predates Thomas More's book by a few hundred years. Evocative of a 'posthuman' reality the WaqWaq tree grows human fruit that speak of the future. To affect a physical breach of 'the binary' viewers needed to wear 3D glasses, which disrupt signals between the left and right eyes, providing glimpses of a borderless future animated along the Z-axis.

My shattered thinking was further developed by the discussion convened by Marina Gržinić and Marissa Lôboat at the Secession that highlighted the power of self-articulation and action, the specificity and fragility of dialogue, and the necessity of continuous

13
M. Foucault, *The Order of Things*. London/New York: Routledge Classics, 2002, p. 356.

deconstruction of whiteness without reconstituting discourses that allow it to re-fall in love with itself.[14] In her recent book, Gržinić quoted Achille Mbembe on the aftermath of apartheid, a call to arms that for me speaks to the issue of decolonisation more broadly. He argues that we must keep documenting:

*the gaping scars, demolished homes, broken lives; the skeletons, the debris and the rubble; the ruins and the fading memories of that there once was ... but it also demands that we pay attention to the Black people's capacity for self-making, self-reference and self-expression and to alternative versions of whiteness that are not primarily constituted around property and privilege, but around an ethics of mutuality and human solidarity. Looking forward – the politics of possibility, a future-orientated politics – implies a mediation about how to illuminate anew the experience of being human, of human life.*[15]

Unsurprisingly for a drawing produced through experiences of detention, *In The Shade of the WaqWaq Tree* ended

up full of birds. The proud Homa bird is joined by a parliament of other flying nomads and migrants, much like the multitude that populates Farid ud-Din Attar famous poem *The Conference of the Birds*. The birds in Attar's poem lack a divine leader, so they set off on a quest to find the legendary Simorgh, a mythical Persian bird roughly equivalent to the western phoenix. The birds, each of whom represent a human fault that prevents the attainment of enlightenment, embark on an arduous journey before finally reach the dwelling place of the Simorgh where they find a lake in which they see their own reflection: '*Though you have struggled, wandered, travelled far/It is yourselves you see and what you are.*'[16] We will only know who we are and what we are capable of by seeing the entire assemblage of those who stand at the edge of the mirror and look into its reflection.

Salon Fluchthilfe installation view with Katherine Ball, Imayna Caceres, Katarzyna Winiecka with Refugee Protest Vienna, *Visual Vocabulary of the Refugee Protest Vienna*, Posters, 2013–2014; Refugee Protest Vienna. Layout: Firas Shehadeh, *Solidarity Statement Against the Criminalisation of Migrants and Refugees*, wall poster, 2014; and Fluchthilfe & Du, *Interview with Yusuf Said Haibeh: Refugee Activist and Vice President of 'JEF for Africa'*, 41 mins, 2014; photo: MP

14
Gržinić and Tatlić, *Necropolitics, Racialization, and Global Capitalism.*

15
Ibid.

16
Ahmad Karimi-Hakkak, 'At the sign of the Simorgh: Mythical Birds and the Mystical Discourse in Persian Poetry', Iranian Lectures, *Foundation for Iranian Studies*, at: http://fis-iran.org/en/programs/noruzlectures/simorgh-hakkak (accessed 13 November 2014).

Barat Ali Batoor, *The Unseen Road to Asylum*, framed photographic print from a series of prints, 2013

Undrawing the Line, *In The Shade of the Waq Waq Tree*, collaborative drawing the anaglyphic 3D (Lead artists are Safdar Ahmed, Zanny Begg, Mona Moradveisi and Murtaza Ali Jafari with contributions from Bashir Ahmed, Mansoora Gulzari, Parastoo Bahrami, Neda Bahrami, Mohammad, Madina Sayer, Farnaz Yegan, Kamaleshwaran Selladurai, Susie Egg, Daminda Ehsan and Tabarak [some names have been changed to protect the security of participants])

People looking at *In The Shade of the Waq Waq Tree* on the façade of Secession with 3D glasses; photos: ID

Sign introducing how to use the 3D glasses in front of Secession; photo: ID

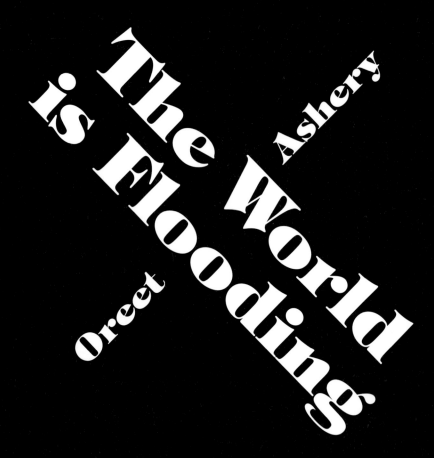

# The World is Flooding

Oreet Ashery

*Urgent Alternatives: Utopian Moments*
**July 2014**

*The World is Flooding*, takes Mayakovsky's free-to-use play *Mystery Bouffe* as both structure and starting point for collective works in which the figure of the Eskimo has been developed all at once as: a whistleblower, a messenger, an innocent child forming an early comprehension of the system and a newcomer experiencing a new environment for the first time. The figure of the Flood came to represent that which is 'too much': too many feelings, too many demands, too many traumas, while the Boat is a saving device which, alas, is liable to be taken over by the privileged.

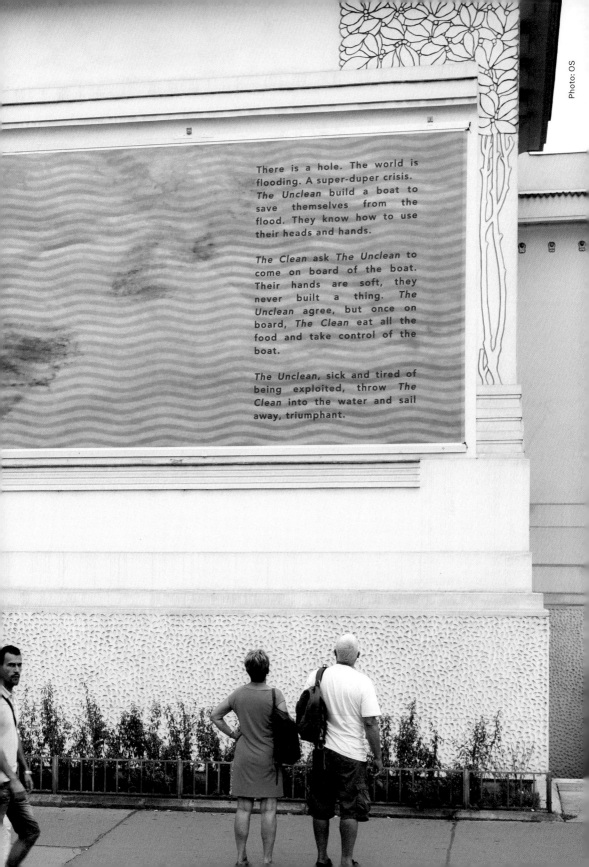

There is a hole. The world is flooding. A super-duper crisis. *The Unclean* build a boat to save themselves from the flood. They know how to use their heads and hands.

*The Clean* ask *The Unclean* to come on board of the boat. Their hands are soft, they never built a thing. *The Unclean* agree, but once on board, *The Clean* eat all the food and take control of the boat.

*The Unclean*, sick and tired of being exploited, throw *The Clean* into the water and sail away, triumphant.

# OUT OF THE SALON
## Female Counter-Spaces, Anti-Colonial Struggles and Transversal Politics

### Sophie Schasiepen

Illumination in *Livre de la Cité des Dames*, 1405, Bibliothèque Nationale

1

'Now there are juridical, aesthetic, political, radical, conservative, ladies, men, hairdressing and tailoring salons, while in the happy days I only knew our garden salon.' [„Jetzt gibt es juridische, ästhetische, politische, radikale, konservative, Damen-, Herren-, Friseur- und Schneidersalons, während ich in den glücklichen Tagen keinen anderen kannte als unseren Gartensalon."] Adalbert Stifter, 'Wiener Salonszenen', in Gesammelte Werke in vierzehn Bänden, Basel: von Konrad Steffen, 1969, Vol. 13, p. 220.

2

She is nowadays considered to be one of the most important salonnières. The Haskalah, the Jewish enlightenment, a movement significantly shaped by the philosopher Moses Mendelssohn, was largely elaborated through discussions among habitués and Jewish salonnières in Berlin during that time. It was through these debates that Jewish emancipation was brought forward; only in 1812 were Jews granted citizenship in Prussia and still with severe restrictions.

3

This can be seen, among other examples, in a letter to her husband Karl August Varnhagen von Ense from 1813; she remarks that the Viennese salons had dulled Friedrich Gentz: 'He would have to live among people as clever as him for a short time: the salons dulled him. He needs only little time to descale.' [„[E]r müßte erst wieder kurze Zeit unter eben so Klugen leben, als er ist: die Salons haben ihn engourdirt. Er braucht nur weniges sich zu entrosten."] (Rahel to Varnhagen in Bremen, Prague, 20 November, 1813, in: Briefwechsel Rahel-Varnhagen III [Rahel Bibliothek V, 3], pp. 213–14. cited in Peter Seibert, Der literarische Salon: Literatur und Gesellichkeit zwischen Aufklärung und Vormärz, Stuttgart: Metzler, 1993, p. 13).

What *is* a salon? Already in the 1840s Adalbert Stifter complained about the sheer variety of different salons that had come into being – from the juridical and political, radical, to hairdressing and tailoring establishments.[1] Rahel Varnhagen – the famous Jewish *salonnière* who welcomed guests such as Friedrich Schlegel, Dorothea Veit (later Schlegel), Caroline and Wilhelm von Humboldt and Heinrich Heine at her *Teegesellschaften* in Berlin around 1800 – also felt the need to distance herself from the salons of her times.[2] She considered them to be less egalitarian and intellectually challenging than the meetings in her garret.[3] Two generations later Berta Zuckerkandl's salon in Vienna was central in the founding of the Secession; her articles in newspapers and her connections to politics and court were influential in shaping public opinion of the Secessionists, the Wiener Werkstätten and their reformist approach to fine arts and craftworks.

The notion of the salon as such was an invention of the nineteenth century and then was retrospectively applied to different kinds of gatherings dating back to the sixteenth century. Western research is usually concentrated on forms that developed in France at the beginning of the seventeenth century; in *maisons*, *sociétés*, *cercles* or the more intimate *ruelles*, these relatively informal meetings were part of the evolution of the European Enlightenment. They functioned as meeting places in which new kinds of social interaction could be practised, the aristocracy meeting with writers, artists, musicians and members of the evolving bourgeoisie. While the meetings were mostly associated with the court, they provided a space, and were a tool, for gaining autonomy from the absolutist Monarchy. Out of these semi-public, intimate spaces a new criticality blossomed, bourgeois cultural life developed and competing publics were created; they offered an escape from individual economic patronage to the building of networks that promised social and cultural capital. Pierre Bourdieu describes them as mediators between fields; those holding political and

4
Pierre Bourdieu: *Die Regeln der Kunst. Genese und Struktur des literarischen Feldes.* Frankfurt am Main: Suhrkamp, 1999, pp. 88–89.

5
Ibid., p. 87.

6
Sarah Gwyneth Ross, *The Birth of Feminism: Woman as Intellect in Renaissance Italy and England,* Cambridge, MA: Harvard University Press, 2009.

economic power profited from cultural production to legitimise their own positions, while artists and writers formed a kind of pressure group to enforce their own interests.[4] For him, salons are a key component in the evolution of a literary market with its ambivalent autonomy, while themselves hierarchically situated in relation to each other.[5] The more common narrative suggests that within the different salons themselves, the social restrictions of class difference were breached by new, less formal and less hierarchical ways of being together, creating the conventions of the salons.

These conventions were substantially shaped by women. They not only took over the role of host and created the atmosphere of the meetings, they also set the themes to be discussed. Often they were themselves authors, if not of books or novels then of extensive correspondences with other *salonnières* and the *habitués* of their salons. The *Querelles de Femmes*, 'the woman question', was debated heavily and the *salonnières* often used their authority to push for women's emancipation. Women such as Madeleine de Scudéry, a *salonnière* and author of seventeenth-century France who not only challenged the patriarchal order by living her life as an unmarried writer, but in her subject matter as in *Femmes Illustres* of 1642 in which she wrote a history of educated women and their literary achievements. Such work built on Europe-wide networks created by intellectual women. Women like Christine de Pizan, who lived from her literary productions, challenged the boundaries of the concept of 'woman' by introducing a new option, 'woman as intellect'.[6] With her work *Le Livre de la Cité des Dames* (1405) she created an early utopian vision of a society in which women had gained equal rights. Salons also served as places for discussing and practising new, romantic concepts of love, partly overcoming strategic and patriarchal marriage arrangements, and sometimes transgressing heteronormative boundaries.

The networks of the *salonnières* were in effect 'female counter-spaces', spaces in which women

7
Scholars are still confronted with the difficult task of (re)inscribing a salon historiography into the literary historiography. See for example: Stephanie Bunge: *Spiele und Ziele. Französische Salonkulturen des 17. Jahrhunderts zwischen Elitendistinktion und Belles Lettres*, Tübingen: Narr, 2013.

8
Ibid., pp. 32–71.

9
In an *Appeal to women!* in the feminist magazine *La femme libre* from 1832 Jeanne Victoire (pseud.) writes: 'Women of the privileged class – you who are young, rich, and beautiful, you who think yourselves happy when, in your salons, you breathe the incense of flattery lavishly bestowed by those who surround you; you reign, but your reign is of short duration; it ends with the ball! When you return home you are slaves once again; you find there a master who makes you feel his power, and you forget all the pleasures you have tasted.' *Appel aux Femmes in La femme libre*, No. 1, 1832, pp. 1–3, cited in *Women and Social Movements, 1600–2000* http://womhist.alexanderstreet.com/awrm/doc5.htm (accessed 24 November 2014).

10
For an overview, see Marjanne E. Goozé, 'Utopische Räume und idealisierte Geselligkeit: die Rezeption des Berliner Salons im Vormärz', in Wolfgang Bunzel, Peter Stein and Florian Vaßen (eds), *Romantik und Vormärz. Zur Archäologie literarischer Kommunikation in der ersten Hälfte des 19. Jahrhunderts*, Bielefeld: Aisthesis, 2003, pp. 363–90. Goozé also analyses the specific projections of male non-Jewish *habitués* on the (bodies of the) *Jewish salonnières*.

could develop and enforce their own discourses. Not surprisingly then they were, from the very start, objects of stale male ridicule. The very praxis of conversation was devalued: discussions were said to be only entertainment, their cultural critiques a sham, clichéd and tame. Patriarchal gatekeepers were insistent that rhetoric was an art form while conversation was not, and in the process devalued the oral as opposed to the written.[7] Contemporary comments, both supporting and criticising, focused on the physical appearance of the *salonnières* and their personal biographies;[8] her trajectory determined by her looks and social standing.

More pertinent critiques of the time attacked the predominantly bourgeois character of the salons as well as their lack of influence on the 'real' politics outside of their circles. German writers of the *Vormärz* for example dismissed the societies for not being out 'on the street'. Feminist women equally criticised the bourgeois *salonnières* in 1830s France, accused them of fake emancipation before returning to their husbands, caught up in the dominant patriarchal relationship.[9] Another contested field concerns the way Jewish and non-Jewish collaboration in modern-day Germany around 1800 has been depicted in the salon historiographies. In contrast to overly idealising descriptions of these new alliances more critical scholarship today emphasises that the Christian guests, befriended with the Jewish hosts and *habitués*, often continued to utter anti-Semitic statements; also both Christian and Jewish men continued to articulate anti-women opinions.[10]

The contradictory perceptions of the ability of the salon networks to suspend hierarchies and discrimination at least for the time of their interactions and among their protagonists raises the crucial question of the relation between the space of the salon (not in the sense of a physical space but as the space that opens up between its members) and the rest of the world. From one point of view it is precisely the balance of the cultural, critical and entertaining nature of the discussions that allows the members to obtain a

11
This, of course, cannot only be said of progressive ideas. The salon of Elsa Bruckmann in Munich is one of the examples of racist and reactionary salons; she opened her meetings with a lecture by Houston Stewart Chamberlain with his anti-Semitic 'classic' *Grundlagen des XIX. Jahrhunderts*, and was an influential supporter of Adolf Hitler in the 1920s.

12
For more information on the history of their family see, Emily Musil Church, *In Search of Seven Sisters: A Biography of the Nardal Sisters of Martinique*, in Callaloo, Vol. 36, No. 2, 2013, pp. 375–90.

13
white in italics and lowercase indicates the socio-political construction of that category. Black with a capital B highlights the fact that it serves as a self-designated political term that holds the potential of resistance to it and also indicates the social construction of the term. See Maureen Maisha Eggers, Grada Kilomba, Peggy Piesche and Susan Arndt (eds), Mythen, Masken und Subjekte. Münster: Unrast, 2005, p. 1.

non-hierarchical communication; debates should never go beyond a certain point of consensual interaction, never open up into dispute or reach out into the socio-political conditions outside of the protected sphere. At the same time, their quality of converging aspects of what came to be called 'private' and 'public' spheres makes them a prototype for a basic feminist idea and demand, that the Private cannot be separated from the Political: private power relations are shaped by public discourses and socio-political conditions and therefore also need to be of public interest. Salons were and still can be a space in which daily life and political analysis can inform conversations that transgress the boundaries given by patriarchal state policies, opening up possibilities of a different kind of (societal) organisation. Undoubtedly, they have as such served as a means of establishing social and cultural practices that were unwanted in the societal structures they were situated in, thereby also having an impact on political developments.[11]

This is also true of a salon usually not included in the salon historiography: the Clamart salon of the sisters Nardal in Paris in the 1930s. Here, Paulette, Jane and Andree Nardal, who had grown up in Martinique[12] and come to France for their studies, enabled meetings between Black (and *white*)[13] French, African and American intellectuals and artists. The Clamart salon became one of the centres for Pan-Africanist ideas, the elaboration of the notion of Black internationalism and eventually the evolution of the Négritude movement. In 1931 the meetings led to the founding of a bilingual review called *La Revue du Monde Noir*. The review introduced a new position within the magazines of Black, anti-imperialist organisations of the time since it focused on cultural, artistic and literary developments. In a contribution titled 'Our aim' the editorial team, with Paulette Nardal as Chief Editor, clearly articulated their Pan-Africanist ideas and challenged the universal claims of a *white* humanism right in the first edition. The manifesto closes with the words:

14
'Our aim', in *La Revue du Monde Noir*, No. 1, October 1931, p. 2, quoted in T. Denean Sharpley-Whiting, Negritude Women. Minneapolis, MN: University of Minnesota Press, 2002, p. 55 ff.

15
Ibid., pp. 127–29.

16
Cited in Denean Sharpley-Whiting, *Negritude Women*, p. 57.

17
It lost its funding after only six issues; the French police and Colonial Administration accused the editors of being Communists and Garveyites. (Ibid., p. 59) Police observation of Black organisations was omnipresent during the inter-war period in Paris; Black people were tracked daily by informants and police. Philippe Dewitte, *Les Mouvements nègres en France*, 1919–1939, Paris: Editions L'Harmattan, 1985, cited in Jennifer Anne Boittin, 'In Black and White: Gender, Race Relations, and the Nardal Sisters in Interwar Paris', in *French Colonial History*, Vol. 6, 2005, pp. 120–35, at p. 120).

*The motto is and will continue to be:*
*FOR PEACE, WORK and JUSTICE.*
*BY LIBERTY, EQUALITY and FRATERNITY.*
*Thus, the two hundred million individuals which constitute the Negro race, even though scattered among the various nations, will form over and above the latter a great Brotherhood, the forerunner of universal Democracy.*[14]

Through their salon and publishing activities, Jane and Paulette Nardal managed to create a space for exchange between artists and writers of the Harlem Renaissance in the USA, Caribbean and African intellectuals, women's rights and pacifist organisations and political activists. Despite the mainly bourgeois character of her projects, Paulette Nardal also collaborated with the more radical Union de Travailleurs Nègres (UTN), mostly in her function as secretary of the Comité Mondial contre la Guerre et le Fascisme. In her engagement against the fascist Italian invasion in Abyssinia she called especially for an internationalist, female unity – positions that were featured prominently in *Le Cri des Nègres*, the paper of the UTN. Here, class frictions could apparently be bridged by her gendered political activism.[15] Both Jane and Paulette Nardal also tackled exoticisms and racisms in everyday cultural life in Paris in varying formats, from political analysis to fictional short stories, providing a critique of contemporary 'negrophilia' from their perspective as Women of Colour. Nevertheless, *La Revue du Monde Noir*, the magazine that can be seen as the most closely linked to the Clamart salon, financed in the public world by the Ministry of Colonies, was also criticised as '"rose water", apolitical, bourgeois, and assimilationist',[16] by, among others, Aimé Césaire.[17] Together with Léopold Sédar Senghor and Léon Damas he is said to have founded the Négritude, a literary and ideological movement that was poetic, Marxist, socialist and anti-colonialist. It is only now that the

18
Paulette Nardal, in Jacques Louis Hymans: *Léopold Sédar Senghor*, cited in Denean Sharpley-Whiting, *Negritude Women*, p. 17.

19
Today, the idea of the salon is flourishing; examples like The Queer Salon of Antke Engel in Berlin, which brought together people able to share a sense of unity while also articulating their differences, the Bart al-Qasid based in Damascus, a place for young writers to come together, and the Johannesburg Salon, a web journal arguing for a Southern salon dedicated to the political and aesthetic, show the vast variety of approaches among them.

20
Donna Haraway, 'Situated Knowledges: The Science Question in Feminism and the Privilege of Partial Perspective', *Feminist Studies*, Vol. 14, No. 3 (Autumn, 1988), pp. 575–99.

21
Jo Freeman: *The Tyranny of Structurelesness*, at: www.jofreeman.com/joreen/tyranny.htm (accessed 5 December 2014).

close intertwinement of Négritude with the Clamart salon has become acknowledged; as Paulette Nardal has put it: 'we were but women, real pioneers – let's say we blazed the trail for them.'[18]

These few fragmentary examples suggest that the idealised descriptions of salons as spaces in which discriminations and hierarchies of 'the world outside' were totally suspended were never exactly so. In light of the fragility of alliances and the necessity of conflicting, even contradictory practices and strategies within political activism, an evaluation of the significance of the salons for current emancipatory struggles[19] must also question whether such imaginations are desirable at all and whose interests they represent. Feminists have been working and practising intensively on the question of situated speaking positions, on enabling 'partial, locatable, critical knowledges sustaining the possibility of webs of connections called solidarity in politics and shared conversations in epistemology.'[20] Conflicts and the struggle for acknowledging differences have been central in feminist thought; and one might argue that perspectives that overlook these conflicts, who instead narrate a 'single story' (Chimamanda Ngozi Adichie), are usually the dominant ones, those against whom the conflicts partially arose. Jo Freeman, in her key text of the second wave of the women's movement *The Tyranny of Structurelessness* (1970),[21] described the informality of the salon as a suitable format for a crucial period of 'consciousness raising'; but she warned against the dangers of an unstructured group: '[It] always has an informal, or covert, structure. It is this informal structure (...) which forms the basis for elites.' Acknowledging that in her era a crucial step was made by rejecting 'the ends justify the means' politics, Freeman's text can be read as a problematising of a fetishisation of the means, a lingering in organisational (informal) narcissism.

But salons could actually also be ideal spaces in which to develop transversal perspectives (Nira Yuval-Davis): this includes 'shifting' as a method to put oneself in a situation of exchange with a

Mario Nunes-Vais, *Congress of the Italian Socialist Party, Florence*, 1908. Istituto Centrale per il Catalogo e la Documentazione, Gabinetto fotografico nazionale.

Anna Kuliscioff, here at a meeting of the Italian Socialist Party, established a space at her home in Milan that could be called a proletarian version of a salon. From 1891 onwards, journalists, socialist leaders, seamstresses, rice-pickers and other workers came for discussions with and advice from this revolutionary.

22
Nira Yuval-Davis, 'Women and Coalition Politics', in Mary Kennedy, Cathy Lubelska, Val Walsh (eds), *Making Connections. Women's Studies, Women's Movements, Women´s Lives.* London 1993, pp. 3–10, here p. 8 f.

23
Nira Yuval-Davis: 'What is Transversal Politics?', in *Soundings*, issue 12, 1999, http://biblioteca-alternativa.noblogs.org/files/2012/11/davis_transversal-politics.pdf (accessed 5 December 2014).

person who is positioned differently, without self-decentring oneself.[22] Based on a standpoint of epistemology, the conviction that 'the only way to approach "the truth" is by a dialogue between people of differential positionings' and 'the encompassment of difference by equality'[23] transversal politics can be generated. It is this quality of bringing together different positionings and their potential of transgressing identity politics which today might be the most important aspect – or flare in the darkroom – of the potentials of a salon.

# SALON PUBLIC HAPPINESS

## Christoph Schäfer

with
Videoccupy; PlanBude St.Pauli
(Margit Czenki, Renée Tribble);
Esso-Häuser Filmteam (Irene
Bude, Steffen Jörg); Echohäuser
(The Good The Bad and The Ugly,
Frank Egel, Julia Priani, Thomas
Wenzel, Ømmes Andreas Fröhling,
Mense Reents,Ted Gaier, Oxana
Smakova, Der Buttclubchor);
Esso-Häuser Echo (Megafonchor/
Sylvi Kretzschmar, Svenja
Baumgart), Der Investor (Die
Goldenen Zitronen, Gaier, Duve,
Schierhorn), Wien TV,

In her essay 'Revolution and Public Happiness' Hannah Arendt analyses the term 'public happiness', used by Thomas Jefferson and the Enlightenment thinkers of his time.

*The point of the matter is that the Americans knew that public freedom consisted in having a share in public business, and that the activities connected with this business by no means constituted a burden but gave those who discharged them in public a feeling of happiness they could acquire nowhere else.*[1]

The link between 'public' and 'happiness' had been made to seem so natural by a widely shared (*gemeinsam*) practice of democratic meetings, political salons and collective mobilisation that by the time Jefferson drafted the 13 Colonies' Declaration of Independence it could never have occurred to him that 'pursuit of happiness' might mean anything other than the right to (and enjoyment of) collective discussion, decision-making and activity.

*What makes Jefferson's substitution suggestive is that he did not use the then current term 'public happiness,' which was probably a significant American variation of the conventional idiom in royal proclamations where 'the welfare and the happiness of our people' quite explicitly meant the private welfare of the subjects and their private happiness. The pre-revolutionary insistence on public happiness was revolutionary in essence because it insisted on the citizens' right to a share in the public power as distinct from the subjects' right to be protected by the government and even against the public power. Even more important in our context, the very fact that the term 'happiness' was chosen in laying claim to a share in public power indicated very strongly that there existed such a thing as 'public happiness,' and that men therefore could not be altogether 'happy' if their happiness was located and enjoyed only in private life.*[2]

Yet only a few decades later this idea had sunk so far into oblivion that bourgeois society was left more or less defined by the sharp division between private and public spheres, *Separating the useful and necessary from the beautiful and from enjoyment initiated a development that abandons the field to the materialism of bourgeois practice on the one hand and to the appeasement of happiness and the mind within the preserve of 'culture' on the other.*[3]

'Happiness' becomes a personal issue, a private matter, a field where politics should not intrude.

1
Hannah Arendt, *On Revolution.* New York: Penguin Books, 1977, p. 110.

2
Hannah Arendt, 'Revolution and Public Happiness', *Commentary* Magazine, 11 January 1960, at: www.commentarymagazine. com/article/revolution-and-public-happiness/ (accessed 6 November 2014).

3
Herbert Marcuse, 'The Affirmative Character of Culture', in I. Szeman and T. Kaposy (eds), *Cultural Theory: An Anthology.* Chichester: Wiley-Blackwell, 2011, p. 27.

*Freud knew well the difference between progressive and regressive, liberating and destructive repression. The publicity of self-actualization promotes the removal of the one and the other, it promotes existence in that immediacy which, in a repressive society, is (to use another Hegelian term) bad immediacy* (schlechte Umittelbarkeit). *It isolates the individual from the one dimension where he could 'find himself': from his political existence, which is at the core of his entire existence. Instead, it encourages non-conformity and letting-go in ways which leave the real engines of repression in the society entirely intact, which even strengthen these engines by substituting the satisfactions of private and personal rebellion for a more than private and personal, and therefore more authentic, opposition.*[4]

The dominant view that art is not political corresponds to this division and has its roots in it. The opposite of all this – public space, public speech and political discourse – is incrementally reduced to bureaucracy and accordingly impoverished.

## Space is the Place

Space is social: it involves assigning more or less appropriated places to the social relations of reproduction, namely, the biophysiological relations between the sexes, the ages, the specified organization of the family and to the relations of production, namely, the division of labour and its organization. (...) Spatial practice defines its space, it poses it and presupposes it in a dialectical interaction. Social space has thus always been a social product, but this was not recognized. Societies thought that they received and transmitted natural space.[5]

The groups presented at Salon Public Happiness are linked by their search for a practice that could be understood as a rediscovery of 'Public Happiness'. And they are also linked by something else: they find this new commonality (*dieses neue Gemeinsame*) neither in political parties, nor in the factory, nor in the field of shared (*gemeinsam*) discourse, but in space: the urban space that Henri Lefebvre called 'social space',[6] produced exclusively through action.

4
Herbert Marcuse, *Repressive Tolerance* 1965, at: www.marcuse.org/herbert/pubs/60spubs/65re pressivetolerance.htm (accessed 7 January 2015).

5
Henri Lefebvre, *State, Space, World: Selected Essays*, Neil Brenner and Stuart Elden (eds). London: University of Minnesota Press, 2009, pp. 186–87.

6
'Social space is not a thing among other things, nor a product among other products: rather, it subsumes things produced and encompasses their interrelationships in their coexistence and simultaneity – their (relative) order and/or (relative) disorder,' Henri Lefebvre, *The Production of Space*, (1974), English translation by Donald Nicholson Smith, Oxford: Blackwell, 1991, p. 73.

Opening of Salon Public Happiness,
Secession, 10 September 2014;
photo: CF

This urban space is rapidly regaining importance as the site of production of ideas, relationships, trends, atmosphere, networks, images, innovations, lifestyles and increasingly also of things shaped by these 'soft', 'immaterial', 'urban' qualities.

*One vast reservoir of common wealth is the metropolis itself. Today we are witnessing a shift, however, from the industrial to the biopolitical metropolis. And in the biopolitical economy, there is an increasingly intense and direct relation between the production process and the common that constitutes the city. The city, of course, is not just a built environment consisting of buildings and streets and subways and parks and waste systems and communications cables but also a living dynamic of cultural practices, intellectual circuits, affective networks, and social institutions. These elements of the common contained in the city are not only the prerequisite for biopolitical production but also its result; the city is the source of the common and the receptacle into which it flows.*[7]

For the same reason, cities are increasingly the focus of capital. With renewed momentum since the financial crisis, money flees to the artificially tightened urban land market in its search for security and yield, pushing up prices and increasingly displacing to the margins those who can no longer keep up in this game.[8] The days when gentrification and social division were 'states of mind' are long gone. Now these processes are dominant urban development paradigms in the global Go-To-Zone. This is true even in Vienna: the former squatters of the city's Pizzeria Anarchia, who were invited to Salon Public

7
Michael Hardt and Antonio Negri, *Commonwealth*. Cambridge, MA: Harvard University Press, 2011, pp. 153–54.

8
See David Harvey, 'The Urban Roots of Financial Crisis: Reclaiming the City for Anti-Capitalist Struggle', *Socialist Register 2012: The Crisis and the Left*, Vol. 48.

PlanBude, *Taktische Möbel, Volumen Knet Modell, Die hundert Millionen Euro Frage, Team-Bändel* [Tactical Furniture, Volume Knead Model, The One Hundred Million Euro Question, Team Ribbons], 2014; photos ID and CF

Happiness at short notice, were evicted from their small social centre by around 1,400 police. It took the cops several days to get some 20 people out of the house. The disproportionate scale of this operation shows how seriously police strategy takes the prospect of urban struggles. It's also a clear message to anyone attempting to organise everyday life outside the increasingly dysfunctional market form.

### Spatialise your desire

All the projects appearing in Salon Public Happiness are part of new resistance movements that anchor their practice in urban space, transforming practice into space and in this way making new connections

possible: The Videoccupy Collective was formed in the first days of the Gezi Park occupation in Istanbul. Soon afterwards, the Gezi commune – along with a manifold protest movement in all of Turkey's large cities – developed out of a small group of park occupiers. Occupygezi initially opposed a building project in an inner city park slated for replacement by a shopping mall in the style of an Ottoman military barracks. The fight for the park became a fundamental dispute about democracy, human rights and the neoliberal transformation policy of the Erdogan government. A completely different face of Turkey became visible in the occupied park: manifold, witty and full of love for life. The LGBT (Lesbian/Gay/Bi/Transgender) tent was in the centre of the park, and arranged around it was an utterly diverse crowd: a Sufi dancer in pink skirt and gas mask, Besiktas, Fenerbahçe and Galatasaray football fans, the previously irreconcilable

9
https://bak.ma/
(accessed 7 January 2015).

Kemalists and PKK, anti-capitalist Muslims, bio-gardeners and new non-governmental groupings such as Müstereklerimiz (Our Commons), critical pharmacists, hedonist youth, girls in dresses, women in headscarves, and a little later Davide Martello of Konstanz (Germany), who became well known as the Taksim Pianist. Videoccupy archives[9] thousands of hours of material received from hundreds of film-makers working with phones, tablets or video cameras. The collective works with 'Videograms', a title the young film-makers borrowed from Harun Farocki. Each Videogram is about 3 minutes long and focuses on a specific moment, a particular angle or a single person. The film-makers make no claim whatsoever to deliver the Grand Narrative: they don't want to make THE Gezi film.

The Gezi genie has escaped from the bottle and will not, contrary to what many in Istanbul suggest, be re-imprisoned in a new bottle. In the words of cultural scholar Göksun Yazici: 'This is a phenomenological revolution, an earthquake in the unconscious.'

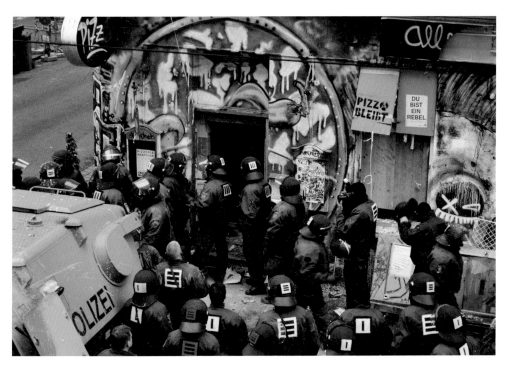

Wien TV, *Documentation of the Eviction of Pizzeria Anarchia squat,* 2014, film still

Salon Public Happiness installation view with PlanBude, *Ideenarchiv (Anfang)* [Archive of Ideas (Beginning)], 2014; photo: CF

The exhibition focuses on the current conflict around the 'ESSO Houses', a block of former municipal flats near the Reeperbahn, built in the 1960s and sold to developer Bayerische Hausbau in 2009, where residents resisted demolition for years until late one night in December 2013, when the buildings were declared to be in danger of collapsing and the residents were evacuated by police.

As part of the ESSO Houses Initiative, Irene Buder and Olaf Sobczak have followed the struggle of the residents from the beginning. Steffen Jörg, the producer of their film, organised basic work on the buildings for the St. Pauli Work in the Community project. The film-makers' first film *Empire St. Pauli* came to international notice and was already an important part of the resistance against gentrification in St. Pauli: all the more so because the team continued to screen the film at contested and hard-won locations in the city and took the video medium out of the web to put it back into a spatial and political context. The ESSO House's film *Buy Buy St.Pauli*, which premiered in October 2014, moves in even closer than its predecessor, showing in all the grace, humour and ability to laugh at themselves of the residents who, over decades, turned the modern functional building into a living place full of secrets and covert beauty.

## Right to the City

The situation along the Elbe hasn't progressed as far. Nonetheless, the Right to the City movement has been supplying utopian sparks in Hamburg for the past five years. 'Spatialised' initiatives (to name just a few, Gängeviertel, S.O.S.-St.Pauli, St. Pauli Selber Machen [St. Pauli DIY], Fette Mieten Party [Fat Rents Party], Mietenwahnsinn Stoppen [Stop the Rent Madness] and FabLab St.Pauli) are co-ordinated city-wide and continue to win concessions from the city council; they are even starting to change legislation.[10]

10
Among other examples, the neo-liberal 'auction system' for the sale of public space to private investors was abolished, not least because of the Gängeviertel occupation. Also, the city bought back the Rote Flora building.

## Utopian excesses

The Hamburg situation is characterised by co-ordination of groundwork – including legal advice and active resistance – between the various initiatives and endangered self-organised spaces (e.g. Rote Flora[11], Gängeviertel[12], Park Fiction[13], Golden Pudel Klub and Centro Sociale[14]). It is also notable for the way artists and musicians continue to play a major part in the movements, and for the development of their artistic work in this context. The song 'Echohäuser' by The Good, The Bad & The Ugly,[15] an anonymous all-star combo enriched by ESSO residents Oxana Smakova and Julia Priani, is a dark dub that demands solidarity with the ESSO tenants: 'United We Stand – Divided We Fall'.

11
Rote Flora, at: www.nadir.org/
nadir/initiativ/roteflora/
(accessed 7 January 2015).

12
Komm in die Gänge, at: http://
das-gaengeviertel.info/
(accessed 7 January 2015).

13
Park Fictiona, at: http://park-fiction.net (accessed 7 January 2015).

14
Centro Sociale, at: www.centrosociale.de/ (accessed 7 January 2015).

15
'"Echohäuser" der Song für den Erhalt der ESSO-Häuser!', S.O.S. St.Pauli, at: www.sos-stpauli.de/
echohauser-der-song-fur-denerhalt-der-esso-hauser/
(accessed 7 January 2015).

16
Sylvi Kretzschmar's performances during the 9. Festival Politik im Freien Theater, Freiberg, November 2014, at: www.politikimfreientheater.de/
esso-haeuser-echo/ (accessed 7 January 2015).

## Public Address

Performer Sylvi Kretzschmar's megaphone choir also came from the Right to the City movement. She started with extensive research into PAs – Public Address systems and/or voice-amplifying machines. Kretzschmar is interested in the effect of amplifiers on 'public speaking'. Her performance 'Esso Häuser Echo'[16] was preceded by 'Aufruf zum Nachruf' ('Call for Obituaries'), an invitation to neighbours to leave their memories of the ESSO-Häuser on an answering machine. The director then made a text collage from these scraps of everyday speech, to be recited by the megaphone choir like a Greek choir armed with technology. The text makes artful use of grammatical anomalies, semantic leaps, dragged-out words and the personal idiosyncrasies of private speech and reasoning to produce tension, changes of pace, surprises, correlations and flashes of inspiration – things that 'political speaking' can no longer evoke. In laying claim to the contested site itself as a stage, the performance poses an artistically complex challenge to public speaking.

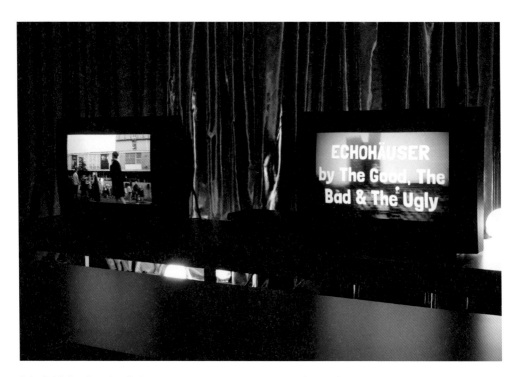

Salon Public Happiness installation
view with Frank Egel and Julia Priani,
The Good The Bad & The Ugly,
*Echohäuser* [Echo Houses] *(United
We Stand – Divided We Fall)*, music
video, 4:25 mins, 2013 and Irene Bude,
Olaf Sobczak and Steffen Jörg, *Die
Essohäuser* [The Esso Houses], trailer,
20 mins, 2014; photo: OR

17
See the PlanBude website, at:
http://planbude.de (accessed
7 January 2015).

### Participation de Luxe

It follows only logically from this
manifold and persistent resistance
then, that PlanBude[17] is about to
organise participation in the on-site
replanning of the ESSO Houses. The
group was officially commissioned
by the city of Hamburg. An
interdisciplinary team of planners,
artists, social workers and architects
recruited from the St. Pauli initia-
tives is developing a set of participa-
tory tools that enable 'co-planning',
that is, the contribution of ideas and
thoughts through mutual exchange
as a basis for further planning on a
broad basis. The team, which already
distinguished itself with 'Projekt Park
Fiction' at Documenta 11, shows in
the exhibition some of the tools
intended to make the complex
planning process accessible to
non-professionals. PlanBude is
currently setting up a strong visual
presence on the site, consisting of a
public planning office that can be
extended into urban space by means
of tactical furniture, stencil and
sticker lettering, events and lectures.
All this suggests a paradigm shift for
planning culture: culturally informed

participation, followed by its actual implementation. A platform for exchange, a culture of sharpening one another's insights.

### The city is our factory

Artists know that innovation can only exist as part of a double bill with rebellion and autonomous self-organisation. The fact that the market continues to incorporate these innovations is a commonplace of abbreviated gentrification critique, as taken up in the Goldene Zitronen video *Der Investor*.[18] But this does not lead the band to the sort of resigned 'I won't get involved' attitude that often leads to political-cultural paralysis. Instead, some band members are involved with the ESSO Houses Initiative. As with the other projects in the exhibition, they work to make sure that social and cultural protests can't be divided. But the burgeoning conflict in the cities, as they replace the factory as the site of production worldwide,[19] is a matter either of holding back the neoliberal sucking-up of surplus value or of overcoming it altogether.

Salon Public Happiness installation view with Margit Czenki, *Bewaffne Deine Wünsche, Performance des Megafonchors während des Abrisses der Esso-Häuser, St. Pauli 2014*, [Arm Your Desires, Performance of the Megafon Choir during the Demolition of the Esso Houses, St. Pauli 2014], photo print, 140 x 340, 2014; photo: OR

In this context, 'Public Happiness' can also mean that we must now develop forms of political agency that don't withhold the payoff until after an imaginary revolution: while on the way there, the particular projects and forms of action should already be in themselves a utopian pulse that makes another world possible. This has already paid off for some of the residents of the ESSO Houses, despite all hardships: they appear in three of the videos exhibited; they formed a background choir for the Echohäuser song; they travelled with the Initiative to Paris and to the Architecture Biennial in Venice in search of alternatives to demolition, and through political self-organisation, they appropriated new cultural territory.

Arm your desires!

18
Thomas Vorreyer, 'Die Goldenen Zitronen »Der Investor« (video)', *Spex Magazin*, 17 October 2013, at: www.spex.de/2013/10/17/der-investor/ (accessed 7 January 2015).

19
Christoph Schäfer, *Die Stadt ist unsere Fabrik [The City is our Factory]*. Leipzig: Spectormag Gbr, 2010.

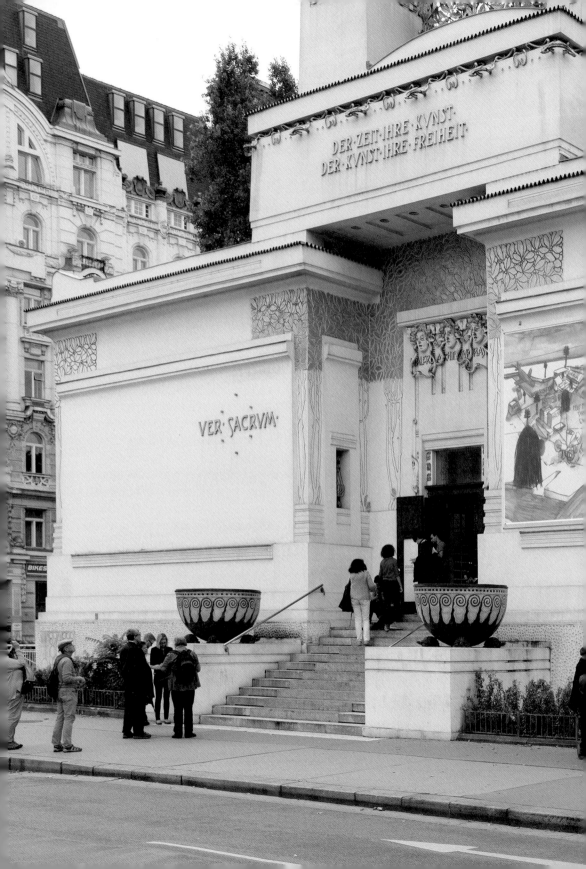

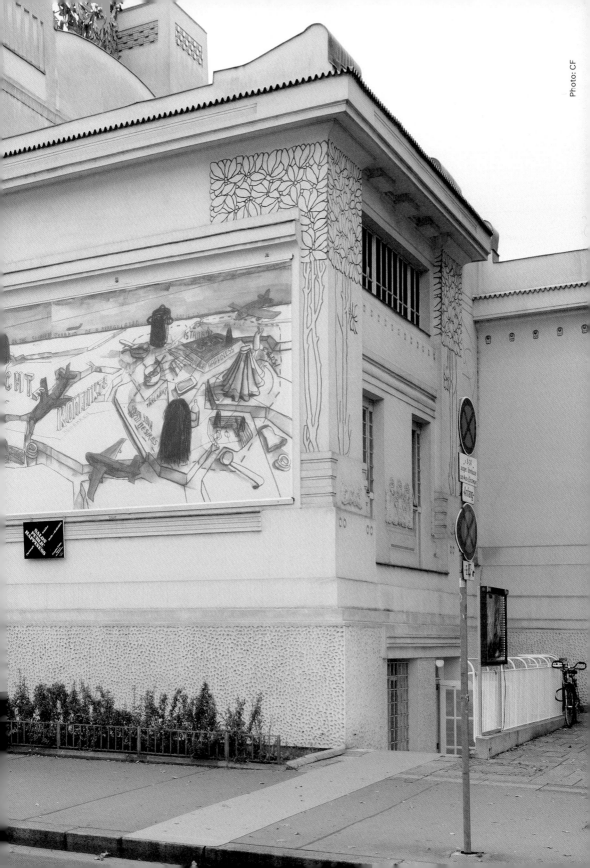

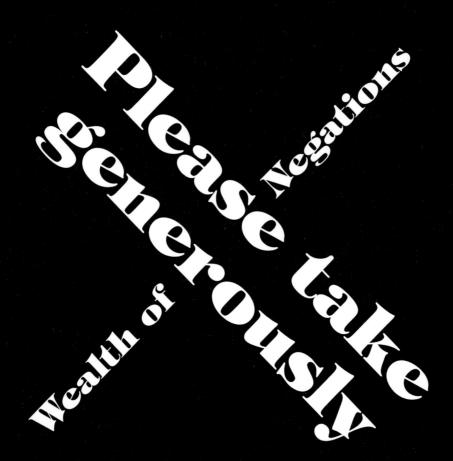

**Please take generously**

Negations

Wealth of

Urgent Alternatives: Utopian Moments
April 2014

The Banner

**The past: domestic violence.**

**The present: anxiety attack.**

**The future: desertion, mutiny or more of the same?**

*Rien ne va plus.*

**Place your bets.**

The Handout

**FUTURE** /ˈfjuːtʃər/ *n*. **1** The emergency exit where wise pessimists desert the present. **2** The vacant lot where the fate of the past is fought over.

**SELF-ESTEEM** /selfɪˈstiːm/ *n*. Consent to the conditions that compose the self.

**SKILLS GAP** /skɪlsgæp/ *n*. Mass passive insolence.

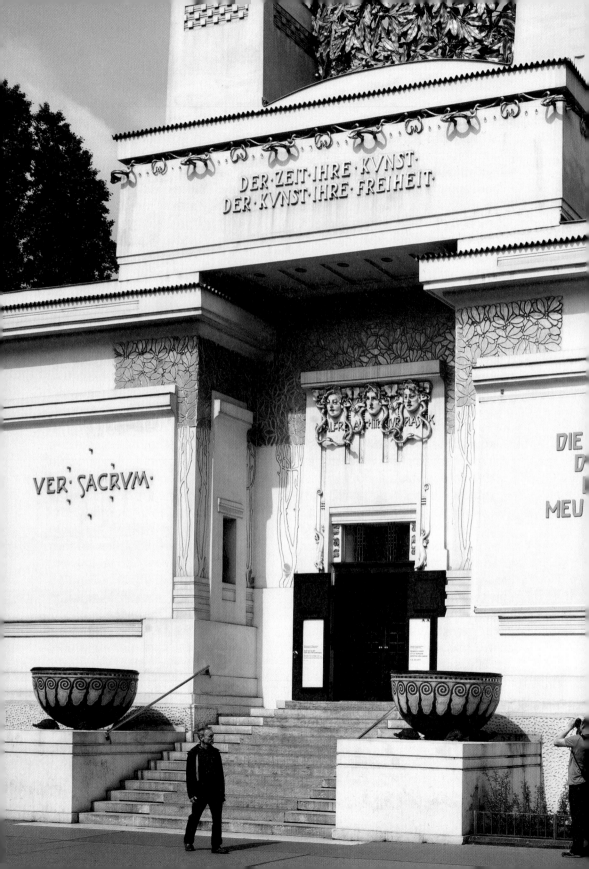

NGENHEIT: GEWALT DAHEIM
NWART: ANGSTATTACKE
UNFT: FAHNENFLUCHT,
ODER MEHR VOM GLEICHEN?
IEN NE VA PLUS
EREN SIE IHRE WETTE

# SELF-INSUFFICIENCY

## Matthew Hyland

*I decided to retire from private life* — **Karl Kraus**

*Death be not proud...* — **John Donne**

1
Or *ou* + *topos*: no place.

## In and against the universe

Over the past five centuries the words 'utopia' and 'utopian' have been applied belittlingly to almost every kind of human artifice. The pejorative ring is strong enough that few alleged utopians since Thomas More himself have attached the word to their own products or practices, at least until a recent spate of artworld reappropriations.

No new attempt at utopian interruption of the managed present need answer for the incontinent use of 'utopia/n' by commentators and Wikipedists. One stricture is enough: a utopia is NOT an imaginary world, but a work or act *within the given world* that imagines, foreshadows, calls forth or negatively invokes a life incommensurable with Things As They Are. The incomplete assertion within what IS of what IS NOT. Not an arbitrary fancy, but something latent in the social ganglia, vagrant and seeking vindication in complete upheaval of the hosting body. If Utopia is a made-up island, it's simply trivial. At least since the inquisitor who invented it lost his head in 1535, the island is whatever anyone wants it to be. The name *Utopia* bears lower-case repetition only with reference to utopian *works* (not just products cultural or otherwise but social acts) and those works' impossible place[1] *in and against* their historical conditions. A *realized* utopia is a contradiction in terms, because it would no longer be utopian: it would either be a self-contained, inconsequential

*An artificial island is not totality*

The Dubai Palm Islands:
Palm Jebel Ali

*Positive alternatives*

Sepo, Affiches Dorland, 63 Champs
Élysées, Paris; Source: Lo Duca,
L'Affiche ('Que-sais-je' series); Presses
Universitaires de France, Paris; first
edition 1945; physical copy 1951

2
Although disagreements with
David Bell are highlighted here,
his research and criticism to be
found in the blog 'Art's Utopian
Function', 22 April 2011, should
be read by anyone interested in
these questions, at: http://
nomadicutopianism.wordpress.
com/2011/04/22/art-and-utopia/
(accessed 7 January 2015).

3
The Utopia Station curators'
paraphrase of Bloch and Adorno,
'What is a Station?', is at:
www.e-flux.com/projects/uto-
pia/about.html (accessed 7 Jan-
uary 2015). The Bloch–Adorno
conversation, headed 'Some-
thing's Missing', appears in *The
Utopian Function of Art and Liter-
ature*, a collection of Bloch's writ-
ing translated by Jack Zipes and
Frank Mecklenburg, Cambridge,
MA: MIT Press, 1989.

fantasy or straightforward celebration of some
already satisfactory world. *Self-insufficiency*, the
condition of squirming in and against conditions,
provokes utopian outbursts from those obliged to
writhe in its double bind.

Some such rough definition would encompass
Lyman Tower Sargent's 'faces of utopianism' –
literary works, 'intentional communities', political
theory – while reserving the right to refuse admit-
tance and at the same time admitting the 'utopian
impulse' grasped as *latency* by Ernst Bloch and by
Theodor W. Adorno as *negation*. Without Bloch's
'impulse' the stakes of utopia would be too petty
to mention: the relative merits of blueprints for
states or villages, plus the odd attempt to play-act
them into being. Only if understood as impulse
can utopia be found in non-discursive arts, non-
programmatic language and non-communitarian
social practice. The 'impulse' admits that utopia's
proper form is impropriety, unsustainability or in
Bloch's own term *non-synchronicity*.

'Nomadic Utopias' theorist David Bell thinks
Bloch 'saw utopia in just about everything'.[2] But if
Bloch's 'impulse' ever seemed indiscriminate or
anodyne, Adorno restored its negative force in a
conversation between the two, picked up in part
by the curators of *Utopia Station* (Venice Biennale,
2003).[3] If 'there is no single category by which
Utopia allows itself to be named', so that 'one can
only actually talk about utopia in a negative way',
this is because 'whatever can be imagined as

*Realists plot the abolition of death*

Max Reeves, London, November 2010. S-Kollective, *Papakura Post Office,* 'New Jerusalem' edition, Entropy Press, London, spring 2011. http://s-kollective.com

4
Stephen Duncombe, 'Imagining No-Place: The Subversive Mechanics of Utopia', Utopia Revisited Conference, ARKEN Museum of Modern Art, Denmark, 7–8 April 2011.

utopia, that is the transformation of the totality'. The scope of such transformation is paraphrased by the Utopia Station curators as 'an unfettered life freed from death'; but Adorno is more specific: 'a consciousness for which the *possibility* that people no longer have to die does not have anything horrible about it, but on the contrary is what one one actually wants'. In terms of this absolute horizon, utopian works must always be mere impulse, bathetic straining; and always negative, affirming total transformation by straining for and falling short of it. But Adorno's 'commandment' against positive utopian 'depiction' is too often oversimplified. OpenUtopia 'creator/curator' Stephen Duncombe declared at an ARKEN Utopia conference that 'criticism is now pretty ineffectual; using art/negative utopia to blast away false consciousness/dystopia is not sufficient; it must create spaces which offer positive alternatives.'[4]

An innocuous statement (or not) in itself, but it answers the wrong question about utopian gestures, the negativity of which lies not in 'satire'

5
Bloch and Adorno, 'What is a Station?'.

6
Ibid.

of the world they emerge from, but in distance they can fly from it and *still* fall short of the total transformation needed before any detail could be meaningfully changed. 'Try again, fail again, fail better' is a utopian proposition: every strained utopian symptom raises and *qualifies* the stakes of total transformation; the minimum conditions must now include THIS, THIS and THIS, though transformation will render every THIS unrecognisable.

Positive thinkers reducing 'negative utopia' to satire mistake the commandment against depiction for indifference to particulars, a high-minded insistence on a Utopia Without Qualities. But the prohibition is iconoclastic, not wilfully blind. It attacks images passed off as their object's *incarnation*, self-satisfied utopias that already claim accomplishment, nestled comfortably within the world they also pretend to replace. Whereas positively specified longing for what IS NOT (and wouldn't match pre-figurations anyway) is utopianism itself. For Adorno, utopia 'is essentially in ... the determined negation of that which merely is, and by concretizing itself as false, it always points at the same time to what it should be.'[5] Contrary to the 'Utopia Station' gloss, Bloch does not 'follow' only 'part of the way'. He restates much the same thing while turning the emphasis upside down. Yes, every qualified or 'concrete' statement of utopian longing must break down, and yes, this is the secret of its Negative Capability. But the same series of breakdowns records the persistence of the impulse in time, the insolent inflation of minimum 'utopian' demands. Bloch cites Brecht's two-word sentence 'something's missing' (*etwas fehlt*) as a 'decisive incentive towards' a utopia *conditional on* 'freedom from earning instead of freedom to earn'. Stakes raised to the minimum. 'What', asks Bloch, 'is this "something"? If it is not allowed to be cast into a picture, then I shall portray it as in the process of being (*seiend*)'.[6]

If 'something's missing' is read as satire, or as Bell puts it as an injunction 'to critically return to our present', its non-specific notice of a fault in the world is little more than a Customer Service

7
See in particular the essay by Fredric Jameson, 'Varieties of the Utopian', at: http://monumenttotransformation.org/atlas-of-transformation/html/u/utopia/varieties-of-the-utopian-fredric-jameson.html (accessed 7 January 2015).

announcement. But those two words do speak for a 'process of being', an indefinite urgency, if 'something missing' refers not to some pothole in the *pre*-utopian ground, but to the gap between the *most* a utopian gesture can specify and the final utopian horizon, the transformation of totality on which transformation of any detail depends.

All of which is exactly what Fredric Jameson misses in a taxonomy that aligns the incomplete 'utopian impulse' with 'liberal reforms and commercial pipe dreams', as opposed to fully programmed utopias and 'intentional communities' tending towards 'revolutionary praxis'.[7] This slander of merely impulsive utopians rests on a misreading (to put it kindly) of 'totality', which Jameson identifies with *small closed systems*. When the founder of Utopia in More's novel orders a trench dug around the land mass to make it an island, Jameson imagines that the moat *makes* a totality of the artificial island, rather than *cutting the island off* from totality. Hardly surprising, then, that the Professor fails to see why serious utopian work recoils from illusions of accomplishment: not because it sets the stakes lower but precisely because it comprehends their enormity. By contrast, the perfected programmes and 'intentional communities' most often called 'utopian' tend to sell utopia short by mistaking their own borders for the limits of the universe, their synchronicity for the end of time. But the bifurcation

*Tonight it's on the cards the mill blows outside in*

Otfried Preußler: *Krabat*, Illustrationen von Herbert Holzing, (c) 1981 Thienemann Verlag in der Thienemann-Esslinger Verlag GmbH, Stuttgart

8
Successors varying from the capitalist 'model villages' like that of Robert Owen's New Lanark mill on the River Clyde which paid higher wages if workers were willing to be edified; to the USSR's 'socialism in one country'; or the Centrepoint hippie commune, Auckland, New Zealand, all of which voluntarily separated from the rest of the world, intent on perfecting a circumscribed space.

of utopia into two 'varieties' is no more than Jameson's whim, better discarded altogether than reversed. The utopian impulse also rages *in and against* some of the Utopian programmes and communities, its wider implications foreclosing any settlement with secular powers. Gerrard Winstanley's 'Digger' communism (exceptionally among utopias, expressed as tract *and* practice), was punished like Millennial communities before it for its *universalism*, something prudently renounced by certain truly insular and correspondingly tolerated 'successors'.[8]

Utopia is not *already* an alternative, just as Carnival is not an alternative to work. But like many carnivals and certain so-called riots, it screams of the need for a *total* alternative (*something's missing*: WHY must Carnival end and we go back to work?) and more dangerously still, it reveals the *latency* of the alternative in elements of present social life. The 'social safety valve' function of carnivals, utopias and riots is well known, but the effort and money spent regulating, recuperating or suppressing them betrays authorities' fear that too much steam might be let off, leaving a dangerous void (something missing, nothing to lose) or worse, the idea of an engine. That threat lies in a refinement of the question: no longer simply 'why must Carnival end, why doesn't all life look like this?', but: 'what latent power, which in Carnival/utopia we PROVE is real, is so unbearable to see shut down? And how shall we perpetuate it: how could it be switched back on and not cut off again?'

Carnival is a work of social, visual, musical, poetic and logistical artistry, capable of carrying a utopian impulse but not assured of doing so. The impulse may also – though less often than not – be found latent in any of the arts, as understood in the oldest and broadest sense: material techniques involving some sort of subjective intention. (Political trouble-making is one potentially utopian art among others, but nothing justifies Bell's claim that a utopian impulse without a 'place' is indistinguishable from 'left-wing politics'. First, because there's nothing intrinsically left-wing about utopian

'Riot' not necessarily in the recent vernacular sense of violent confrontation, but the older and broader one encompassing all forms of lawless, licentious and insubordinate behaviour.

10
'Anacharsis Clootz deputation' is the name Melville gave to the real protagonists of *Moby-Dick*: the Polynesian, African-American, Native American, Asian, European and European-American crew of the whaling ship *Pequod*. Melville acknowledges the crew's unrealized (or utopian) world-historical standing by naming them for Clootz, the Prussian itinerant in Paris who tried from the start to globalise (NOT just Europeanise) the French Revolution and gathered a deputation of noisy foreigners (including Tom Paine) to that end. There's no daydreaming in either deputation. The crew of the *Pequod* almost turned the ship around, then died because they failed to complete the mutiny.

gestures towards totality, as market idealism, imperial heroics and punitive piety prove; second, because the power of utopia is not the grim one of political logistics. The impulse can't contrive *alone* to destroy or defend institutions; to imagine otherwise is a symptom of historical powerlessness.)

A commandment against depicting Utopia in no way prohibits utopian artistry, including the making of pictures. Even supposedly inert and commodified artworks – paintings, recorded music, writing – can carry a utopian charge that calls their self-contained status into question. Nothing about the conditions 'depicted' in the elder Pieter Bruegel's crowd scenes or Melville's account of the 'Anacharsis Clootz deputation' of seafarers in *Moby-Dick* permits wishful identification. But something latent in those conditions, an unkillable utopian germ, is magnified by the work and released in the strange non-synchronous immediacy of the encounter with it, in which the viewer/reader is estranged from the work done and all at once caught up in it, because her nervous system is the one place of its present realization. The freedom-of-the-shadows claimed by Bruegel's almost-Anabaptist rioters;[9] the *autonomia operaia* of the *Pequod*'s nationless shipmates[10] (and their still more formidable brothers, the self-emancipated slaves of *Benito Cereno*) play out Adorno's point about abolishing death: they're *ready to die for a life that would justify death's elimination*. But the personae don't exemplify that life, they can't appear outside the framework of captivity. When they strain and flail against the petty present and fall short of the totality sought, the artistry of Bruegel or Melville momentarily supplements *something missing*. No 'gap' is 'filled', the supplement is negative, the failure felt more acutely than ever; but the impulse and the artist's vindicating gesture make 'something's missing' something other than a statement of despair.

The utopian charge, the vindication of what Susan Howe called 'every first scrap' of social memory, is compounded again in work that leaves a trace of its collective production showing. The

actual working process of (say, again) the Sun Ra Arkestra or the first John Waters film collective invites no emulation: Waters himself and Sun Ra's biographer describe an endless round of cold and drudgery, insult and underpayment. But in each case a brittle surface of direct utopian reference (Ra's hermetic Saturnalia, the underclass aesthetes avenged in *Pink Flamingos*, *Desperate Living*, *Female Trouble*) gives way to the more powerfully utopian semblance (could Fassbinder-worshipper Waters object to *Schein*?) of the groups themselves producing what is heard and seen. Sun Ra's cosmic mapping only shadows the mystery of the collective playing; the plots and characters in the Waters films are props for the genius of local speech, exalted in and against itself by Baltimore's living margin for error. In the films and the music, the utopian semblance of the real collective work is absolutely not its 'documentation'. (Ra's recording methods made early mockery of that pretence.) In both groups' products, the *apparent* alliance of technique and lawlessness proves not that such interdependence ever existed anywhere, but that in the monstrous birth of new alliances *it might*.

What any such alliance could look like will transpire only as it forms in some conjunction of accident and slow research. The only things assured in advance are non-resemblance to previous examples and incongruity with whatever passes for a *Zeitgeist* at that moment. Because non-synchronicity, *resistance to the present and its version of the past*, is the one element that runs continuously through all utopias, the reason an immense entanglement of impulses is also an impulse. No serious attempt at accomplishing total transformation can remain utopian in the sense meant here. Real political upheaval, mass religious conversion, bloody conquest or social refoundation: whatever sets out to impose its necessity, to become what IS, passes beyond impulse and becomes subject to utopian contradiction in turn.

The utopian impulse outrages presumed laws of probability. What follows shows it at its most

improbable work, in the upholstered parlour of its enemies: the bourgeois salon of the eighteenth–ninteenth–twentieth centuries.

### Secession from the past and future of the present

The history of the various artistic and social arrangements called 'salons' is, among other things, a nest of unsustainable utopias (i.e. the only possible kind. To repeat: utopias are either dissolved/demolished or left unrecognisable by their realisation. One way or another they cease to be utopias). Yes, many or most recorded salons were counter-utopias, self-satisfied celebrations of precisely the conditions they flourished in (and of the participants' exalted place in those conditions). No need to be detained by this fact here: the same thing is true *in general* of artworks, political groups, artistic and social movements, social life. The point is not to name an intrinsically utopian form (the allegorical novel? the closed community? the Freemasons?) but to take notice when utopia briefly seizes and upends one of the world's dispiriting forms. Anyone who still takes seriously, say, 'poetry' or 'revolutionary politics' loves these things for the *exceptions* to what the categories generally mean. And any such love still seeks to generalise not 'exceptional' poetry or politics *as they appear now*, but something encrypted in the exception, something not susceptible to definition until the exception finally dissolves the rule.

But! the conscientious objector will stutter, even the Secessions and the *Salons des Réfusés* were bourgeois bohemian affairs; Mme d'Epinay bankrolled Enlightenment from tax farms; Mesdames Roland and Condorcet created regicides while bound to the Girondin slaveholding party, Mariquita Sánchez de Thompson herself was a revolutionary socialite ...

All true, but it adds up to less than the ghost of an objection. Utopia resists the present not *in spite*

*A subterranean salon*

Jason Rothe, *Miners drinking and smoking with the Tío of La Negra mine*, Bolivia, 2009

of its compromised condition but *because* of it: *in and against*. The utopian gesture of the compromised salon or the pre-defeated riot fails every test of viability as political strategy, but the question misses the point. The work of abolishing the social form common to the eighteenth and twentyfirst centuries is prosaic, unpromising but ongoing. Utopias are necessary to it but *in themselves* they are useless, outrageously void of utility. They abolish nothing, but abolitionist fury would die without them. (Or to put it another way: those who say art is already social transformation say so because their idea of enough transformation is none. Those who plan social transformation without utopian artistry are charity bureaucrats.)

A utopian current flickers through two series of 'salons' generally referred to as such, both centred in France though imitated elsewhere. On one hand the state-sponsored art shows that sidelined private patronage and connoisseurship, provoked the invention of 'criticism' and were eventually outdone by the state-sanctioned 'refused' and self-organising 'independents'. On the other, the social gatherings, led intellectually by women, that

11
Jules Michelet, *Histoire de la Révolution Française*, Livre V, Tome 1, vol. 2, Paris: Gallimard, 1952. (1st edn: Paris, 1847–53).

sheltered class contamination, unlicensed polemics and sometimes outright sedition through the eighteenth century.

The salon of Sophie Condorcet was one such self-consciously unfinished utopian enterprise, taking place 'almost directly opposite the Tuileries,' says Michelet, 'within sight of the Pavillion de Flore and the royalist salon of Mme de Lamballe.'[11] For a brief period in 1791 it was the meeting place of the original 'Anacharsis Clootz delegation': Clootz himself, Tom Paine and others from Scotland, Switzerland, England – revolutionary international-ists before the term was coined. Those few months under the last royalist ministry also saw the short ascendancy of republican women: Etta Palm d'Aelders (another foreign internationalist), Olympe de Gouges, Anne-Josèphe Théroigne de Méricourt, Louise de Kéralio, Manon Roland. Excluded from the Assembly, they became organ-isers, writers, public speakers or *salonnières*. Women 'have a perfect right to step up to the speaking platform, since they have the right to step up to the scaffold,' said Olympe de Gouges, who was soon to take the latter step.

If the reference is stretched beyond the eight-eenth/nineteenth-century gatherings and exhibi-tions commonly called 'salons', the same kinds of strange alliances, unlicensed criticism and seditious virtuoso performances show up on a wider scale. The quasi-salons and compromised utopias are too numerous to list, and case-by-case debate over their status would be futility fit for Peer Review. But around the turn of the nineteenth century, consider the intellectual and class promiscuity, the role of formidable women and the claims on the universal staked among the Paris Cordeliers and London Corresponding 'Jacobins', the Wollsten-craft/Godwin circle, the Jena Romantics in thrall to the 'rabid' utopian Böhme, the late-Antinomian sects frequented by William and Catherine Blake. Since which time the informal universalist groups, the open conspiracies against the present, have only multiplied: the secret Blanquiste societies and the network of Wobbly boxcars, the Secessions

12
Jürgen Habermas's *The Structural Transformation of the Public Sphere: An Inquiry into a Category of Bourgeois Society*, available in an English translation by Thomas Burger with Frederick Lawrence, at: http://pages.uoregon.edu/koopman/courses_readings/phil123-net /publicness/habermas_structural_trans_pub_sphere.pdf (accessed 7 January 2015).

and the Dada Cabaret and onwards. All the self-elevated artistic and political Elect of the last two centuries: most forever obscure, all utopian in their *refusal* to 'take their desires for reality', that is, to mistake present reality, *including their own practice in its existing form*, for anything to be perpetuated.

In *The Structural Transformation of the Public Sphere* Jürgen Habermas sets the first public exhibition-salons of the French Academy and the social salons of the eighteenth century properly at odds with the order of their time, describing the affront to what he calls 'court society' in the explosion of lay judgement and publication provoked by the exhibitions and aggravated by the plebeians in political drawing rooms.[12] Habermas also connects salons to other social forms of the eighteenth and seventeenth centuries, with a telling choice of examples. He cites the coffee houses of the early London literary bourgeoisie, the German *Tischgesellschaften* and the Rota Club of James Harrington (the English theorist, influenced by his friend Hobbes, whose 'utopia' *Oceana* of 1656 was a really a pragmatic political manifesto meant for immediate application, calling for social pacification through something not unlike a Thermidor/Napoleonic settlement), rather than any of the plebeian political-religious sects that published and polemicised furiously, forming and breaking alliances with more than salonesque disregard for station, throughout the English revolutionary period and more quietly thereafter. The omission is legitimate on Habermas's part, because the brief utopian flicker in some salons is not what interests him about them, and is anyway as far as could be from defining 'the salon' as a general category. Like any utopian moment, that of the salons is the contradiction built into its own setting, threatening to tear it asunder. But Habermas sees even the disruption wrought by the artistic and social-political salons, like the *Tischgesellschaften*, *Deutsche Gesellschaften* and coffee houses before them, as a stage in the development of a *consensual* bourgeois 'public sphere', or what might just as well be called an *anti-utopia*.

Consensus cries out
for spoiling

Hannah Höch, *Abduction* (from the
Ethnographic Museum series), 1925,
Photomontage with *collage elements,
bpk / Kupferstichkabinett, SMB /
Jörg P. Anders*

A utopia may be many things including bourgeois,
but it can never be an orderly stage in the develop-
ment of anything, and above all it cannot be *consen-
sual*. As the salonesque examples show, utopian
practices may be scandalously inclusive in their
social composition, but in straining towards rupture
with the same world they emerge from they are
always also *exclusive*, not necessarily of particular
individuals, but of *the world to be overthrown*
as it appears in everyone, including the 'utopians'
themselves. In real conflicts this may mean choosing
one of the belligerent sides – and sometimes
stepping up to the scaffold – but even the alterna-
tive of extreme disengagement is a form of repudi-
ation, division, anything but consensus. Utopia is
*secession* with the destination undefined. Secession
is automatically dissent and non-development: it
steps out of line. The secessionist utopia must be
*partial* and *partisan*, ready to judge not between
persons but between worlds. Within what 'sphere'
or other enclosure, what metaphysical Focus
Group, could there be 'free and rational debate'
about that judgement?

The plane of abstraction on which such a question could even be asked was supposed to be off-limits to the lower orders not just under 'court society', but also, to varying degrees, across the eighteenth- and nineteenth-century Europe of the 'public sphere'. The failure of states, state churches and state-church universities to kill popular abstraction owes little to the orderly stages of Enlightenment and much to utopian-sectarian mechanick preachers, pampleteers and seditionaries from the German peasants' and artisans' wars of the 1520s through the English revolution of the 1640s–50s and onwards from there. (Perhaps far onwards: David Abulafia argues for two-way influence in the Smyrna of the 1660s between religious-radical English shipping crews – Quakers and Fifth Monarchists – and the messianic-utopian revolt of the Jewish heretic Shabbatai Zevi, which started in the Ottoman trading city in 1665.[13]) It should also be remembered that an abstract question need not be posed in abstract words, or indeed in words at all.

One affront to the world's proprietors recurs in all utopian salons whether visible or not: the lay or downright lumpen claim to the privilege of *idle* artistry and judgement, speech and sociability. 'Idle' not as in languid (though languid it may also be), but as in unprofitable, or unproductive if 'productivity' means contribution to another's profit.

Here, then, is one last account of self-insufficient utopia straining in and against wretched conditions.

13
In David Abulafia, *The Great Sea: A Human History of the Mediterranean.* London: Allen Lane, 2011.

14
See Alexander Cockburn's article, 'The Underclass', in the collection *Corruptions of Empire: Life Studies and the Reagan Era.* London: Verso, 1987.

15
Cockburn, 'The Underclass', p. 69.

16
Ibid.

Brixton (South London) scholar-seditionary Darcus Howe was interviewed by one of his few peers, the late Irish-American journalist Alexander Cockburn, not long after the multiracial uprisings of 1981 in Brixton and some 30 British cities.[14] Howe sees 'permanent unemployment' as the future of the black and white working class, and he deplores as left-wing piety the notion of a 'right to work'.

'Less work, more money.' And that's a vulgarity too. 'Less work, more leisure.' We have built up over centuries the technology to release us from that kind of servitude.

But what matters most for the stakes of utopia is that this is not Howe's personal expert opinion, it's an idea he sees tested collectively, imperfectly, on the streets of Brixton every day.

*'I look at the young blacks. [Howe is a Trinidad-born nephew of CLR James, aged 38 at the time of the interview] If you look at the development of Rastafarianism on such a massive scale, this cannot be separated in my view from the material basis and the creeping consciousness that one will not work again and one must now be concerned with what is life? Is there a God? Who is he? What is the relationship between yourself and your kind?'*[15]

Then he reminds the reader of an obvious and correspondingly ignored truth. The utopian critique of work, the social artistry of idleness, is not the invention of European intellectuals or activists. It comes from the disavowed side of history, the 'darkness' on the *outside* of the global public sphere.

*'The first set of people to know that there ain't no work anymore were ex-slaves. From the moment we came off the plantation, labour-intensive, and you started to present us with factories, there was no work ever again. That is new to advanced countries, but to the underdeveloped countries ... I could take you to Port of Spain now and point to him, him, and him and say he is a grandfather who never worked in his life. This is a grandmother who never worked in her life. We come easy to it.'*[16]

# SALON ORIZZONTI OCCUPATI

## Bert Theis

with
Isola Art Center collective and: Luca
Andreolli, Aufo, Bad Museum, Roberto
Balletti, Emanuel Balbinot, Kristina
Borg, Antonio Brizioli, Tania Bruguera,
Angelo Castucci, Cooperativa Nuovo
Cilento, Antonio Cipriani, Comune di
San Mauro Cilento, Irene Coppola,
Creative Olive, Paola Di Bello, Fornace
Falcone, Maddalena Fragnito, Edna
Gee, Etcétera, Gianfranco Marelli,
Orestis Mavroudis, Valentina Montisci,
Philippe Nathan/2001, Nikolay Oleyni-
kov, Maria Papadimitriou, Dan
Perjovschi, Steve Piccolo, Edith Poirier,
Daniele Rossi, Gak Sato, Milena
Steinmetzer, Mariette Schiltz, Serio
Collective, Superstudio, Stefano
Taccone, Camilla Topuntoli, Milliarden-
stadt, Utopia Urbis, Nikola Uzunowski,
Flora Vannini, Jiang Zhi et al.

## Isola is not a utopia, and Utopia is not an island!

'Isola Utopia' is an ongoing collective research and production project that started in the Isola district in Milan, setting forth on nomadic 'Utopian Odysseys' and returning at regular intervals to Isola, collecting fragments and moments for new Utopias along the way. In the past 14 years Isola Art Center[1] has responded, together with other activists and neighbourhood associations, to the constant pressure of neoliberal development and gentrification in the Isola district in Milan, inventing tools and concepts along the way.[2] Based on this long collective experience that has also produced the concrete utopia of the self-managed park Isola Pepe Verde since 2013, Isola Art Center organised the Isola Utopia project starting in summer 2014. The first stage of the work in progress has been a workshop in San Mauro Cilento:

In August 2014 on the Cilento hills near a clear blue sea, artists, philosophers, sociologists, and a large part of the community of San Mauro Cilento, continuing on the interrupted path of the Situationists, started the experiment of Isola Utopia: the space freed by creativity to live moments of intense emotion thanks to a future already present. It is difficult to express it in another way, especially if one has lived the concrete utopia that has no authorized heirs to theorize about it. There are only artists, that is to say all those who have not given up on imagining a reality that starts from their own desires – collectively ready to give / give oneself emotions of the practice of freedom that everyone can realize in the present, so that the revolution of individually experimented art can be transformed into an art of the revolution through a collective project, shared for its open issues (as the logo 'Isola Utopia' attests with its font that refers to an innovative Sabir language), its imaginative curiosity, its utopian hopes.[3]

Gianfranco Marelli

It was followed by a stopover at the former 'Bol̦ševička' Factory for the 'Survival Kit – Utopian City' project in Riga, followed by the one-week 'Salon Orizzonti Occupati' at the Vienna Secession during *Utopian Pulse – Flares in the*

1
Isola Art Center is an open, experimental platform for contemporary art. It is powered by energy, enthusiasm and solidarity. Its projects continue to be 'no-budget', precarious, hyperlocal. Doing away with conventional hierarchical structures, Isola Art Center rhizomatically brings together Italian and international artists, critics and curators, artists' collectives, activists, architects, researchers, students and neighbourhood groups.

2
The history of this artistic and urban transformation is narrated in the book *Fight-Specific Isola: Art, Architecture, Activism and the Future of the City.* Berlin: Archive Books, 2012, English and Italian editions.

3
See his critical history of the Situationist International: Gianfranco Marelli, *L'amara vittoria del situazionismo*, Pisa: Editore Biblioteca Franco Serantini, 1996 and Gianfranco Marelli, *L'amère victoire du Situationnisme*, Arles: Éditions Sulliver, 1998.

*Darkroom.* At least 40 artists, curators, theorists, students, inhabitants, musicians and journalists took part in the elaborations. Most of them are members or friends of Isola Art Center, including international artists. At each stopover local intelligence is integrated in the research and production process.

Salon Orizzonti Occupati at the Vienna Secession presents a selection of the materials produced for the 'Isola Utopia' project, and at the same time continues the research and production of new art works and other materials, adding new elements to our Utopia mosaic.

*Utopia is now. (...) U-topia as now-time prompts us to think non-subservience in a new and machinic way. Machinic non-subservience, non-compliance, a wild monstrosity against subservience does not emerge as a heroic break with a full space, with limited shapes and beautiful form, but rather as a lasting, repeated and recurrent breach in the overabundance of measured and immeasurable time. Questa e la questione della disobbedienza in capitalismo macchinico.*[4]

Gerald Raunig

In keeping with this statement, we don't display a traditional 'exhibition', but transitional moments, a work in progress with fragments, different workshops, presentations, discussions, and 'real life situations' where the making of the show coincides with the show itself.

*The tense of utopia seems to be the future. But in European modernity the future is the telos of a three-way temporal scheme of past, present and future. The story of the winners is narrated in this linear arrangement criticized by Benjamin in his historical-philosophical theses. In this linear history future means progress, white civilization and the capitalization of the convivial. The present matters only as a punctual reassurance of this transition to the future. It is not appreciated and still discredited in the Hegelian tradition as 'authentic' 'immediacy.'*

*The utopia that breaks with this space-time logic of domination defends the present, with the goal of resisting. Utopia does not settle in an elsewhere. It reveals its force in the now, in order to together find the strength for a constituent process that transforms the society. Utopia can become an exodus, to expand the present, in a becoming without future. The expanded present is without future, but not without a past. This futureless relationship between an expanded present and the past is discontinuous, a Tiger's Leap. The Tiger's Leap wrests shards shivers from the past, unfulfilled, failed and successful revolutionary practices, composes them in the present with new struggles, to invent again and again constituent powers, new and better forms of conviviality.*

Isabell Lorey

4
'This is the issue of disobedience in mechanic capitalism.'

'Utopia just left the building'. We occupied a former factory in Milan and created a new kind of center for art, philosophy, music and neighbourhood activities, confronting international real estate companies, greedy bankers, weird politicians, timeserving architects and servile journalists.

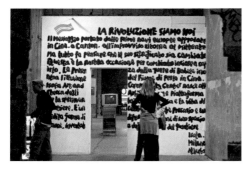

In all these years we never met Utopia, but she was always close to us.

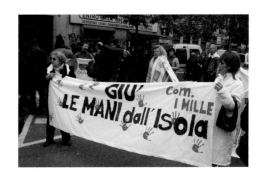

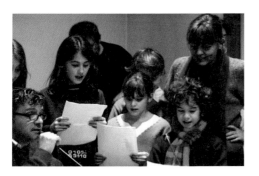

We sang songs by Adriano Celentano to the decision-making city officials (in a choir together with the Isola kids in the Zone Council).

One night, together with Christoph Schäfer, we painted his mural 'Strategic Embellishment' designed for the Isola newspaper kiosk.

We threw seed bombs over the wire fence of a space that was still closed to the neighborhood ... a space we opened later with the name of Isola Pepe Verde, making it into a park, 2012.

The self-managed Isola Pepe Verde park in 2014.

Together with Macao we occupied the
Galfa Tower in Milan and unfurled the
banner 'One could even imagine flying'
on its façade.

'We tried to occupy horizons with
Nikola Uzunowski's solar clouds.'

## San Mauro Cilento

The Utopia workshops started with a flight of the participants in an ultra-light airplane over Naples, Salerno and the buried cities of Paestum, Pompeii and Elea with its philosophical school.

The landscape of San Mauro Cilento with the red ribbon by Kristina Borg. San Mauro Cilento is a small town in the hills near the sea in southern Italy, and the home of a local cooperative that produces olive oil.

San Mauro Cilento: Installation by four groups of architects from Salerno: Amor Vacui Studio, GheloStudio Architettura, Laboratorio di Progettazione Ferrara, Project 2.0.

Part of the Isola Utopia team in San Mauro Cilento, summer 2014.

'Atterrare l'Utopia'. 'Landing Utopia' or 'Bringing Utopia down to Earth', the title of a drawing by Maddalena Fragnito.

In San Mauro Cilento we saw Utopia in an APE (small Italian three-wheel delivery car) flying and laughing over our heads. We looked at each other, and without hesitation we decided to dedicate our research project to Her. In fact, we have called it 'Isola Utopia'.

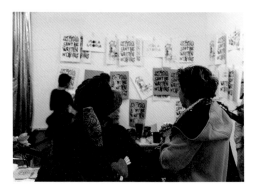

The one-week 'Salon Orizzonti Occupati' at the Vienna Secession during *Utopian Pulse – Flares in the Darkroom*.

'The Vertical Jungle' by Edna Gee.

'Rising Isola Utopia' by Camilla
Topuntoli, video-still.

'Isola delle Rose', research by Philippe
Nathan and Milena Steinmetzer
with the production of a video and
silkscreen print.

The 'Hypotopia' project by
Transdisziplinäres Planungsteam
Milliardenstadt, Vienna. Ajit Niranjan,
'Hypotopia: How a €19 billion model
city has changed Austria's attitude to
protest: Campaigners wanted to help
the public understand how much
money the government had used to
bail out a bank – so they created the
model for a vast city that could be built
for the same amount of cash.'
*The Guardian*, 11 November 2014.

A video by Luca Andreolli about the
impressive new student movement in
Luxembourg, 2014. Milena Steinmetzer
during her talk at Vienna Secession
says: 'For me the utopian idea is that
the strike is not the end, but the
beginning of something.'

Steve Piccolo and Gak Sato dedicated
a daily workshop to the Theremin, Lev
Sergeevich Termen's early electronic
musical instrument invented during
the Russian Revolution.

The painting 'The Time of Anarchy' by
Edith Poirier, a tribute to Paul Signac,
Secession 2014.

**Elements of the banner for the Secession facade**

The Banner on the façade of the Secession combines elements from the present and the past and inserts them into a classic view of the streets around Vienna's Stephansdom: 'Balloon Ride over Vienna', Jakob Alt, 1847.

The *Diver* on a Greek tomb painting in Paestum 470 BC.

A group of revolutionaries during the Storming of the Winter Palace in St Petersburg, 1917–1920.

The composer Arseni Michailowitsch Awraamow directing a concert with factory sirens in revolutionary Moscow in 1920.

The micro state island *Isola delle Rose* built in the Adriatic Sea in 1968 and destroyed instantly by the Italian State.

We are beginning a fantastic journey toward it, toward the implementation of the central concept of utopia. To find it, to find the right thing, for which it is worthy to live, to be organized, and to have time (...) build into the blue, and build ourselves into the blue, and there seek the true, the real, where the merely factual disappears – incipit vita nova.

Ernst Bloch

Dancers on the cover of the book *Feminist Utopias* written by Frances Bartkowski in 1989.

'Sous les pavés, la plage!' – slogan, May 1968. 'Derrière l'horizon, la mer!' – Isola Utopia 2014. ['Under the *paving* stones, the beach!' – 'Behind the horizon, the sea!']

A group of unionists during the general strike in Guadeloupe in 2009, with the banner 'Together let's reinvent hope'.

**Isola Utopia 2**

'We will build our Utopias on the Ruins of the Utopias of the past.' photo by Bert Theis (with a work by Tania Bruguera).

Part of Isola Utopia collective taking a rest.

A stopover at the former 'Bolševička' Factory for the 'Survival Kit – Utopian City' project in Riga.

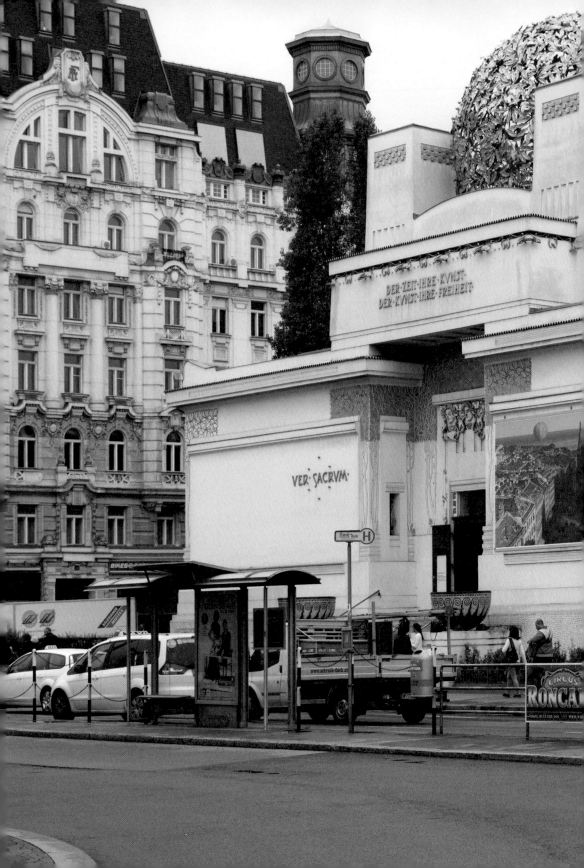

# KNOWN NOWHERES: Some short thoughts on going beyond

**Marina Vishmidt**

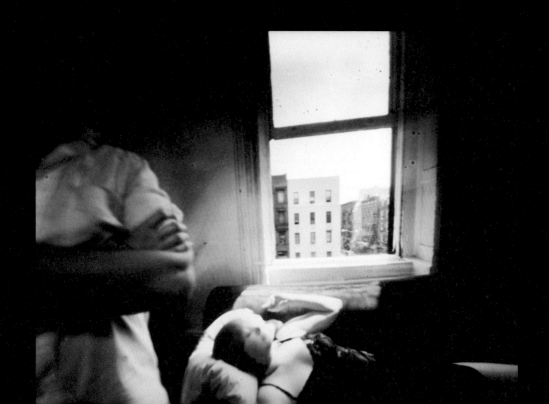

## Introduction

This text aims to find a way towards a critical articulation of utopia by dismantling the conceptual structures of useful labour and value production from both a feminist and ecological standpoint, defined as speculative in both cases. In doing so it will counterpose two different approaches to 'going beyond' capitalist relations of production that are grounded in the structural necessity of gendered and unwaged reproduction to those relations, approaches which have emerged as dominant in materialist feminism today. A certain polemical 'forcing' will be used to make distinct the political implications of the two. This will necessarily gloss over the nuances of the positions, and thus some of their counter-potentials and internal contradictions, in the attempt to make evident both their logical conclusions and the need for another position, one which, however, is still inchoate here.

A politics of reproduction stance predicates its vision of a 'reproductive commons' on an idea that you can separate reproduction (subsistence that produces use–values) from production (capitalist labour that produces exchange–value) and that you can separate a commons-based from a capitalist institution of gendered reproductive labour. Rooted as these visions are in the theoretical legacy of autonomism, they are part of that legacy's valorisation of labour as a revolutionary subject, as well as the recent loss of its focus on antagonism. Further, inasmuch as this position affirms one half of a capitalist whole as the route to emancipation it seals up the space of negation. This can make it politically innocuous, both from a communist and a feminist standpoint. The other stance to be explored here is 'abolition' as enunciated through communisation theory, which is applied to gender insofar as it constitutes part of the value relations that reproduce capital. This direction is comparatively more productive because it reaches for a systemic negativity in its analysis, though still abstract and tending towards prescription. This then leaves a choice of two kinds

Hugo Gellert: *Machinery and Large-Scale Industry: Primary effects of machino-facture upon the worker.* From *Karl Marx' 'Capital' in Lithographs.* Series of 62 lithographs. New York: Ray Long and Richard Smith, 1934

of utopia: a utopia of maintenance versus one of an absolute break with what is. An alternative is to excavate the classed relationship of gender to useful and useless labour as it unfolds through a subject/object dynamic in capitalist modernity. It's only through a position of non-identity between human activity and usefulness, that labour, as objectification of the world and the humans who perform it (that which legitimates all exploitation), can ever really be overcome.

## Charting Affirmative and Negative

Marxist feminism, like any social movement, has always harboured what can be broadly seen as a tension between affirmation and negation. In feminism's case, this manifested as a split between the valorisation of gendered reproductive activity as a ground for social recomposition versus a rejection of this activity as irrevocably supportive of the exploitative nature of capital, termed in some recent writing as 'abject'. Parenthetically, the mapping that these terms have inherited place them onto varieties of critique and political practice either geared more towards reform (affirmation) or revolution (negation). The friction between critique and proposition however complicates this binary. While it is easy to read critique as negative and propositions as affirmative, there is also a sense in which the descriptive aspect of critique affirms the status quo even if it is portrayed as 'wrong', whereas the propositional might set itself the more ambitious (and thus 'negative') project of changing the horizon of the world that critique describes. There is a dialectic of affirmation and negation, and when this dialectic is thwarted, or the movement decomposes, there is a stagnation and crystallisation of categories of struggle into sociological or cultural categories like the cultural concepts of women or of class-belonging, which are essentially categories of administration. In the words of Denise Riley, 'The dangerous intimacy between subjectification and subjection needs careful calibration.'[1]

1
Denis Riley, *Am I That Name?*. Basingstoke: Macmillan, 1988, p. 17.

Intersectionality is a term which first emerged into feminist discourse from an essay by sociologist Kimberlé Crenshaw in 1989, 'Demarginalizing the Intersection of Race and Sex: A Black Feminist Critique of Antidiscrimination Doctrine, Feminist Theory and Antiracist Politics', although the work of black feminist group the Combahee River Collective was conducting intersectional analysis in their writings at least a decade prior. It refers to the impossibility of structural oppression being defined for any one subject through a single identity category.

This dialectic then, as a constitutive thread in materialist feminism, needs to be seen in at least two ways. First, in a structural or objective sense: the analysis of how different secular tendencies in the crisis capital relation play out differentially for the gender relation. In what ways can we see capital as affirming or negating 'women' at the level of state and legal strategies, and in the renewal of accumulation prospects? Specifically, how are women addressed as a group with specific interests and individualised through labour-market competition and 'rationalised' social services? Second, in the political or subjective sense, what are the kinds of feminist organising and agendas coalescing under these conditions and redefining them in the process, shaped as they are by logics of class, racialisation and nationalism as well as gender identification? For Marxist feminism, these strategic and theoretical dilemmas also get played out with the question of the status of women as a revolutionary subject, that is, a political subject constituted in its relation of negativity *to* the current order by its position *in* the current order. This question of determinate negation is modelled on the role of the proletariat in abolishing capitalism. The focus is thus on seeing how the capitalist form of value produces the divisions, subordinations and exteriorities necessary for preserving this value, be it through gender, racialisation or class. The emphasis on defining structural logics which render a social relation in those terms both unifying and contradictory, rather than the intersection of these as categories of oppression, is perhaps the symptomatic difference between Marxist feminism and intersectionality,[2] though these have been taken apart and combined in a number of novel ways in recent times. Further, as pointed out by Jodi Dean among others, there are problems to seeing oppositional or revolutionary politics as hinging upon the presence of structural unities rather than a contingent, subjectifying process coming out of a social field characterised by division. The tension between 'reproductivist' versus 'abolitionist'

perspectives tends to define the field of – as well as pointing to the outside of – Marxist social reproduction feminism.

### Utopias of Reproduction

It seems as if affirmation and negation might be an abiding problematic for materialist feminism, or any materialism. Looking at the Italian autonomist feminism of the 1970s, it is possible to get a sense of the transition from negation to affirmation in the 'politics of reproduction' perspective. Its best-known theorists – Silvia Federici, Mariarosa Dalla Costa, Leopoldina Fortunati and Selma James – articulated it in the Wages for Housework campaign. They elaborated a politics of reproduction which was more strategic than deconstructive – an eminently practical politics but which, in its use of Marxist political economic categories, often got bogged down in esoteric debates about the nature of value production levelled at it then and now. The main point was to see how women's unpaid labour in the home and society, which according to Marxist theory fall into the realm of reproduction rather than production, contributes to not just the oppression of women, but to the whole organisation of capitalist society, chiefly in the wage system and male domination. For this work to become visible as work, or rather as labour, they said, it has to be collectively refused and 'collectively' paid. Wages for Housework, then was from the beginning at the same time Wages Against Housework, as was always pointed out by its campaigners. It was, in other words, a transitional demand, one which could get the movement to a state of mobilisation wherein the profound structural challenge of such a demand to the wage relation would be forced, rather than requested, from capital. Like the basic income demand of today, the potentially revolutionary undertone of Wages for Housework is that it aimed to exceed the state's capacity to accommodate it. Another intent was to change both the familiar

Richard Rayner-Canham, *Hermine Performs The Washing Up*, photograph

3
Maria Dalla Costa, *The Power of Women and the Subversion of the Community*, at: http://radical-journal.com/books/maria_dalla_costa_power/ (accessed 7 January 2015).

4
The US group WAGE (Working Artists and the Greater Economy) agitates around artists' fees on the premise that the regularisation of artists' labour conditions is a matter of equity, placing the artist on the side of the worker and not the speculator.

co-ordinates of the role of women in the community,[3] and what was understood to be class politics at the time, asking who counted as a worker, and thus whose struggles counted as political. This strategy is still frequently exercised in campaigns around unpaid labour, for example by students, interns or even artists.[4]

From this stance there has thus been a consistent emphasis on what materialist feminists call the 'hidden abode' or 'arcane' of reproduction. It has been viewed as a potentially strong basis for upsetting the capitalist order because the 'continent of housework' (and, more broadly, what is called 'affective labour') is both so broad and so disregarded, vital and yet invisible. Marx talks about following the worker and the boss into the 'hidden abode of production' to see what's really going on beneath the apparent equality of contracts, with its exchange of labour time for

Previous page: Erinç Seymen, *Serva Ex Machina*, 2010, ink pen on paper, 63 x 88 cm, Courtesy the artist and Rampa / Private Collection, Istanbul; photo: Can Akgümüş

money in the market; that this is where the domination and exploitation really unfold as an intrinsic part of capitalist production. The 'hidden abode of reproduction' is even more hidden, because it is gendered, unmonetised and in the 'private' sphere.

Over time, the strand of Marxist feminism which focuses on reproduction has joined with eco-feminism, developing discourses around the commons and indigenous rights activism into a perspective which can be defined as 'the politics of reproduction': care and maintenance as the ground for a revolutionary politics which privileges the construction of community over the destruction of opponents, and where a new society can be brought into being through attention to the material and social preconditions for the productive and political activity that earlier variants of revolutionary politics disregarded to their detriment. The politics of reproduction perspective sees (gendered) reproduction as something to affirm. The valorisation of reproduction generally stems from case studies of peasant subsistence agriculture in the 'global south' and, less frequently, small anarchist communities in the West. As capitalist property relations seizes hold of village communities – a process Silvia Federici sees as largely analogous in early modern Europe and contemporary Nigeria and Ghana – women's positions are undermined, food security is broken, and internal violence and competition strafes communities which formerly managed to thrive beyond or under the radar of global neo-colonialist exploitation. Reproduction becomes a political battleground for community autonomy, and, tendentially, the basis for non-capitalist life such autonomy implies. The fact that it happens to be assigned to women in a patriarchal order inflected variously by capitalism, religion, custom or white supremacy only means that it is thus women's responsibility to transform it away from how it supports these forms of exploitation and domination. Here the negativity of reproduction to capital is at the same time its positive: its *necessity*.

Oskar Schlemmer: *Das Triadische Ballett, Drahtfigur,* 1924; (c) Photo Archiv C. Raman Schlemmer, IT 28824 Oggebbio (VB)

What this position does not do is to see the space of reproduction as an aspect of the mode of production that must be analysed from the standpoint of its elimination, but instead sees it as something independent. Basing a politics in 'reproduction' *per se* suppresses the need for change, and privileges the need for maintenance, for continuity and survival. Since these are the very elements of life which capital is constantly attacking, they must evidently be preserved – rather than transformed or perhaps even abolished. Because it has dispensed with the analysis of the structural negativity of reproduction, itself not unproblematic, reproduction can only ever return as that which is despised by techno-capital but is thus all the more politically important and experientially rich. Reproductive work is affirmed but *otherwise*; however, the space of this 'otherwise', unless it is filled by some kind of socially transformative process, affirms both work and gender as they are currently constituted and just asks for it to be recognised. This is a recognition that has both an ameliorative and a utopian character, depending on its space of articulation. The space is determined by how reproductive practices play out in the course of any socially transformative process; how these are taken up and transformed, displaced from their normative places and roles, which indicates the radicality of the process, its break with the 'reproduction' of things as they happen to be. The politics of reproduction, then, seems to fall down as a critique for a present that is always *getting worse*; but it does capture the real contradictions of subjugation under capital through the optic of gendered labour. Grounded in such real contradictions, the shortcomings of the politics of reproduction perspective, however, cannot be put to rest by immanent critique alone, and it is these real contradictions which put ostensibly 'reformist' politics into a more complex light.

5
Most clearly articulated in the
journal *Endnotes*, at: http://end-
notes.org.uk/

## Utopias of Cancellation

Just as Marx notes that the reproduction of capital is also, even primarily, the reproduction of the class relation, can the same be said for social reproduction and the gender relation? It is on these grounds that the politics of reproduction are queried by writers such as Miranda Joseph and Roswitha Scholz. Joseph sees the politics of reproduction as premised on romanticised notions of community and immediacy, in which the reproduction of gender (and gendered labour) does not get addressed. The question is then whether new mediations and other abstractions are not more helpful for revolutionary thinking than the reproduction of small communities, a form which has always borne oppression for the people socially stigmatised as 'women'. The feminist value-form theorist Roswitha Scholz meanwhile diagnoses the nexus between left and right-wing ideologies which target women as bearers of care or as 'crisis managers' – structurally reinforced by austerity cuts to social provision.

These critiques, which identify the naturalising aspect of the politics of reproduction, make space for a discourse of gender abolition, one that also appears in the 'anti-social' turn in queer theory. This set of terms comes out of a structural analysis which seeks to prove that gender and the capitalist form of value have internal or logical connections, and thus fighting one should also mean fighting the other. This is chiefly articulated by the communisation theory strand of materialist feminism.[5] Here the idea is that the existence of women is functional, even constitutive, to a capitalist society, since it needs the division into public and private, paid and unpaid, nature and culture, and the association of women with one side of those binaries, in order to continue in its current form.

The contradiction is analogous to the one in workers' struggles – do we want to affirm our identity as workers in this society, no, but at the same time we want to improve our conditions and build our power to overcome this society.

Romana Schmalisch / Robert Schlicht,
*Catastrophes*, HD, 2013/2015, film still

6
'The Logic of Gender: On the
separation of spheres and the
process of abjection', Endnotes
3: Gender, race, class and other
misfortunes, September 2013,
at: http://endnotes.org.uk/en/
endnotes-the-logic-of-gender
(accessed 7 January 2015).

Communisation theory is concerned with how
these moments of affirmation and negation get
articulated historically and, in the current situation,
how they require organising around identities
which are seen and experienced as limiting both in
daily life and to transformative movements. This
can be seen in both the debate about intersection-
ality versus focusing on the 'form of value' as the
main priority for materialist feminist struggle, and
on the issue of reproduction. Both ask whether the
conceptual and strategic emphasis in the politics
of reproduction should fall on what we have and
already are, or on destroying or withdrawing from
that. The text 'The Logic of Gender'[6] for one,
argues against taking socially reproductive activi-
ties as a communist or feminist political
programme: 'we must fight against this process
which reinforces gender. We must treat it as it is: a
self-organisation of the abject, as what no one
else is willing to do.'

The virtue of 'abolition' is that it sets a horizon
decisively within the immanence of struggle. It is
interested not in an abstract and ideal dismissal of

7
See Ray Brassier, 'Wandering Abstraction', *Mute*, 13 February 2014, at: www.metamute.org/editorial/articles/wandering-abstraction (accessed 9 January 2015).

certain elements or structures of the present reality, but in seeing what the specific structural role those elements have and how they reproduce the total system to be transformed or exited. The limitations of both the concept and its implied praxis, however, centre on the break between the determinacy of the analysis and the abstraction of the imperative 'to abolish'. They also contain a strict and possibly untenable analytic split between 'structure' and 'history'. One of the most salient of these abstractions is the paradox of self-abolition, which has lately been opened up in incisively in a specific philosophical context by Ray Brassier.[7] The subject emerges through the oppositional activity that abolition entails, yet must also arrive at a point where the militant identity that goes with it has to eliminate its own basis in the society the movement wants to change or overcome: being a woman, in this instance. This is not a situation which can be dealt with by fiat, but has to be one of the modes and horizons of activism itself, in which it will continue to unfold as a painful contra-diction. Who is the subject that initiates and who comes out of the other side of self-abolition? The politics of abolition seem to be unable either to be done with, or even to really formulate, this paradox of 'subjectivity'. Such inability risks the slide into Gnosticism that the 'abolition' discourse seems to harbour within itself, the postulation of a wholesale cancellation of a fallen world.

### Utopias of Materialisation

It is perhaps materialisation rather than just negativity that critique should provide, what I earlier alluded to with the term 'propositionality', which can lead to a thinking of the materialism of utopia. In that materialist feminism is both about the moment of saying, and the estrangement from, the category of women, this disavowal of an identity concept and subsumption to it as part of the same dynamic recalls the movement of the concept in Adorno's discussion of identity and

non-identity thinking as an invariant of thought, and thus, part of all types of overcoming. It is also the basic structure of his aesthetics; the dialectic between mimesis and alienation in the aesthetic object, or the subject becoming object, becoming something else through the mediation of the object. But identity is unavoidable; all thinking is driven to identify. The antagonism posed by non-identity is the resistance of the object to being subsumed by the concept. It is therefore the structure of thinking which forecloses an encounter with alterity; the need to conceptualise means true otherness is literally unthinkable.

What does that mean for the 'ruthless' negative critique required for a utopian approach to the social? The relationship to the identity categories of 'women', say, or 'nature' or the 'bios', guides the ability to conceptualise a different 'politics of reproduction', that is, different from capital's reproduction of otherness (or 'externality', liable at any time to morph into an investment opportunity) on a social as well as a planetary scale. The move of identification and subjectivation remains operative; identity and subject–object are not mistaken ideas we can simply dismiss in thought, not in a world where capital continually asserts its status as the only subject. A non-reproductive feminist communism has to reckon with the unknowability of this frangible, corrosive subject–object relation as it traverses the materiality of the natural and the social as history has made them.

Primary to such an undertaking would be to undermine the category of useful and useless labour which sustains the social division of labour – the division of labour from non-labour, waged from unwaged, production from reproduction, and the hierarchies of gender and race which follow. Women have historically been appropriated and stratified through their relation to use-value, with the bringing forth of children or performing as a luxury good as the respective polarities of women's existence in class society. The politics of reproduction involves the re-coding of the 'useless' labour of the household

ok.

Ida Wilde (Keren Ida Nathan), *A Very Wilde Story: The True Story of the Marriage of Ida and Henry Wilde / Eine wirklich wilde Geschichte: Die wahre Geschichte der Ehe von Ida und Henry Wilde*, second edition 2014, Berlin, Kollektiv Tod Verlag. With Antonia Baehr, Gili Ben-Zvi, Mirjam Junker, make_up prod, Itamar Lerner, Conrad Noack, Yael Stein and William Wheeler.

8
This is a problem, albeit framed differently, which also attends the notion of the 'Anthropocene', and its highly ideological ellision between capitalist industrialisation and 'humanity in general'.

or the maintenance of life as 'useful'. This is a productivist gesture inasmuch as emphasising use-value over exchange-value has traditionally been a founding gesture of political organisation for the working class. The maintenance of the capital relation, with its divisions between productive and reproductive, useful and useless, is upheld rather than challenged by such a move, even if there are clear material advantages to be won from access to a wage or legal rights. But perhaps more damagingly, the negative charge of such attempts at re-valorisations of activity and the subjects who perform it is stalled by the fact that this cannot proceed without a moralisation: this activity is necessary to life. The question of whether it is this life as it is historically constituted or some kind of 'life in general' is elided, neutralising any utopian energies aimed for in the original desire to re-code and transform.[8]

What of the 'useless' side of the equation? The rejection of a politics of use–value allows us to cut the links between gender and value which create such moralising visions of reproduction. But this doesn't mean that the 'useless' is to be positively held up as a counter-strategy, with all the Romantic afflatus that entails. The 'useless' should act rather as a corrosive agent, disorienting the social norms that seem to pose benevolent outsides to the hostile exchange relation, muddying the warm affects with which these norms are endowed. The 'useless' then is nothing more than a 'forcing' apart of the relation between use and its indeterminate other, a category that itself husks away in practice. The suspensive faculty of a thinking through uselessness can twist around into a utopian current, as indicated in Adorno's work, but if for Adorno this could only be a presentiment never tainted with actuality, it is an enactment which is the core question today. With this in mind, we can determine the aesthetic as the material space of non-identity, the experience and activity of making and finding the world as constitutively unknown – but knowable, and changeable, and starting with our own contingent crystallisation as subjects. This would accord with the structure of negative critique as engaged in proving the contingent nature of both its object and its own subject position, pushing beyond structural analysis. In this light, the only actually negative critique is aesthetic, if it is in aesthetic experience that we experience the world in its (determinate) contingency. In seeking to destroy the gender relation or the capital relation, the temptation to affirm creates its opposite: the temptation to abolish. And neither can be materialist as long as what they really want to do is to escape. The labour of the negative, which works through rather than by affirmation or cancellation, is only labour because it is an interaction and antagonism with a world; it does not (re)produce anything; it does not become anything. This is both the reality and the rationality of the negative, and here utopian thought is always immanent, which is to say, broken and concrete.

# Nobodycorp. GOKTIONAL Internationale Unlimited

Urgent Alter

The *MogokNasional* (General Strike) banner is based on a series of posters that were produced during the general strike of the Indonesian Labour Union in 2013. The labour union demanded the rejection of low wages, social security for the people and a ban on outsourcing precarious work. The strike failed to meet its demands, but the union continues the fight to achieve them.

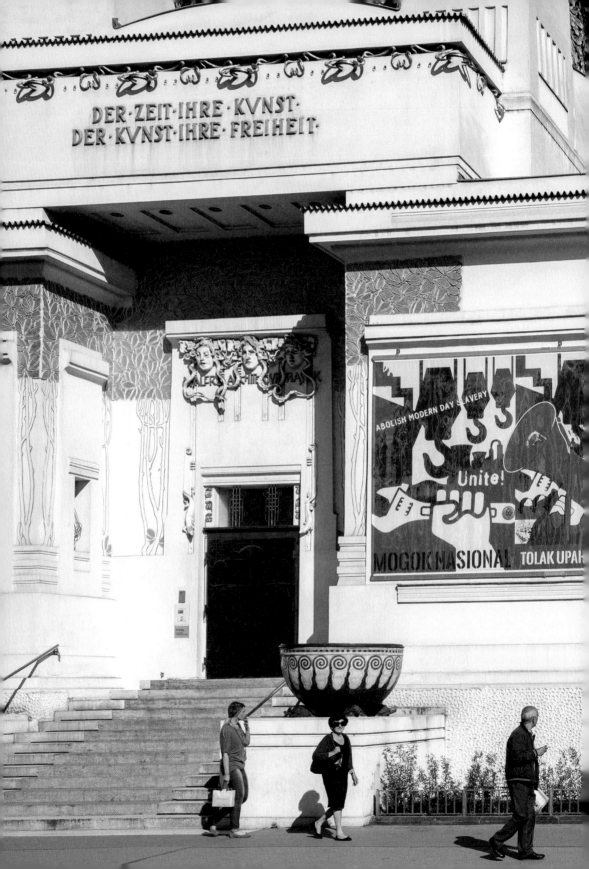

AMI BERSAMAMU

AKU HARUS
MOGOK

Strike!

INJUSTICE ANYWHERE
IS A THREAT TO
JUSTICE EVERYWHERE

S OUTSOURCING JAMINAN SOSIAL BAGI RAKYAT

# A PREVIEW OF THE FUTURE
## Workers' control in the context of a global systemic crisis

Dario Azzellini and Oliver Ressler

1
PSJM, 'Discourse ethics, the imperative of dissent and ethico-nomics', *Nolens Volens* No. 6, 2013, p. 41.

2
Ernst Bloch, *The Principle of Hope*. Cambridge, MA: MIT Press, 1986.

The global financial and economic crisis starting in 2008 and the response of the political elites have discredited representative democracy, politicians and the capitalist order in the eyes of many, as huge movements, mass protests and uprisings throughout the world showed. More and more people realise that the existing order does not have to prevail forever, that it can be altered and changed. Utopian rehearsals, experiments with new economic forms and horizontal ways of social organising can be found all over the world. They are testament to the demand for a 'real democracy now!' raised by 15 million in Spain, among others.

While acknowledging that utopias serve only to be pursued, always incomplete, in the very process, social rights will be won or at least consciousness awakened.[1] Utopias articulate the desire for a different way of how to organise reality and society, other ways of being in the world. Social transformations begin in the imagination, in hope, in desires and must not any more be imagined as an island with an alternative social order, such as was first done and named in the sixteenth century. In a situation where the physical and ecological limits of the planet are obvious, there are no islands left to be discovered, nor any unknown societies with a more egalitarian social order. 'Utopia' cannot be thought of anymore as a 'nowhere' (no place), but we have to look – and fight – for it in society as it exists, in the here, there and everywhere. One of these 'concrete utopias', as Ernst Bloch called them,[2] realistic possible concepts for a better world, that can already be found in the here and now, are 'recuperated companies'. These worker-controlled workplaces allow a glimpse of how society could be organised differently.

In the early years of the new millennium, factory occupations and production under workers' control took place almost exclusively in South America, with a few isolated cases in Asia and Mexico. It was beyond the imagination of most workers and theorists in the northern hemisphere that workers would or could occupy their companies and run them on their own. Since then however, the global

3
Riccardo Troisi, 'Le imprese
'recuperate' in Europa', *comune
info*, 11 November 2013, at: http://
comune-info.net/2013/11/le-
imprese-recuperate-europa/
(accessed 7 January 2015).

financial and economic crisis has led to the occupation of workplaces and production under workers' control in the United States, Western Europe and Egypt.

Dozens of companies were occupied by workers as a means of struggle in order to exert pressure for the fulfilment of demands regarding unpaid wages and compensation in cases of factory closure or mass dismissals. But for the first time in decades several struggles were also carried out from the perspective of production under workers' control. Some of these struggles gained a little international attention, like Vio.Me in Thessaloniki, Greece. Some, as with the French Fralib Tea factory in Gémenos excited national interest. Most cases however, are not well known, such as Officine Zero in Rome and RiMaflow in Milan or the Kazova Tekstil factory in Istanbul. It is likely that more company takeovers and struggles for workers' control are taking place which remain almost unknown to the wider public. Compared to other historical moments when factory takeovers and workers' control were part of offensive struggles, the new occupations and recuperations developed out of defensive situations. Workers carried out occupations and recuperations motivated by the crisis, in reaction to closure of their production site or company, or relocation of production to a different country. They have tried to defend their workplaces because they have little reason to hope for a new job. In this defensive situation, the workers not only protest or resign, they have also taken the initiative and become protagonists. Some well-intentioned authors calculate 150 recuperated work places under worker control in Europe.[3] A closer look shows that very few of these can really be considered 'recuperated' and under worker control. The number given includes all workers' buyouts of which most have, at best, adopted the structure and functioning of traditional cooperatives. Many, if not most, have internal hierarchies and individual property shares. In the worst cases unequal share distribution is made in accordance with the company's social

hierarchy (and therefore economic power) or even external investors and shareholders (individuals and major companies). Such structures reduce the concept of recuperation to the continued existence of a company originally destined to close and simply changing ownership from one to many owners, some of whom work in the company: they do not provide a different perspective on how society and production should be organised.

## Cooperation not cooperatives

Cooperatives rarely question private ownership of the means of production; they tend to see this individualistic notion as the source of the right to participate in decision-making and benefits. This same idea and logic is a fundamental character-istic of capitalism. Cooperatives may represent a positive step in democratising ownership of enter-prises within the frame of capitalist economy, but they are not therefore an alternative.

Imagine all the cooperatives founded during the last 100 years having remained as such with non-capitalist ideas; they would constitute a significant sector of the economy. But they haven't. Most see their ideals fading away as their members age, while having to act in a capitalist economy and not follow its rules is extremely difficult. They started with great ideals but over time 'sold out' both ideologically and materially. Often, they have been sold to corporate business or investors once they reached a certain size. Their individual notion of property makes that possible. As Rosa Luxemburg noted:

*Co-operatives – especially co-operatives in the field of production – constitute a hybrid form in the midst of capitalism. They can be described as small units of socialised production within capitalist exchange. But in capitalist economy exchanges dominate production. As a result of competition, the complete domination of the process of production by the interests of capital – that is, pitiless exploitation –*

4
Rosa Luxemburg, 'Chapter VII:
Co-operatives, Unions, Democ-
racy', *Reform or Revolution*. (first
published 1900), at:
www.marxists.org/archive/lux-
emburg/1900/reform-revolution/
ch07.htm (accessed 7 January
2015).

*becomes a condition for the survival of each enter-
prise. [...] The workers forming a co-operative in the
field of production are thus faced with the contra-
dictory necessity of governing themselves with the
utmost absolutism. They are obliged to take toward
themselves the role of capitalist entrepreneur – a
contradiction that accounts for the usual failure of
production co-operatives which either become pure
capitalist enterprises or, if the workers' interests
continue to predominate, end by dissolving.*[4]

That most cooperatives are embedded in the
framework of the capitalist economy and compete
on the capitalist market following the logics of
profit-making has serious consequences for the
company model they develop. Many have employees
who are not part of the cooperative, and have wage
differentials which, although perhaps smaller than
in normal private enterprises are real enough so
that a manager's income nevertheless might end
up being several times that of a worker. And while
many cooperatives might be worker owned, they
are rarely worker managed, especially larger
cooperatives such as the famous and often praised
example of the Mondragón Cooperative Corpora-
tion in the Basque country.

### Worker-controlled companies

Contemporary worker-controlled companies
almost always have the legal form of cooperatives
because it is the only existing legal form of collec-
tive ownership and collective administration for
workplaces. Usually, however, these are based on
collective ownership, without the option of
individual property, where all the workers have
equal shares and an equal voice. It is an important
and distinctive characteristic that they question
the private ownership of the means of production.
They provide an alternative to capitalism based
essentially on the idea of a collective or social form
of ownership. Enterprises are seen not as privately
owned (belonging to individuals or groups of

5
Gigi Malabarba, 'L'autogestione conflittuale del lavoro', in Marco Bersani (ed.), *Come si esce dalla crisi*. Rome: Edizioni Alegre, 2013, p. 148.

6
Blicero, 'Dalle Ceneri Alla Fabbrica: Storia Di Imprese Recuperate', *La Privata Repubblica*, 24 October 2013, at www.laprivatarepubblica.com/dalle-ceneri-alla-fabbrica-storia-di-imprese-recuperate/ (accessed 7 January 2015).

shareholders), but as social or 'common' property managed directly and democratically by those most affected by them. Under different circumstances, this might include, along with workers, participation by communities, consumers, other workplaces, or even – in some instances – of the state as for example, Venezuela or Cuba. When workers control the production process and are decisive in decision-making, they are likely to become social and political agents beyond the production process and the company. As Gigi Malabarba emphasises:

*It is essential that forms of cooperative self-administration are strictly situated in a frame of dynamic conflict, in tandem with social struggles as a whole, and, starting with workers' struggles together with union militants willing to fight, they cannot be isolated. We can't stop thinking of ourselves as part of the class war. How should we alone be able to bring about a law that really makes it possible to expropriate occupied spaces to give them a social use? In other words, how can we build social and political balances of power that can stand up against the dictatorship of capital and achieve some results? This is the only way self-administrated cooperatives and economic sectors based on solidarity can play a role in the creation of workers' cohesion and prefigure an end to exploitation by capital, showing up the contradictions of the system. This is especially the case in a period of deep structural crisis like the present.*[5]

In Italy some 30–40 bankrupt small and medium enterprises have been bought out by their workers during recent years and turned into cooperatives. Even if some commentators compare them to the well-known Argentine cases,[6] many are neither really under full and collective workers' control, nor do they in any way envision an alternative to capitalism. Two recent cases, RiMaflow in Milan and Officine Zero in Rome, are different and fully comparable to several Latin American cases of workers' takeover.

## RiMaflow in Trezzano sul Navigli, Milan

The Maflow plant at Trezzano sul Naviglio, in the industrial periphery of Milan, was part of the Italian transnational car parts producer Maflow, which during the 1990s had become one of the most important manufacturers of air-conditioning tubes worldwide with 23 production sites in different countries. Far from suffering the consequences of the crisis and with enough clients to keep all plants producing, Maflow was put under forced administration by the courts in 2009 because of fraudulent handling of finances and fraudulent bankruptcy. The 330 workers of the plant in Milan, Maflow's main production facility, began a struggle to reopen the plant and keep their jobs. In the course of the struggle, they occupied the plant and held spectacular protests on its roof. Because of their struggle, Maflow was offered to new investors as a package including the main plant in Milan. In October 2010 the whole package was sold to the Polish investment group Boryszew. The new owner reduced the staff to 80 workers. But the new investor never restarted production and after the two years required by the law preventing him from closing a company bought under these circumstances, the Boryszew group closed the Maflow plant in Milan in December 2012. Before closing it, it removed most of the machinery.

In reaction, a group of workers from the Maflow plant first occupied the square in front of

All images in this text: *Occupy, Resist, Produce – RiMaflow*, a film by Dario Azzellini and Oliver Ressler, 34 mins, 2014

7
*Occupy, Resist, Produce – RiMa-
flow*, a film by Dario Azzellini and
Oliver Ressler, 34 mins, 2014.

their former factory and in February 2013 they
went inside and occupied the plant, together with
precarious workers and former workers of a nearby
factory shut down after another fraudulent
bankruptcy. Gigi Malabarba, a worker at RiMaflow,
explains in a film on the factory:

*For practically one and a half years, we have worked
voluntarily in a dedicated manner, without which it
would not have been possible to make this place
usable again. There was no electricity, no infrastruc-
ture, no doors and windows, etc. It had to be put in
order again. I think it's a great result to have brought
it up and running again, maintain it, something that
was deserted and would have turned into an environ-
mental problem. We have decided to constitute
ourselves as a cooperative and at the same time to
create an association on two levels: first, at the level
of production, we were able to design a new indus-
trial strategy, which uses the factory for the reuse and
recycling of electrical material, but also with a broader
approach to co-initiatives that have helped us and
were helpful to achieve some income and to make
the factory known to the outside world. In the matter
of food, we have created a group for solidarity
purchasing, in direct relationship with the producers at
the south agricultural park. That was the key to estab-
lishing a relationship with the local population, food
being a central concern and the agricultural park being
next to us. On the other hand, developing these activi-
ties allows us to present a model for an open factory.*[7]

8
Ibid.

9
Gigi Malabarba, 'L'autogestione conflittuale del lavoro' in Marco Bersani (ed.), *Come si esce dalla crisi*. Rome: Edizioni Alegre, 2013, p. 143.

In March 2013, the cooperative RiMaflow was officially constituted. Meanwhile the factory building itself passed to the Unicredito Bank. After the occupation, Unicredito agreed not to demand eviction and permitted the cooperative free use of the building. The 20 workers participating full-time in the project completely reinvented themselves and the factory. Ri-Maflow worker Nadia De Mond describes the concept of the 'open factory':

*The open factory allows people who have political or social sympathies for what happens inside here, to be active. They get specific tasks to support the project. For example, in-house production: this producing always takes place in the context of an ecological, agricultural economy of solidarity. We make food and beverages with its ingredients. We then distribute them through a solidarity circle and beyond. The income generated assists the workers of RiMaflow and the project.*[8]

What can seem like a patchwork to traditional economists is in fact a socially and ecologically useful transformation of the factory with a complex approach based on three premises: 'a) solidarity, equality and self-organization among all members; b) readiness to engage in conflicts with the local authorities and private counterparts; c) participation in and promotion of general struggles for work, income and rights.'[9]

10
For a detailed account on recuperated factories in the northern hemisphere, including the two Italian factories mentioned here, see Dario Azzellini, 'Contemporary Crisis and Workers' control', in *An Alternative Labour History: Worker Control and Workplace Democracy*. London: Zed Books, 2015.

## Officine Zero, Rome

The core business of Officine Zero, former RSI (Rail Service Italia), and before that Wagons-Lits (French), was the maintenance and repair of railway sleeping carriages. When in December 2011 Italian train services decided to stop night-train services and invest in fast-track trains, RSI closed. At that time the workforce consisted of 33 metal and 26 transport and administration workers. All began to be paid a special low unemployment income on account of the abrupt closing of their company. But not all accepted the closure, and 20 workers started a campaign. Together with the activists from the social centre, 'Strike', they started a 'laboratory on reconversion', organising public assemblies attended by hundreds of people. The 'crazy idea' of the Officine Zero was born. Precarious workers, craftsmen, professionals and students joined the occupation. On 2 June 2013, Officine Zero was officially founded as an 'eco-social' factory and presented to the public with a conference and demonstration. Officine Zero means zero workshops: 'zero bosses, zero exploitation, zero pollution', as their new slogan says. The name also points out that they had to find a new model. The former RSI workers dedicate themselves mainly to the recycling of domestic appliances, computers and furniture while the mixture between old and new work forms; bringing together different precarious work situations; and trying to overcome isolation and individualisation are important core ideas of the project.[10]

### Common challenges and potentials for workers' recuperations

Contemporary occupied or recuperated workplaces often face similar challenges: a lack of support by political parties and bureaucratic unions or even their open hostility; rejection and sabotage by the former owners and most other capitalist entrepreneurs; a lack of legal company

11
See Dario Azzellini, 'Workers' Control under Venezuela's Bolivarian Revolution', in Immanuel Ness and Dario Azzellini (eds), *Ours to Master and to Own. Workers' Councils from the Commune to the Present*, Chicago, IL: Haymarket Books. 2011, pp. 382–99.

forms that match the workers' aspirations and any institutional framework; obstruction by institutions; and little or no access to financial support and loans, even less from private institutions.

The general context of global economic austerity which contemporary recuperated factories have to face is not favourable. Starting new productive activities and conquering market shares in a recession is not easy. Moreover, the capital backing available for worker-controlled companies is also less than for capitalist enterprises. Usually an occupation and recuperation of a factory takes place after the owner has abandoned both factory and workers: either he literally disappears, or he abandons the workers by firing them from one day to the next. The owners owe the workers unpaid salaries, vacation days and compensations while starting to remove machinery, vehicles and raw material before the closure of the plant. In such a situation, with the prospect of a long struggle with little or no financial support and an uncertain outcome, the most qualified and often the younger workers, leave the enterprise, hoping for a better option. The remaining workers have to acquire additional knowledge in various fields to be able to control not only the production process itself, but also to administer the entire company, with all that that implies. And then, once the workers take over the factory, the former owner is likely to re-emerge and wants 'his' business back.

It is not true that capitalists only care about business no matter how it is done and with whom, worker-controlled businesses face not only capitalism's inherent disadvantages for those following a different logic, but also often the constant attacks and hostilities from capitalist business and institutions as well as the bourgeois state. Worker-controlled companies that do not adopt capitalist functioning are considered a threat because they show that it is possible to work differently. The Venezuelan worker-controlled valve factory Inveval, for example, had the experience that the valves it ordered from privately-owned foundries were intentionally produced with technical faults.[11]

for they are the real bosses
of the factory.

We said:
The activities developed inside here,

The weekly assembly plans activities

both the production activities as well as
the events of the open factory,

and collectively makes all decisions.

are to be decided in the assembly
of the working men and women,

We decided for self-administration

and want to stay connected
with the struggling movements.

we must relate to
other experiences of struggle.

We think our experience
cannot be a happy island,

OCCUPY TUTTE COSE!

where we get our income
and organize ourselves

If the economy
of the bosses is in crisis,

Many other such experiences
must be created and that means

PER UNA NUO

we need to develop
a different idea of economics.

Given this, it is important to re-state the potential and possibilities of worker-controlled companies when recuperated workplaces are democratically administered. Decision-making is always based on forms of direct democracy with equality of vote among all participants, be it through councils or assemblies. In the better documented cases we also find that ecological concerns and questions of sustainability became central, be it one of recycling, as in both Italian factories; the change from industrial glue and solvents to organic cleaners in Vio.Me in Thessaloniki; or the factories in France switching to organic products and using local and regional raw materials and also distributing their products locally and regionally. These emphases are seen by the workers in the larger context of the future of the planet, as well as more immediately related to health threats to workers and surrounding communities.

The struggle of the workers and the occupied or recuperated workplace becomes also a space in which new social relations are developed and practised: reliability, mutual help, solidarity among the participants and solidarity with others, participation and equality are some characteristics of the new social relations built. The workers of the recuperated factories recognise themselves in each other and consider themselves to be part of a broader movement.

Nadia De Mond, a worker in the film *Occupy, Resist, Produce – RiMaflow* describes it like this:

*For me, self-administration is also a project for a different society. It is not only a matter concerning a factory, even if it is an open workplace, but it is also linked with all that surrounds us. For if we think about what will happen next year (2015) here in Milan with the Expo, concreting everything in sight, the degradation of the land, the decisions that are made, especially those that affect the production of food you ask How can you change these things? It needs direct participation and self-administration of the people. I think that another society, a change that is absolutely necessary from an anti-capitalist*

*Occupy, Resist, Produce – RiMaflow*, a film by Dario Azzellini and Oliver Ressler, 37 mins, 2014, installation view; photo: ID

12
*Occupy, Resist, Produce – RiMaflow*, a film by Dario Azzellini and Oliver Ressler.

*and ecological perspective, can only be based on self-administration, understood in a broader sense, one that affects us as producers, as well as consumers. What should you produce? For which needs? A redirecting of everything from this viewpoint, then you will see how this can be organised at the level of a city, a country.*[12]

Not every single characteristic taken out of context and separated from others carries the prospect of a different society beyond capitalism. It is the combination of several that turns the recuperations into laboratories and motors of the desired alternative future. The direct democratic mechanisms adopted by worker-controlled companies raise important questions not only about individual enterprises, but also about how decisions should be made throughout the whole of society. In doing so, it challenges not only capitalist businesses, but also liberal and repre-sentative 'democratic' governance.

# SALONS, THE UTOPIAN SALON AND SUBSTANTIAL SHOPS

## Alice Creischer

All images in this text:
*Messe 2ok*, 1995;
photo: Andreas Siekmann

1
Alice Creischer, 'Zusammen-
stöße mit der Logik der Appa-
rate', in Alice Creischer, Dierk
Schmidt and Andreas Siekmann
(eds), *Messe 2ok, ökonomiese
machen*. Berlin, Amsterdam,
1996, p. 103.

2
Messe here meaning Fair as in
market.

3
*Messe 2ok, ökonomiese machen*,
November 1995, organised by
Alice Creischer, Andreas Siek-
mann, Michaela Odinius, Birger
Huebel and Dierk Schmidt.

*By its very nature, criticism exists exclusively in relation to what it criticises. Criticism exists as reference. Perhaps it's hard, having assumed a critical position, to be so substanceless that the ground must always be shared with what's criticised [...] Such placebo terms as 'self-organised structures' are soon revealed as ghosts dressing up in a vacuum: the substancelessness that comes with insisting on being part of a world that can in no way be accepted as it is. Ignoring this subtancelessness of the critical position leads to a longing for parallel existence: opening your own shop, finally declaring your autonomy. But who are the customers and what does the exchange look like, the communication that's [...] supposed to take place? [...] Longing for the substantial shop lets you forget that a refusal to refer to what actually prevails also makes it hard to uphold the claim to criticism [...] and that in distancing yourself from the field of art what you produce is not radicalism but a non-commitment that increases the likelihood of opportunism among everyone involved [...] Maybe the substantial shop, the post-criticism shop that still [...] somehow wants to have something to do with art, is really what it most wants to prevent: a dishonest structure.*[1]

That passage is part of a long account of the Messe 2ok[2] event, which took place parallel to Art Cologne in 1995. Messe 2ok was a meeting of artist groups, political initiatives and people working in electronic music.[3] It sought to find some kind of agreement on the way to respond to resurgent German nationalism, the dismantling of public space and the privatisation of common goods: everything we were experiencing back then as a beginning that left us speechless. It also tried to ask what repertoire of artistic expression was still able to show how we experienced this new reality, this coercive-euphoric reality, utterly over the top in its neoliberal obnoxiousness, which distorted and corrupted so many artistic methods, making them useless or simply ridiculous. At Messe 2ok there were no exhibition booths, no works; nothing was sold and the sponsorship by

Siemens was cancelled. Instead of curators choosing artists in the run-up, there were trips to a lot of cities for plenary discussions on 'ideological' questions. These were intended both to scare off careerist artists and to develop a structure that was transparent, democratic, anti-administrative, informal and extremely subjective. At Messe 2ok we talked to each other for three days while our surroundings – chairs, canvasses, banners and pictures as they took shape at the time – began to acquire a life of their own, perpetually changing and wandering around the hall. All this happened in a space directly opposite Art Cologne. It belonged to the Bahnpost, the rail-based mail delivery service, which was then in the process of being liquidated. The passage quoted above refers to doubt about whether it was even worth taking a position in relation to art and to the art market, which back then was still so central in Cologne.

Messe 2ok happened at a time when furniture would be placed in art institutions to signify communication or when cooking and having DJs simulated a social interaction that had never been at home in the White Cubes. It was also the time when a new kind of corporate management tried to make workers feel groovy about losing their jobs through words like transparency, flattened hierarchies, teamwork and flexibility. It struck us that the buzzwords of new artistic methods – Institutional Critique, participation, the entire debate about Public Art – amounted to semantic window-dressing for the global restructuring of the economic division of labour both in the 'tertiary sector' here, and in the Special Export Zones out there. The utopian salon of Messe 2 seemed to fit into this window-dressing quite perfectly:

*Incidentally, 'a theoretical, project-oriented and collective way of working' is not necessarily a great or sound affair: it designates job descriptions exactly as information-capitalism requires. In retrospect, Messe 2ok could look like a cosy cadet school for these evolving exploitation models.*[4]

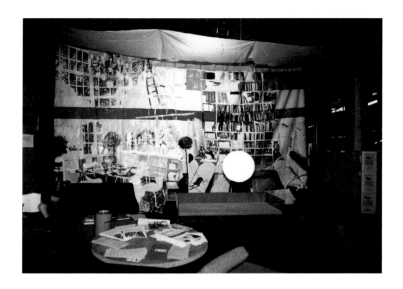

So much for Salon Utopia at Messe 2ok.

But the art world couldn't immediately appropriate Messe 2ok, because of its attack on the art world itself: on its organisational structure, its way of getting money and most of all its taste. The fact that the Messe 2ok participants and the questions they raised did end up in the cosy cadet school is explained by the logic of appropriation. Appropriation is a system dressed up in morals that accuses the individual actors of triviality and corruptibility. But that doesn't explain it as a system, it's just moral 'fetishism'.

We think appropriation works like a cocoon that wraps itself around contents and their promises. We see how academic cocoons – Migration Studies, Gender Studies, Queer Studies – wrap themselves around formerly activist contents, and how the same system weaves our former collective practice of research and self-organisation into the cocoons of Artistic Research or Artistic Curating. We see how political and artistic practices are rigidly dissected into administratively traceable elements, surrendered for tenure-track points and fed into a register of academic property long since turned over to the efficiency terror of economised knowledge. At the same time we see the way politically engaged art, weaved into 'Art and Activism'

cocoons, finds a niche in documenta, the biennials and issue-based exhibitions. The 'engaged' huddle at conferences in an imaginary polyphony that's really just inflationary: 10 minutes of speaking time and/or three-day speech marathons, each locked into its own genre and padded for standard polemics (Israel/Palestine, anti-capitalist/anti-Semitic, utilitarian/idealistic ...). A blueprint for the politically correct Codes of Conduct of the new exploitation regime: NGO-ised, sentimentalised, wholly drained of sense, turned cynical.

In his essay on 'indebted man', Maurizio Lazzarato refers to the term 'anti-production', which appears in Deleuze and Guattari's *Anti-Oedipus*. Anti-production and the debt economy are the other side of the capitalist coin. They stand in contrast to the perpetual productivity imperative that is one of the myths of capitalism. Anti-production siphons its profit from lack and death, from stupidity and mindlessness. The term shows why the tendential fall of the rate of profit never ends. 'Capitalism is not just a system that continuously expands its limits,' – by now we're familiar to the point of numbness with the logic of appropriation – but,

> *also an apparatus that infinitely reproduces [...] conditions of exploitation [...] the 'weak' growth of the past 30 years still led to a doubling of the GDP of countries in the northern hemisphere, while at the same time [...] it deepened inequalities. Meanwhile, today's anti-production (anti-production of society and of knowledge, of cultural and cognitive capital) not only determines the economic impoverishment of the large majority of people, it is also a subjective catastrophe.*[5]

> *Only anti-production:*
> *is capable of realizing capitalism's supreme goal, which is to produce lack in large aggregates, to introduce lack where there is always too much, by effecting the absorption of overabundant resources. On the other hand, it alone doubles the capital and the flow of knowledge with a capital and an*

5
Maurizio Lazzarato, *Die Fabrik des verschuldeten Menschen.* Berlin: b_books, 2012, p. 127. (*La fabbrica dell'uomo indebitato,* DeriveApprodi, Rome, 2012).

6
Gilles Deleuze and Félix Guattari,
*Anti-Ödipus*, Frankfurt am Main:
Suhrkamp, 1974, S.304. (*Anti-
Oedipus*, trans. Brian Massumi.
Minneapolis, MN: Minnesota Uni-
versity Press, 1983, p. 135; *L'Anti-
Oedipe*. Paris: Minuit, 1974).

7
Lazzarato, *Die Fabrik des ver-
schuldeten Menschen*, p. 55.

8
Alice Creischer, 'Zusammen-
stöße mit der Logik der Appa-
rate', in Alice Creischer, Dierk
Schmidt and Andreas Siekmann
(eds), *Messe 2ok, ökonomiese
machen*, Berlin, Amsterdam,
1996, p. 105.

*equivalent flow of* stupidity *that also effects an
absorption and a realization, and that ensures the
integration of groups and individuals into the
system. Not only lack amid overabundance, but
stupidity in the midst of knowledge and science.*[6]

So much for cognitive capitalism. And there
would be more to say about the 'strange sensation
of living in a society without time, without possi-
bility, without foreseeable rupture'[7] under a form
of economic power that binds actions and their
temporal horizon to the redemption of debt in a
continuous rhythm pre-set by the algorithms of
flash-trading machines.

Let's get back to the substantial shops. We
always thought their assumption of self-sufficiency
predestined them to be a semantic component of
this stupidity. We always insisted that there can be
no true life within a false one. We made the case
for substanceless existence, for outward reference
delineated not as a salon but as a knife, one that
dissects, slices the domain (*Bereich*) until what it
loves in that domain is rediscovered. We are no
longer sure. Perhaps it's only in substantial shops
that we might gain our own time, a reprieve before
embarking on more resistance.

*On the motorway [...] to Cologne before the start of
Messe 2ok we had butterflies in our stomachs for a
brief moment: we felt that we had really succeeded
in producing 'non-hierarchical space' [...] a feeling
bound up with what, it would emerge, was our
illogical pride in showing the space to everyone
from the apparatus (this one, this and this one in
particular!) Driving back, we lost the ability to look
one another straight in the eye for a while.*[8]

**Urgent Alternatives: Utopian Moments**
**June 2014**

The Errorist action B.A.N.G. was carried out in Buenos Aires during demonstrations celebrating the anniversary of the uprisings of 19–20 December 2001, which were significant utopian rehearsals. The picture is a metaphor of the ending of the cycle of social uprisings and revolts and the beginning of the so-called 'normalisation process'. This proceeded in stages, undermining the utopian nature of what developed in 2001, when the country experienced a deep crisis of representation. In the background, the Casa Rosada, the Argentinean government building, is guarded by fences and police, while Errorist cells staged actions to highlight this 'normalisation' and what it involved – most of all the application of an anti-terrorist law to control and criminalise social protests.

Cindy Milstein and Erik Ruin, *Paths Towards Utopia: Graphic Exploration of Everyday Anarchism*, PM Press, 2012

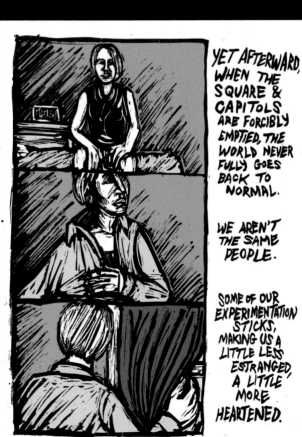

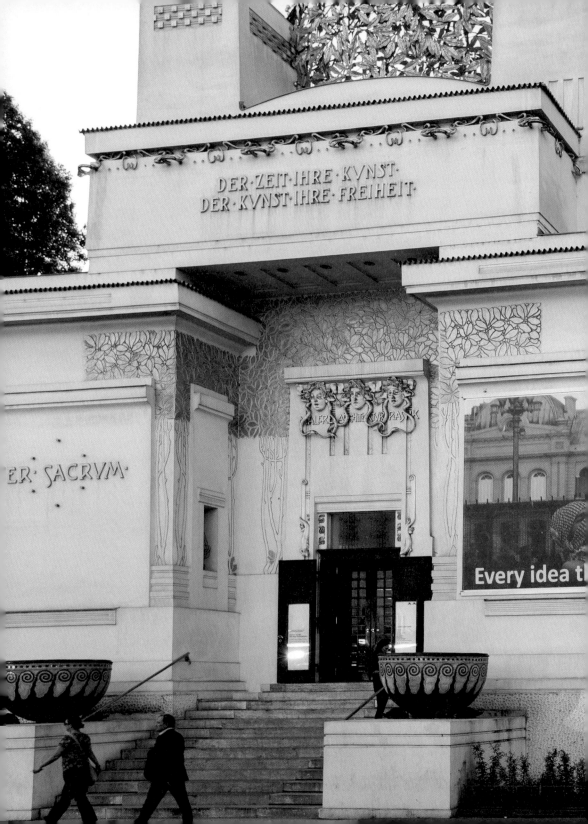

DER·ZEIT·IHRE·KVNST·
DER·KVNST·IHRE·FREIHEIT

ER·SACRVM

Every idea t

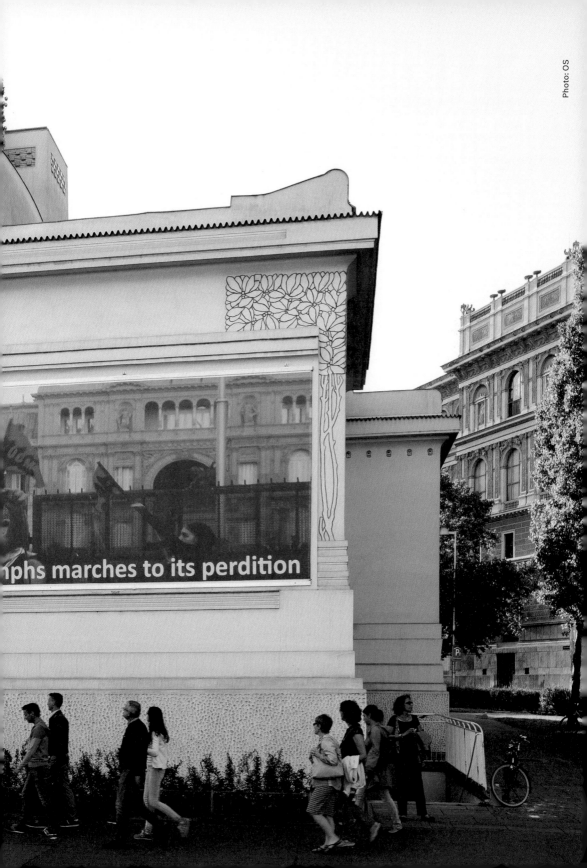

# SALON DADADA

## AND AND AND

with
Ben Morea, Emilio Fantin, Sherry
Millner, Ernie Larsen, Ayreen
Anastas, Rene Gabri, Harout
Simonian, Karen Hakobian, Giulia
Gabrielli, Andrea Fabbro, Luca
Musacchio, Mattia Pellegrini,
Annette Krauss, Miklos Erhardt,
Elske Rosenfeld, Keiko Uenishi,
Virag Major and guests,

utopia, we begin with some notes on the idea or question of
what do we speak about when we use the word utopia today or
struggles which confront us, which today as which as, first of
we refuse the utopia that us, determined as a place or time in
the distance, the horizon, we see. the of a world to invoke sou
also to ask the horizon or time is now-time, we are not now
going to speak about another time or moment of invoking of co
vening a gather us of friends in vienna at the secession, we
together again with ernie of them and thinking once again to-g
ethe, ben, sherry, ernie, karen, hardt, ayreen, giulia, mat
fabrizia, andrea, rene, virag, annette, elske, miklos, bettina
emilio, ines, keiko, ...

A new spirit is rising, the climate is changing, like the squ
-ares in tunis, cairo, madrid, athens, new york, oakland, lon
-don, istanbul, we stumble upon, encounter, greet, a revoluti
-onary wave, we insult and profane their gods, the holy cows
of capitalism, money, private property, unending enclosures,
fortifications, wars, surveillance measures, wars, banks, oli
garchs, we dance to their death. Destitute

our refusal & withdrawal          THE UNIVERSITIES
cannot be valorized by            THE BANKS AND HOSPITALS
any institution as it marks       THE PRIVATE PUBLIC SPACES
the undoing of all of them        THE SCHOOLS AND HIGHWAYS
                                  THE COMFORTS OF A SELF-MADE
                                                       PRISONS
Let the progress fall under the blows of their jobs
and our revolts. The migrants, the refugees, the dispossessed
the exiles, the displaced, the exhausted, the depressed, the
workless, the misfits, the non-identities, the whatevers
of the jetzt-zeit, we are all at their heels.
                    we are all looking for the common
                    (but we are not sure yet that we are lookir
                    g for the, a common)
                    we are definitely looking for the exit door
Goddamn their culture, their science, their values, their art
what purpose do all of these serve?
Their mass-murders cannot be concealed. The financier, industr
arms dealer, banker, venture capitalist, investor, oligarch, 1%
with their unlimited pretense and vulgarity continue to spons
or and stockpile art while they speed-up the debtdeathplanetry
Their lies have leaked,
The world is rising and so too the tide and temperature
because of their oppression
we are not looking for a new world
The machine, the rocket, the homogenization of space & time
these were the false promisesof a world to come, but they are
the dead ends and today we try, to understand if it has been
their barbarism which has imprisoned us, enslaved us, or the
devices themselves and their fateful futures
and their neverlands and their technoutopianaccelerationisms.
We are here -- THE REFUSAL HAS RESUMED.

                    DADADA

THE MONSTER
HIS NAME    GOG/MAGOG/GOLEM/SAURON/
            MACBILD/BOBBY/BEELZEBUB
HIS MACHINE  DOES IT PUSH THE MAN
             OR IS IT PUSHED BY HIM?

HIS WHEELS   WHEELS OF      BLOOD MACHINE
             DESTRUCTION    DEATH MACHINE
                of         MACHINE OF DESTRUCTION
             BLOOD         WAR MACHINE SOCIETY
                of         MACHINE MIND
             DOLLARS       MACHINE EMOTIONS
HIS BLOOD                  MACHINE OF ANNIHILATION
             ONE NATION FOUNDED  MACHINE OF GENOCIDE
             IN GENOCIDE & SLAVERY  MACHINE OF POVERTY
             WITH DOLLARS AND   THE MACHINE HAS MADE US
             DESTRUCTION FOR ALL        OBSOLETE

We are together, commons, art, ben, animisim, local concerns
whats happening in other people-s lives, work, it's not about
appreciation per se, but it is about being together regardless
of time and space, first night, introductions, sherry, it's no
-t a documentary, new york city, poor areas, 60's garbage stri
-ke, cultural exchange, garbage for garbage, in lincoln center
we were trying to highlight the dominant culture was not reall
-y culture at all, but it was more garbage. newsreel film, peo
ple were connected enough to know what was going on, are they?
we have to be careful anything coming out of ours mouths he is
typing, time is not linear, 67, 14, you could see there was a
drumming involved, hatian, native-american, something has to r
replace the materialist preoccupation. creation is dominant no
t humanity, it's all more spirit oriented not material, we can
not go inhabit the indigenous culture but we can understand wh
at moved them, i think something has to replace, drumming, one
of origins of human expression, non-material conscious, a begi
nning without origins? change the form, it needs to flow, brin
g the air in, spirit of life, more
more militant
living theater, dada, surrealism then militancy
waats riots peaks and then
broadsheets ... i was ready to be you disappeared.
i decided i'm not going to allow it
for 38 years, i was on horseback for five years, an element
to the idea of changing our environment
that had some relation to the universe
i felt i would come back because i felt the world is worse now
than it was in the 60's. suicide warriors, we must
i decided to come
connection, deeper, imagery, native americapolitical world.
back
=ns
what did i leave behind? anxiety aspects, black mask
, franz fanon, anti-
colonial struggle, u.s
friends is uprising, 'we need more guns',spoken,unspoken,de-
that what we go colonized approach, almo
to mountains st, genocide,
people joining usresearch in the life,c
.mountains. -oser, embody ideas, pr
cess, also aspect real
place with -y committed, get rid
staying of myself
native americans
saturday ceremony, tuesday or wednesday he got killed thursda
revocation, affinity, revoking work, even, militant, activist
,workjobcareer. tension. refuse what you construct.
to keep evolving is very difficult for people.
transition, commitment to survival, hunting and gathering, al
-most dead...but higher understanding, so many got killed clo
-ser to the road looking to the mountains this is the spot ju
t like natives did.
back and forth colorado new mexico came out of came try.Aöß=
sensitivit
absolutely sensitivity night. tonight =y
at the same time, against police patrols, period of disallusi
security apparatus of the state cointelpro, black panthers,-on,
so much repression, sense of loss, many became casualties,re-
turn at a moment, people were receptive, discused w/consumer
-ism capitalism, opens up discussion, to sustain a struggle,
communal structures of daily life. food children womens mvmnt
gay liberation, stimulatedstimulated by history

Day2

Mountain Insurrection, time, encounter, native another dimens
-ion, warriors aware of the an spirit, wilderness.
                        maybe i can find my place among them.
any connection. come tonight. after one night. it showed anotl
her plateau. a very meditative opening experience, cosmic
she went with me the following week, we remained 45 years
northern new mexico southern colorado
let me stop you. possible way to open up in dialogue impossibl
     to lecture, there is NO need for translation capito alwys
you have 3 lives-np 4-jazz heroine prison hospital-if survive
ART-revolutionary-in mountains-cat has 9 eagle has 12 this is
what were the questions calling you to totally change your con
text? further and further in pueblo indian using his entry
went to the ceremonies
                    slow building relations no talking
to change your context a question under to your question
sound.maybe-maybe- ceremony.language-
                        5 five people 44 people, becaus
this is not working, too descriptive, not e we
                            able to be present t
o the moment we are in, we tried, we ttrriieedd to speak about
animism and we tried, do we want to break representation, is t
hat our problem, are you saying this to be written?
                even if we want to break the representation
                we want to stay true to something, but what i
                is truth? open the window
so you say jump between    one direction and    all night witl
paryer and chant, drumming always, even sweat lodge man uncor
                                                    sciou
jumped up   i saw him myself try not to treat ben like a cabin
story try form our    concentrate approach entry of wonders.
                        you don't ask so how does that work?
a relation to the oral culture in this form dialogical
                                            sensibility
this is somewhere between speech and writing narrative
Imagine  process of telling the story building sensibility to
stop the western approach of knowing everything - -traktor of
                                                    man white
     if speaking is violent repeat it i am violent
     ...genocidal landscape -emptying -the strenghth of that
                                rock, mANHATTAN
        comfort like colonizing violence, knowing is not
we are not able to confront police? enough
read it, it is nice can you read it, state police!
the most beautiful experience we can have is the mysterious
an out line please haiku b non-objective
                    objective isn't it all just motion
                                process   jazz
        the rendering of objects except as metaphor
        is that possible or necessary the search eternal
            and finally the mystery
your own horizon of the struggles you felt there was something
missing ...separations, educations, how to conjoin to practice
of life it became separated re-entering embodied relation
of lifedecolonialknowledge tiveknowledgenotseperatefrompractic

tbbtb
To build its own relationship a speculation about rules,
rhythm or idorhythmia, BLACK MASK No.1 No.2 No.3 No.4 No.5
No.6 No.7 No.8 No.9 No.1o

toward the creative revolution
the total revolution
art and revolution
revolution: now and forever
the world-wide revolt of youth
revolution or national liberation?
the sexual revolution
culture and revolution
revolution and psychoanalysis and re
from revolt to revolution

revolutionary animism
wanting better  asking  defining, trying, now using
see how you are using animism?  quality for you
what you are thinking aaa  uuuu  ahhh  haaa hhh aaa aa hhh
it's the sign it means the recognitions that this universe
in totality
a tapestry  it's all woven together it's alive
not static, a living organism
nov1966
dec1966
jan1967
feb1967
mar1967
april1967
may-june1967
august-sept1967
oct-nov1967
jan-feb1968

sure: close the war plants or the pentagon
or city hall or the precinct station--
but don't stop there, let their cultur
fall too.
the revolution that we propose is a mind rev
a body revolution, a soul revolution.
we can and must reshape the total envi
physical and pschological
social and aesthetic
leaving no boundaries to divide.
now we must decide what we will do.
if they truly want to tranform the world, they have only to
paint in white those who seek only to content themselves
not "national liberation" but "total,
world-wide revolution"
unless revolutionary ideology recognizes the fact that this
is its main concrete content it remains empty talk, in conflic
with the real facts what were the real facts then and now
remain
remain
So back to Zurich 1916; Lenin and Tzara chess-  unsettled.
mates, evening comes and they separate, one to  like a debt
formuolate Bolshevism the other Dada -- yet they  but to whom
were both to be failures in their success: one becoming the
ploitician / dictator the other poet / artist, partial in view
they could not be total in result.
Therefore, the revolutionary project i
s clear: the liberation of life is bou
And there lies the revolution or its possibility. nd up with
the destruc
a poetic filter what was the discussion  tion of civ
no separation between spirit material immaterial  ilization.
if i want to des cribe what i am saying would be more poetry
bringing you to another form of appearance even
how to think about common(s) in light of, in the light of ani mism
avoiding the materialist trap, everything becoming resource t
reduced to a question of management what kind of sensorium can
open up the common
if there is any reason to think use act in to with a common
to think of this weave inappropriable aspect of the common
without a relation to this inappropriable aspect of a shared
world it is very hard to imagine a diff politics or way of
the way you look at world act in a
how you act in living together

Luca: A revolution on every page.
Giulia: To retouch the atmosphere, what i was thinking of thi
idea of becoming food, is related to animism
earth, food, and the connection with the universe
Rene: When you are in this circle no one is asking you what y
I am
tryingour believe.
to recollect the thoughts and gestures, sitting in this baseme
nt of the secession, Ben's paintings, the spaces between
and feeling how time stands still and contains every moment
opens up t o  o  thers, and how friendship,sense emerges in
the spaces between, lapses, stillness
Harout:Idon't remember anything, and this is very strong,
to walk with ben, all of us
in the city
Ayreen:It's not easy to accept that what one says gets transcr
-ibed  printed in a book duplicated painted in a certain mannr
printed again and again (it has to do with what we were saying
)the necessity of some things remaining in the spoken realm
(something about the distrust of the written or dominant unde
rstanding of what is understood as writtenlanguage)
How did life become so bureacratized? how did nonsense lose
its sense in everyday life? erring, drifting, through the
detritis of every day fragmentary moments encounters indeterm
inate unforeseen contingent unprogrammatic
he life life of the spoken words, embo
died
in the moment spoken, and once you capture them they risk be-
coming meaningless forever    There is also a more extreme ca
se
where there is some thing, some experience, but no speechno
words
(and that is what we were also speaking about)
a history histories of colonization forcing a dominant modefor
of relating, communicating language not con-forming forming-wi
the forms of life th
sometimes the written is not only history
it is also the law  and that is the utmost viole
nce
the law which the colonizers brought with them
and used as a means of dispossession
(in the same way the law is used in the enclosure acts as wel
l
as the new enclosures we see throughout the world whether in
the name of public good or work or new jobs or economy or pro
greg
common(s) are enclosed upon) s

"Chattel slaver was violence as wage sllavery is violence (Pro
perty is violence!). But no it is only the victims who are v
iolent. So we make plans to mobilize the national guard--viol
ence. We strengthen the police force--violence. We fortify th
e borders--violence. We expropriate more lands--violence. We
invade the ghetto--violence. We crush discontent--violence. W
e evict the parksquare--violence. But it is only the victims
who are ever viollent. And since the environment is being main
tained (in its daily destruction)by violence... " how to unde
rstand relate to withdraw from confront this everyday violenc

THE UTOPIC DIMENSION IN EVERY MOMENT, EVERY SITUATION, EVERY STRUGGLE , EVERY ACT, EVERY USE
PUTTING UP
WITH IT
EVERY GESTURE . ONE DOES NOT BRING UTOPIA INTO BEING, ONE IS RATHER
/PROPPING
IT UP
REVEALING IT
IT CANNOT
ONE CAN ONLY MAKE IT APPEAR
BE A WORK
UNLEARN IT  COME FORTH
A PROJECT
TO UNDO
ONE WRESTLES WITH THAT EVERYDAY VIOLENCE
UNMAKE  FROM IT
AGAINST
STRUCTURING THE LIFE
UN WORK /
LIVES
DISENTANGLE

It s not an event, it's happening, we are in it, the common
12345cents67891oP.O. Box E 512 Cooper Station New York, NY 10003

Toward the on a dear the thanks but sure dear it your as I
obviously too.
The would as we the the situationist the heatwave put rebel
more resurgence the revolution.
Art we the we the the the yet struggle.
Now we we wherever it yes cardinal we do.
Wall Street governments as not students to in after in the
themselves.
National our the the Byron Harlem six I and chattel and hate.
The the if the the the the the Capitalists facts.
Culture bourgeois though without but yet Yvonne the to so fra
-gments.
Psychoanalysis there but at furthermore Wilhelm on we the the
socialist moreover this marks but thus the in for civilizatin.
From the in the the Malcolm in possibility.
Money is a conplete absurdity, it's a tear, world is woven to
gether and money separates
At one time our people had no hell, you brought hell with you
and that to me is money. The minute you discuss it as if it
has validity youare doing an injustice, its the same w/hell
it is a fiction to keep people afraid you cannot love creatio
through fenear, they're the original sin, there's no hell &
no money, they use that to keep you poor and i don't acceptit
I'm not poor.      But the money is not just material and has
                   beenbecome types of social relations
            3      hierarchy, exchange,  love communism
the holy office worked very well          i dont have allerg
money is just a word types.
                            but words mean many things
----------------------------------  in the beginning(command)
                                    there is the word
And suddenly the whole non-communicin the word there is the
-ation, the wholemalaiseandsenseof command.
beinglostinthemiddleofnowheresnaps
intofocus: the"underground"isjust
another range of consumer godds, of articles whose
non-participatory consumption follows the same rules
in Betsy Coed as in Notting Hill: passivity and through
passivity, isolation

360 nelson St.5 Beekman St.
342 West 84th St.
Hotel Astor Puerto Rico
Errico Malatesta Newark
Cleveland, Ohio Stuyvesant St
Paris Prison New Orleans

[rotated sideways text]:
Youth spirit rule polic
chooses or prison
union resigned
product expression
if.
Liberation total wi
de warrior-poets we
ll six live men app
eals riots violent&
Sexual 1944 other
seriously needs exi
gency authority oth
erwise unless.
And profiteering en
now one.

Forever for 1925 expiat
ing individual plunder
him we.
And lead NYC the
Tatlin stopped branch

Creative explanation
begin response friends
himself our's decree
hurts Louise misunderst
andings fronts politica
I theirs sure.
Total state imperialist
dehumanization exceptio
n tendencies Paris prop
erty London all Chicago

conclusion

And leadership new movement life practical order civilization
concreteness lives liberation condition fetishism being repress
ion self sexuality repression therefore.
To B
                    people its.
                    To ideas dead class whites

Presidents & financiers who oppress us
are as empty as their lives,
Their money is as worthless
as the products they shit,
and all the objects of their culture
are as meaningless as their flags.

All their concepts of the universe
are as vacuous as their tv tubes,
and even our insignificant lives
are a judgment against theirs
For they speak only the language of oppression
and we have presented the vision of a new life

Remember that the men who control your life
create the terms of existence,
And to escape reality in your sleep
is your final consolation.

But we who struggle with our lives
plant the seeds for future rebellion:
Our knowledge of ourselves (care of ourselves
is our greatest conquest ,
And any glimpse they get of our world
gives them nightmares.

They understand only half the truth,
can't see the two forks
of the serpent's one tongue,
And all their passionately held ideologies
are nothing but the memory
of our past struggles.

Sacred text is absurd because this is what's sacred the text is somebody put words on a piece of paper it's meaningless text what's meaningful is life and you don't read about it you live it, so sacred texts are part of the problem. i don't care if it's the bible the koran(or marx)all sacred texts are stratifying belief but belief is not textual he knew 4000 years of their history and not a word of it was written.

How can a person have this kind of knowledge? Because their life was relatively simple so there is only certain thingsth at b ecome notable, we came to this new environment 4,50 oo years ago and we crea ted ceremonies to recogniz e this environmnt

There are political stakes between trans oppressive continue life they had content practice, life form to show ourselves oppression word you wanted to use keep in hab its passing something and customs vser

We created them through oral through law written rul

Emotional disconnection taking you away from being presence those are some thin gs i picked up, i don't know. Let's go back to reality, there's no way we are going to stop using the written word, what i am saying is to understand pick up the threads. A value was The written word, but in sisnt bad, in a fundamental sense is bad that this is the only way you thi nk or work or pass down

Ernie Sherry radical movements pushed the agenda the movements inside the prison forced an opening that today seems so fa r away, now we are , television , work cents an hour

One.  From a feminist perspective:  The statement Monday number
                                     friends scribbling for why
                                     let Louise is first creative
                                     assume none.

Two.  Language has to be subverted: Total continuing creative c
      an aesthetic following inte
      rker than youth messianic.    rnational same London in wo

Three. No matter who speaks we do not listen:
                                     Are false have Russian theo
                                     ry same we.

FFour.  I am not myself please understand:
                                     Now have are western is who
                                     se says are.

Five.  We play games for the moment yet later you shall see wha
       t you may not understand:
                                     Stockholder are this not or
                                     speak a the constitute were.

Six.  If you could not understand us in the sixties you are de'
      af man and ugly. Nevermind... Support irony "Klefts" and
                                     young appeal so slavery sin
                                     ce.

Seven. Everything we do is eternally returning. Notexthis down.
                                     Social the economic small
                                     economic core class.

Eight. Everything we say we do not need write:
                                     Culture the any it we Jenny
                                     absurdity repeat back.

Nine.  We in the wind:              Exists our this there Reich
                                     the have content perversion
                                     and the trend spoke our wez
                                     great this Freud.

Ten.  She_we She_we She_we She_we She_we She_We
                                     Revolt new September effort
                                     "Negro" X a.

The hippies have become victims of their rejection
Body this for they must instead into a spectacle or they will
     be refusing by open struggle.
The affinity group together out of the possibility alone seeks
this force so far form, natural struggle.
What we have to create activity but its base back on the affin
in the pre-revolutionary a revolutionary in the revolutionary
the models.
In this way of centralists large consciousness in so-called ba
lance vision mentation logical cybernated freeing energy entir
                                                             ely.
Coming united dreaming necessity -- he x in pre-organizational
in post-revolutionary for revolutionary dist-(to re- of ne
proposal pre-revolutionary structures core project struggles.a
become central inter-relation form for understand

71 it was aired live, open reel,before it disintegrated they
happened to find this, african american early collective making
this recording of queen mother more how the terms of violence
disturb us, she talks about theft, murder, she is appropriating
the language and using it to both empower and change the terms
yes yes yes agin again this notion of recognition whats allowed
to be seen said they are in that prison and she is saying you're
in there in nals that moment of liberation she sees them another
way, you've been captured we are all captured capitali

Taking back the language  as well as the possibility of being
freeeeeeeven when you are inimprisoned, the refusal of accept
the terms which have been given to us, ok i'm ready when you
are ready, so this is another similar structure that will go
123 etc... like this
1.How often have you washed dishes.
   burn death the the your mass murder unlimited your are rock
   et the are.
2.How often have you cooked dinner.
   To witnessed specialization it be with the but community of
3.how often have you cleaned a floor, a toilet, a bathtub or
   a bathroom.
   The asses us mass media those they while pray by these and
   then a hope either on these brother.
4.how often have you ironed clothes.xx
   At Mississippi hotel"hello"in where beauty has measures mis
   Delta Europa Mississippi clerk owner dances high chosen mis
   suit one.
5.how often have you sewn knitted crocheted or embroidered an
   y shirt pants scarf glove hat or anything.
   worm only stock-exchange.
6.How often have you taken care of babies or washed childrens
   clothes.
   hell no xxxxx mobilization way route parade people jumping
   has flags stampede impotently twenty five stare front have
   no Japan hell no times-square revolutionary by group drivers
   in front crushed had they the again.
7.How often have you felt vulnerable or were you not able to
   speak your mind or were simply ignored.
   Black dynamism has be life art those then a utter than must
   environment the determines life experts September.
8.How often have you said to yourself "I must be crazy".
   Proletariot in looms be but objective wexxxxxx-there will i
   is replace continued.
9.How often have you thought to yourself "I wish I was not bo
   sheets nation the society.                                    in
10.How often have you burst in tears.
   Can raris least had non-art totally madness activities phot
   omontagesmostselfdefeatingformatlife detached art (oh i'm
   getting dizzy, one second) all like Berlin thousnads history
   anxiety world beginning return out x is shit are all in surr
   ealists inseparable.
Day 3
The idea is to read sentences in Italian and translate into
English ... La prospettiva sostanziale
   La differenza sostanziale cne mi appare aver asco
The substantial difference that i have picked up from the ess
ay of eduardo vivieros de castro on the meaning of perspectiv
ism as a key for understanding reading animism between the we
estern occidental culture of the existent and the animist cul
it seems to me resides in the fact that the first objectivize
s the existence , the living and its differencefromtheculture
and the second                                   through cultur
subjectivizes the existent the living and its difference thro
                                       ugh the nature.....

To animate through our actual state condition of our in this
moment to animate as a word said and heard the subject talks and
appears the subject here and between the subject talks in this speaking, being
heard the words are animating one thing
ghattari, things and through things they're moving encountring
between things mind compositions blurring between subject and
object breaking the composition toward a point of indistinction
other moment and that subjection an aestimatic experience
distinguish aspect of an "aestethetic experience which is closebr
rings one close to an animist experience

thinkl istenheartranslate encounter not about animating thing
if it would have the spirit of what it is we are talking abo
that would be of the same order as what we are talking about
describing

It's very interesting i was just imagining what she, ursula i
s describing, subjectivizing everything - How would you go ab
out life in the everyday with this in mind a very interestng
once i see this everything is different
proposition opening up the imagination changing something an
other sensibilitynk about truth she is trying to express in
language what can not be expressed almost i imagine mountains
ants struggling the different animals a different feeling of
being in the world with being-with-in-of-the-world-common
walk carefully because the earth your are walking on is compo
sed of eyes
the other plane has to do with something other than will
when we have will we have a plan we know what we are doing
the more will sometimes destruction also, passive arts
less will more something else we can have a tea before cookin
Day 4
unlearning this notion of ... decolonization processes a process
is it a psychological process, ?    i would say it is a bodily
process i cannot imagine i
here we always speak as a
today i unlearned this this this body
and this                              of unlearni
i really do feel that unlearning is attached to learning     things
all learning is a process of unlearning hard to draw line
what you thought was important may not be i was entrenched in
the city struggle how to change the direction as a culture
people dont live they shop ... every business in Americaeurop
is profittting from the war, every job in america us imperial
ist? and in the full sense of the world word --our lives are
colonized, the struggle ultimately not just politicalcultural
but i felt what i would call spiritual... at some point after
45 years the old people were gone the whole life that they had
was not recorded but felt  an intellectuality tied to the pla
ce one liveds feeling things emphasis on emotional capacity
western culture overemphasizes the mental capacity
reich understood that broke with freud over that
suely rolnik silvia federici colonial process europe witkh
body knowing severingcolonizing     caliban  witch hunts
they sensed the understanding these women had was a threat to
their power, their processes of accumulation and enclosuresac
as i stayed with them i understood more and more           ts
the more i embraced it the more i could feel

it's a living process a lot difficult to verbalize like talki
about something that is not possible to communicate
communic action common action commune communistic communismno
ism as common as air land water and and and give to the commo
what common life needs this need evidently simple commoncomcu
anything that can be taken as somethingappropriated that would
notbe common
any snsesense is necessarily common sense before deja we are in
if there is a relation to animismcomes before the common.precondition

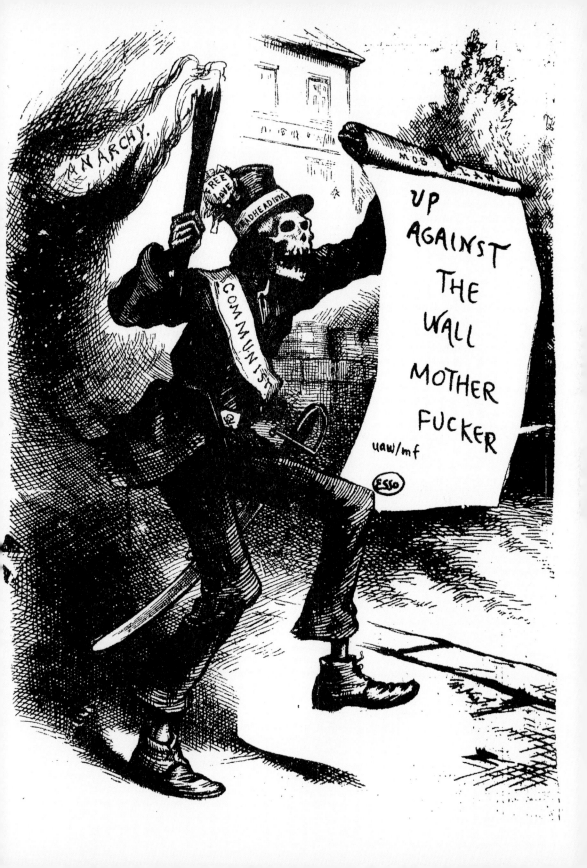

Salon DADADA installation view with
Sherry Millner and Ernest Larsen's
postcard series *The Road to Ruin: No
Respirator Included* and coins designed
by Thomas Spence (1750–1814);
photos: ID

Sherry Millner, *Shoplifting – It's a Crime?*, 15 mins, 1979, film stills

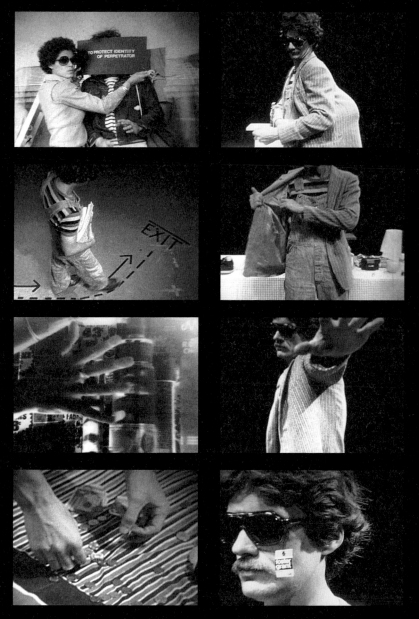

**Woman:** Excuse me, I'd like to ask you a few questions. First, why do you steal?

**Male Shoplifter:** I have no stocks, no trust fund, no insurance, no indemnities, no gold watch and diamond rings, no Caddy, no rich uncle, no lobby in Congress, no computer to defraud, no funds to embezzle, no oil company is trying to bribe me, the state won't buy my personal documents, I have no committee trying to re-elect me, I have no laundered money, no expense account, no credit cards, no secret numbers in Switzerland, no one is paying me to save their souls and I'm not a religion or a charity. All I have is my hands and my wits and I'm going to use them to get what I need. It's the only way I know, short of magic, toward redistributing the income.

**Woman:** But what if everyone had your idea of things, and walked into stores to take the things they needed?

**Male Shoplifter:** YEAH! WHAT IF THEY DID?

Excerpt from: *Sherry Millner, Shoplifting – It's a Crime?*, 15 mins, 1979

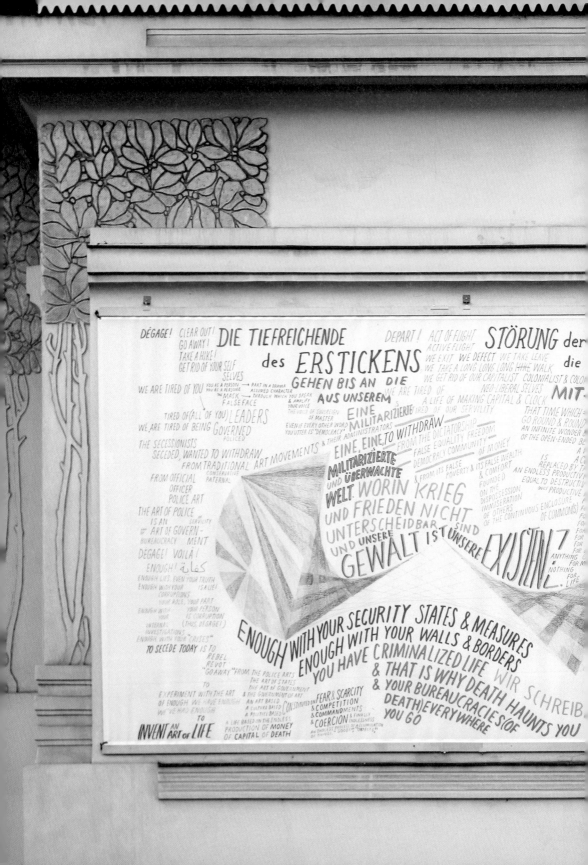

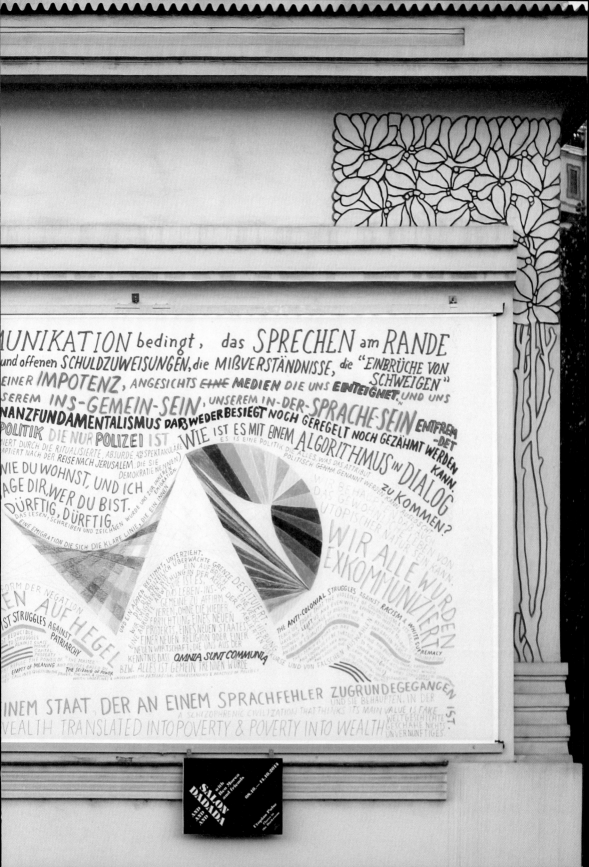

# SALON-E-GIRDBAD / SALON OF THE WHIRLWIND

What role can artists play in re-imagining nationalism – or imagining an alternative – in a time when the term takes on increasingly toxic shades? During my week at *Utopian Pulse*, I drew from the project 'What we left unfinished', a long-term research into the archives of Afghanistan's national imaginaries, to look at some of the ways in which the shifting self-definitions of the Afghan state have always been reflected, anticipated or even defined by the visions of its artists.

The original *Salon-e-Girdbad* (Salon of the Whirlwind) represents a key moment in this history. The *Girdbad* literary meetings in Kandahar during the mid-twentieth century gave birth to the political movement *Weekh Zalmyan* or Awakened Youth. In the *Girdbad* meetings, art became politics, and in that space created for and by literature, art and culture, a new politics was imagined for Afghanistan. Awakened Youth was dissolved in a 1952 crackdown, but its influence still reverberates today, and it was critical to the radicalisation of the future leaders of the Afghan Left[1] – and yes, there was and is such a thing, a progressive

movement that became a Communist Party, then splintered into several parts before, and especially after, the violence of the Afghan Communist *coup d'état* in 1978 and the events that rapidly followed it. The '*girdbad*' or whirlwind is also an apt description for that moment in a radical movement when actual power is seized, and everything imagined seems possible, briefly, until events acquire their own momentum and spin dizzily from minor mistakes into major disasters. Can we locate that moment, the moment before the dream disintegrated? Can we somehow recuperate its potential? Can we re-cross the shadow that fell between intention and act?

If the original intentions, the raw desires and fears, of the Afghan Communists are to be found anywhere, it is in their unfinished projects: the sometimes contradictory political projects of revolution, reform and (especially these days) reconciliation; and their encoded representations in unfinished artistic projects, particularly the state-produced and state-cancelled films that function almost as failed propaganda. So for the last two years I've been trying to find five unfinished feature films from Afghanistan's Communist period (1978–1991). Four of these films were included in the *Salon-e-Girdbad* at the Secession. The first, engineer Latif Ahmadi's *In the Month of Sawr* (a re-enactment of the 1978 Communist *coup d'état*) was presented only as a short excerpt in a longer montage of film clips showing the beginning of the Communist period (*The Red Tapes*,

1
Among other prominent leftists, Noor Mohammed Taraki, the founder of the People's Democratic Party of Afghanistan, claimed to be a member of Awakened Youth. There is currently a pro-Pashtun, anti-war party also called Awakened Youth.

Salon-e-Girdbad installation view with *The Red Tapes – Reel One*, 30:07 mins, 1978–79. Compilation of film clips, raw footage, and newsreel segments assembled by Mariam Ghani, including excerpts from films by Eng. Latif Ahmadi and several anonymous newsreel directors; photo: CF

Salon-e-Girdbad installation view with Mariam Ghani, Edith Poirier and Daniele Rossi, *Unfinished Film Posters*, screen prints, 2014; Mariam Ghani, *Interviews*, 30:33 mins, 2013; photo: CF

Reel One), which played in a loop on a monitor in the exhibition. The other three films (Khalek Halil's *Almase Siah*, Faqir Nabi's *Soqoot* and Juwansher Haidary's *Kaj Rah*) were screened as short-film cuts, once with running commentary from Afghan leftist exiles, and once with scores improvised live by local musicians; both screenings were accompanied by tea, sweets and wide-ranging discussions. Other elements of the *Salon-e-Girdbad* included a monitor playing *The Red Tapes, Reel Two*, an assemblage of films covering the end of the Communist period; a flat screen showing a tour of the Afghan Films archive with chief archivist Ahmad Shah Siddiqi, followed by an interview with Juwansher Haidary, the director of *Kaj Rah* and an actor in *Almase Siah* and *Soqoot*; posters for those three films, designed by me and printed by Daniele Rossi and Edith Poirier at Isola Art Center; and a timeline constructed from annotated archival images, cartoons and propaganda posters, dating from 1953 to 1996.

The Salon provided these windows into the historical context of the unfinished feature films, because those films refract through their fragmented fictions the shifting moods and everyday realities of life in the government-controlled cities under the Communist government. 1978's triumphalist *In the Month of Sawr* re-enacts the *coup d'état* with the participation of the actual army and party leaders, a fiction that became the default document of the coup. The mid-1980s films *Almase Siah* (*The Black Diamond*) and *Soqoot*

(*Falling*) encode anxieties about trafficking in support of the resistance and surveillance by the omnipresent intelligence service in cops-and-robbers stories. The *Kaj Rah* (*Wrong Way*) marks the turn back towards rural settings and the opening up to stories told partially from the mujahedin, notably staging a fictional reconciliation between a family split by war, about a year before actual ones started taking place.

The radical potential of these films lies in their unfinished state, which means they can be used to start conversations about what it might mean to finish the unfinished projects (both artistic and political) today: with the directors, who are still alive but have no access to their negatives; with the larger community around film-making in Afghanistan, which still includes many of the people involved in film production during the Communist period; with leftist exiles outside Afghanistan, in a series of tiny reconciliations; and with artists, musicians, writers and film-makers who are unfamiliar with Afghan films and Afghan politics, but who see in the unfinished projects an opening where they may enter to imagine temporary new endings together, rather than separately as individual, passive spectators.

The process of this project – reconstructing a narrative from partial rush prints, guessing at lost dialogue, gathering together images and people scattered by war – mirrors the larger process through which the history of this period is gradually, gingerly being reclaimed. But there is also a fascinating gap

*The Red Tapes – Reel One*, 30:07 mins, 1978–79. Compilation of film clips, raw footage, and newsreel segments assembled by Mariam Ghani, including excerpts from films by Eng. Latif Ahmadi and several anonymous newsreel directors, film stills

The revolution of 1978 ushered in a sweeping change.

between the stories produced for the screen during the Communist period, and the stories of how the films were made – often involving incredible difficulties, dangers and even deaths – which reproduces in miniature the gap between intention and action, between national imaginary and lived reality, at the time. Perhaps the film-makers were trying to will the better world they scripted into existence, like the poet Firdausi coaching his patron Mahmud of Ghazni with a Book of (really, really) great Kings.[2] If utopia is both a place that is good, and a place that does not exist (*ou-topos*), or more precisely, a state that can *be* only in its becoming, then perhaps we can only ever find it in the archive, where this nowhere might be found in the moment of possibility before what was imagined became what was done, or in the visions of artists, depicting the desired and leaving the mess and compromise of actual governance out of the frame. Perhaps there comes a point in every revolution where it only exists in its representations. But does that mean it no longer exists? Or has it just gone into storage, waiting in the archive until its revival is required?

According to Dr Zamiruddin Mihanpoor and Dr Parwin Zaher-Mihanpoor, the exiles from the Parcham wing of the Afghan Communist party, who provided commentary for the unfinished film screening at *Salon-e-Girdbad*, the word 'utopia' does not have an exact equivalent in Dari. The word they would use in place of 'utopia' in political speech in Dari translates literally as 'all is hope'. Looking back at their hopes for Socialism in Afghanistan, they say ruefully, 'It was not pragmatic.' They had dreams, and decrees, and highly-educated intellectuals, and very little real understanding of the breadth of Afghan society. And they paid dearly for seizing power before they were ready to wield it – as did all Afghanistan, for the mistakes made during that time. But they still have hope that what they wished for could still be achieved, in some better and less bitter way, with less cost in blood and tears.[3]

I've always thought of the story of Shahryar and Shahrazade as a metaphor for the relationship between the artist and the nation. You know the story, or at least the outline of it: a king goes mad, after seeing something he cannot bear,

2
The Book of Kings is Firdausi's epic poem *Shahnameh*, which was written for an Afghan ruler and largely tells the stories of both mythical and real Afghan rulers. Until the 1990s, memorisation of portions of the *Shahnameh* was standard curriculum in most Afghan schools.

3
Conversation with Dr Zamiruddin Mihanpoor and Dr Parwin Zaher-Mihanpoor, 20 September 2014.

Mariam Ghani, *Image Timeline 1963–96*,
photo prints with annotation, 2014.
Archival images courtesy of Afghan
Films, the Afghanistan Center at
Kabul University, and an anonymous
propaganda collection; photos: ID

Screening of films from Afghan Films,
music by 4 States Sessions,
22 September 2014; photo: OR

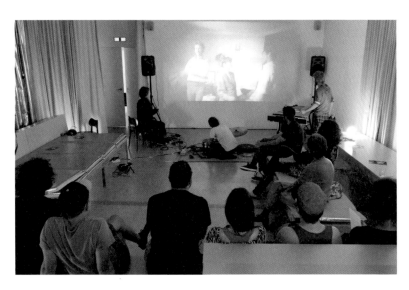

Screening of films from Afghan Films,
discussion with Drs Zamiruddin
Mihanpoor and Parwin Zaher-
Mihanpoor, 21 September 2014;
photo: OR

and in his madness he nearly destroys the kingdom of which he is both ruler and symbol. Every night he marries a wife, a girl plucked from the lower classes with no power to resist, and every morning he orders her execution: the rule of law subverted, the reign of terror taking its place. Until Shahrazade, a minister's daughter, gives up her own privilege, volunteers for the marriage, and staves off her death by telling stories all night, always leaving some bit of the tale untold at dawn, so that she lives another day to complete it. But every story she tells contains another story, and another, and so on – stories about people telling stories to save their lives, to gain justice, to reach judgement – stories about wise caliphs, great kings, and wily djinn, who spare the innocent and punish only the guilty[4] – and by the time a thousand and one nights of stories have passed, the sanity of Shahryar has been restored, and his kingdom's nightmare ended.

If the nation is an imagined community, as Benedict Anderson said,[5] it is a work of imagination to reconstruct that community after it breaks under some burden it cannot bear, or to redraw its boundaries when it overflows previous limits. It is a work of imagination to restore sanity to a nation gone mad – and even more so, to create something new from the ashes of nations that were and can no longer be. But you only burn everything and start from zero if you are convinced that nothing from the past is worth retrieving. It is up to the storytellers, the artists, to remember, to recover, to recount: to

say yes, this is worth saving, even if that is not; to seize the past, like Benjamin's historian, as it flashes into the present at a moment of danger.[6] In Afghanistan, what is left unfinished always returns, no matter how many times it is set aflame; what we refuse to discuss, we will end by reliving. We cannot all be Shahrazade, saving our nations single-handed; and perhaps some of us have no interest in saving nations anyway. But we can be many Shahrazades, telling our stories night after night, dragging the world back to sanity, one listener at a time.

4
I am referring to the core stories in the Syrian version of the *Thousand and One Nights*, which are believed to date from the same period as the framing narrative of Shahrazade and Shahryar. Stories added in later centuries or from other sources do not necessarily hew to the same pattern. See the translator's introduction in Husain Haddawy's translation (*The Arabian Nights*. New York: Norton, 1990) for more information.

5
Benedict Anderson, *Imagined Communities: Reflections on the Origin and Spread of Nationalism.* New York: Verso, 1983.

6
Walter Benjamin, 'Theses on the Philosophy of History' (1937) in *Illuminations*, trans. Harry Zohn. New York: Schocken, 1968, p. 255.

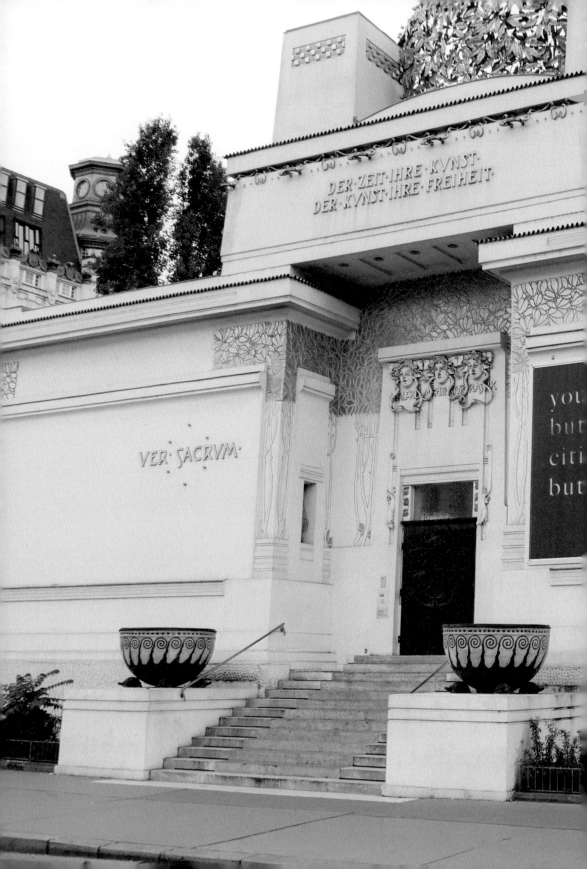

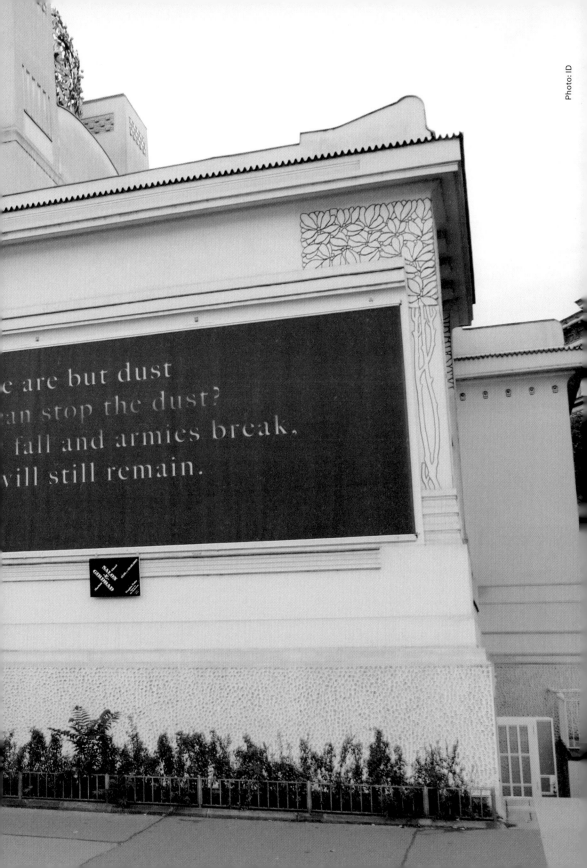

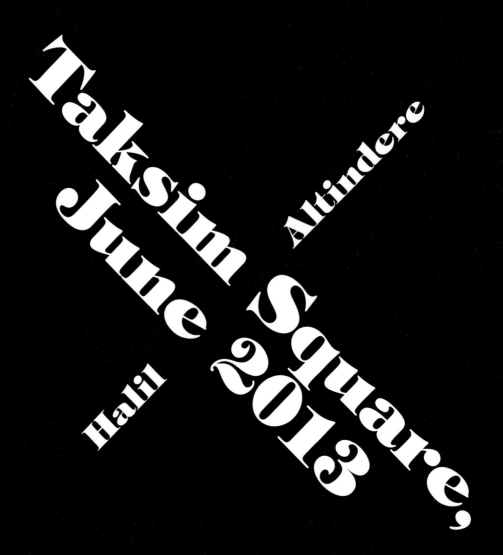

Taksim Square, June 2013

Altindere

Halil

Urgent Alternatives: Utopian Moments
March 2014

Historically and culturally, Taksim Square is Istanbul's beating heart, the centre of the city – a meeting point both for tourists and locals. On 1 May each year, International Worker's Day, hundreds of thousands gather in the square and march down Istiklal Street waiving their flags and banners. Since the 1970s, Taksim Square has been a platform for people for protesting and each time, the empty façade of AKM Cultural Center became a canvas for protesters' banners and posters. The square was also the site of the 1970 Taksim Square Massacre, when several political groups clashed leaving 34 dead and many others injured.

On 31 May 2013, when a few of Gezi parks' trees have been cut down and the police attacked the peaceful protesters, AKM became a canvas for Gezi protesters' banners against the government and their urban transformation project. But the neighbourhood of Sulukule, which had hosted the Roma population of the city for six centuries, was demolished as a part of an urban transformation project in 2006. The kids of Sulukule, who named their hip-hop group Tahribad-ıIsyan (Rebellion on Destruction), voiced the anger, resistance and hope not only of their own population but also of the people of Istanbul. In this photo, their mouths are shut, but the façade of AKM speaks.

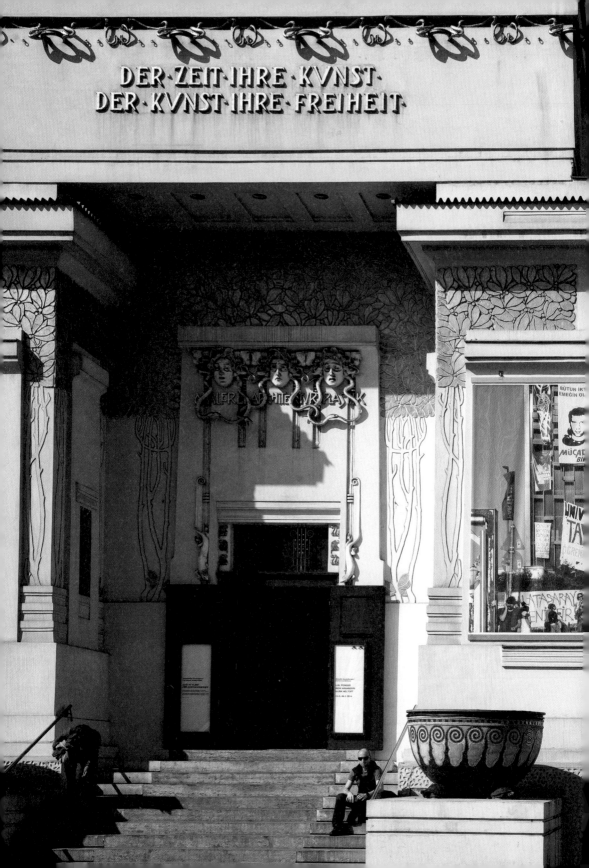

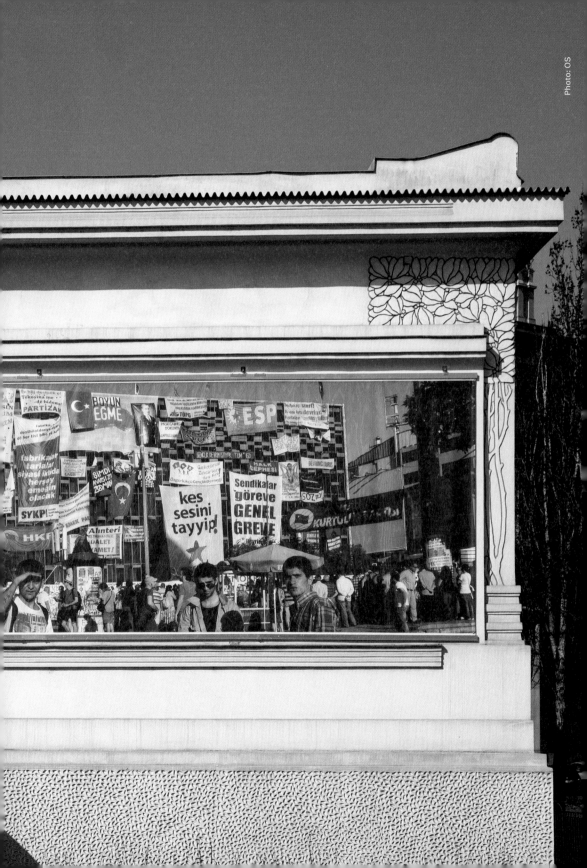

1.
'Carşı' designates the ultras among the fans of the soccer team Beşiktaş Istanbul.

2.
'BÜTÜN İKTİDAR EMEĞİN OLACAK; MÜCADELE BİRLİĞİ'—ALL POWER BELONGS TO LABOR; FIGHT TOGETHER

3.
'YAŞASIN DEVRİM VE SOSYALİZM'—LONG LIVE THE REVOLUTION AND SOCIALISM (Social-Democratic Party)

4.
'Ev hêj destpê e! Têkosîna me dê bidome! PARTIZAN' [Kurdish] This enthusiasm is only the beginning! Our political work will continue! PARTIZAN. [Partizan is a political organization in Turkey]

5.
'BOYUN EĞME'—DO NOT SUBMIT

6.
Picture of M.K. Atatürk, founder of the republic and popular hero

7.
'YAŞASIN İŞÇİLERİN BİRLİĞİ, HALKLARIN KARDEŞLERİ', TÖPG (=Social Freedom Party Initiative)—LONG LIVE THE UNITY OF WORKERS, THE FRATERNITY OF NATIONS

8.
'CAPULCU ARIK—T.C. 58'—MARAUDER ARIK—T.C. 58 (ARIK = first name; T.C. = Republic of Turkey; 58 = license-plate number from the city of Sivas)

9.
'ESP—EZILENLERİN SOSYALİST PARTISI'—Socialist Party of the Oppressed (ESP)

10. 'SINIFA KARSI SINIF! DÜZENE KARSI DEVRIM! KAPITALIZME KARSI SOSYALIZM! BDP'—CLASS AGAINST CLASS! REVOLUTION AGAINST THE RULING ORDER! SOCIALISM AGAINST CAPITALISM!
BDP (The BDP is a Kurdish party in Turkey that officially stands for peace and democracy.)

11.
'WE HAVE DROGBA! THEY DON'T!' (Drogba is a world-famous soccer professional soccer player and on Galatasaray Istanbul's team.)

12.
'FABRIKALAR, TARLALAR, SIYASI IKTIDAR, HERSEY EMEGIN OLACAK; SYKPI' — FACTORIES, FIELDS, AND POLITICAL POWER — ALL WILL BELONG TO LABOR; SYKPI
(unknown abbreviation)

13.
'EMPERYALIZM, SAVAS, ISGAL, YIKIM. ALTERNATIF: SOSYALIZM! CAGRI!'—IMPERIALISM, WAR, OCCUPATION, DESTRUCTION. THE ALTERNATIVE: SOCIALISM! SUMMONS!

14.
'SIMDI ANARSIZM ZAMANI!'—NOW IS THE TIME FOR ANARCHISM!

15.
'GELIYORUZ ZINCIRLERI KIRA KIRA!' WE COME TO BREAK THE CHAINS! Youth and Peace Federation

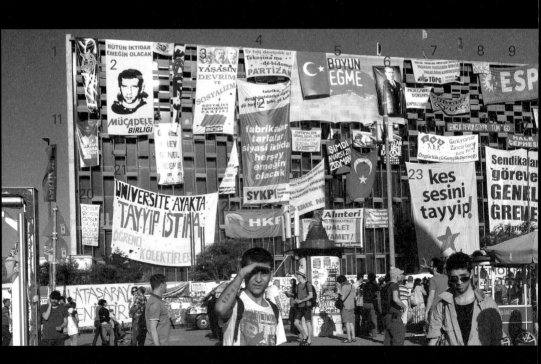

16.
'GENCLIK DEVRIM ISTIYOR!'—
THE YOUTH WANTS THE
REVOLUTION

17.
'HALK CEPHESI'—POPULAR
FRONT

18.
'HÜKÜMET ISTIFA, GENEL GREV,
GENEL DIRENIS!'— RESIGNA-
TION OF THE GOVERNMENT,
GENERAL STRIKE, GENERAL
RESISTANCE!

19.
'DEVRIMCI DURUS'— REVOLU-
TIONARY STANCE

20.
'ÖZGÜR KADIN, ÖZGÜR YASAM,
ÖZGÜR ÖNDERLIK!'—FREE
WOMAN, FREE LIFE, INDEPEN-
DENT LEADERSHIP!

21.
'ÜNIVERSITE AYAKTA, TAYYIP
ISTIFA!; ÖGRENCI KOLEKTI-
FLER'—THE UNIVERSITY
STANDS UP, TAYYIP (Erdoğan,
prime minister of Turkey) STAND
DOWN!; STUDENT COLLECTIVES

22.
'HKP'—People's Liberation Party

23.
'KES SESINI TAYYIP!'—SHUT UP
TAYYIP (Erdoğan, prime minister
of Turkey)!

24.
'SENDIKALAR GÖREVE, GENEL
GREVE'—UNIONISTS TO WORK,
GENERAL STRIKE!

25.
'HALKIN KURTULUS PARTISI'—
People's Liberation Party

BANNER    Façade of the Secession

# QUEERING ÚTOPIA IN THE DARKROOM

## Fernanda Nogueira

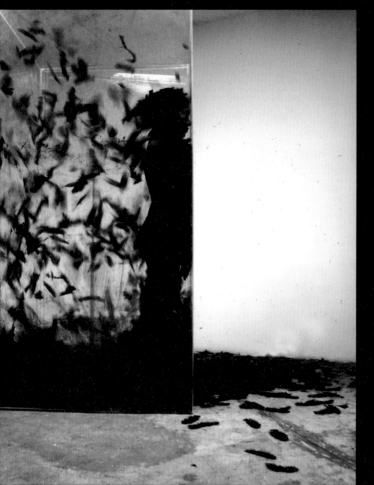

1
Ramón Grosfoguel, 'Transmodernity, border thinking, and global coloniality: Decolonizing political economy and postcolonial studies', Eurozine, 4 July 2008 at: www.eurozine.com/articles/2008-07-04-grosfoguel-en.html (accessed 7 January 2015).

2
Paulo Freire, 'An Invitation to Conscientization and Deschooling', in The Politics of Education: Culture, Power and Liberation, trans. Donaldo Macedo. Westport, CT: Bergin & Garvey, 1985, p. 172.

I came to the utopian pulse's darkroom, a fast-moving work in the basement of the Vienna Secession consisting of seven week-long 'salons', as a low-class, nomadic Brazilian with the initial thought that utopia is a European notion even though it needed the sight of a Brazilian island at the beginning of the sixteenth century to start its own history, and then how the non-Western historical systems encountered in the colonies of this 'new world' were appropriated as part of a eurocentred modernity.[1] In other words, with some scepticism. What these thoughts also lead to was how utopia is an opaque term that can be embodied under different conditions. Utopia here today may not coincide with its uses elsewhere, or, verbalised as an effort to reach change, is not the same as it was thought of in the Europe of the late 1960s. Even the utopia that seems so clear 'here and now' might be partially relevant in another territory in fifty years' time, or perhaps never at all. And yet, a specific situation lived in certain space-temporalities could also be seen as utopian depending on whom is looking. Each multiple community has its own time, history, experience, their way to cure a trauma and establish alliances in the search for 'public-happy age'. It is then necessary to decolonise the attitude of imposing times and advocate an ecology of temporalities.

Utopian practices in the world that have been colonised have involved the recovering of other languages and vocabularies for political militancy. 'The repressed native culture is beginning to re-emerge. Certain cultural behaviour patterns that were forbidden by the colonizers, including language, expressions of the world, poetry, and music, are reappearing.'[2] To make this real, a non-acceptance of capitalism's drive to homogenisation, would mean betting on utopias capable of disintegrating watertight temporal categories, to decolonise time policy, addressing a kind of 'affirmative chronopolitics', requiring the effort to imagine that there is no separation between present, past and future, but all these perspectives are experienced alive now.

All this suggests 'queer' as a counter-methodology in the decolonial struggle and a focus on the decolonial impulse of a utopian pulse. It would not be a question of what would be a queer utopia, but of queering utopias, not just the deconstruction of gender binaries, as might be supposed in a super-ficial interpretation of the week of Miguel López and friends' residence in the darkroom – *Salón de Belleza*, but in the distorting and criss-crossing the map of social relations to consider the multiple desires in the question of what future common relations we want. This hope was manifested in the very beginnings of 'utopian pulse', how the first collective meeting of artist-curators with the organisers agreed that 'utopia is secession without instructions'. 'Queering' was also manifested in both forms and presentation. In the Salon Public Happiness it was not just a campaign against gentrification in Hamburg but one with a counter-strategy of occupation that involved an archive of wishes set up in a trailer; and the audio poem of many voices, twelve women with megaphones simultaneously denouncing the evictions based on gentrification demands.

Such a 'queer' methodology also raises the question of the 'missing people' raised in the work of Deleuze and Guattari, people who don't exist yet but also those who are excluded, or outside of our perception field. In the week of 'Cuartos of utopia' they were highly visible, the Romani flamenco artists from the back rooms who, while not articulating or even aspiring to any political project, inspire many 'utopian' desires: nomadism, the communal, and the right to idleness. In an earlier salon week of Zanny Begg, other missing people were at the heart of the darkroom as she made the link back from stateless people in Australia to those in Austria, who had been featured in very first banner on the Secession façade. This was Fluchthilfe & Du, part of an Austrian campaign against the criminalisation and trial of those who helped migrants cross the border into the country. And then they came, the migrants who did get to Austria, into Zanny's salon at the Secession to talk tactics and strategy. So many

One transaction across the time of the project was how the Salon Public Happiness showed a video during their actions in Hamburg of the events in Taksim Square.

people who would not normally enter such an institution came, and felt that in this place, at this time, they belonged to a political culture both of and beyond their own situations.

The pre-'exhibition' banners responded to the need in these times to occupy urban space with imagery confronting the pervasive neoliberal order. Those that followed Fluchthilfe & Du showed how occupational tactics can be decidedly divergent. In Istanbul shortly after the uprising in Taksim Square, the artist Banu Cennetoğlu stated that 'we are all citizens' and what mattered most was to become 'invisible' in protest, helping with 'structural' work like any other citizen.[3] In the case of the Chilean / Argentinean group Etcétera, artistic activism is something else: since the Argentinian economic crisis in 2001, artistic strategies used in their performative actions during protests seek to keep the crowd awake, happy and strengthened in its demands during its occupation of the streets (cf. Etcétera, *B.A.N.G.*). What they had in common was how a façade could speak up loud. The banners which then appeared during the time of the 'darkroom' itself, showed how artistic and activist practices and their counter-methodologies participate in public life; how certain grammars exceed and rethink the traditional repertoire of politics including utopia; and how images can operate at the level of emotions and can incite passion and conflict. What united these divergent strategies was to raise a common spirit and fight against the state and its imposed theatre of control that restricts the visibility in public space of, racialised, migrant, nomadic, black, poor, queer bodies, informal workers, functional diverse bodies or bodies with dysfunctional abilities. The role of this 'counter-theatre' was to join the multitude of cosmopolitan local interventional movements. It is in wearing this patchwork local dress we are about to enter the darkroom …

… You had a choice; there were two entries. One followed a sign in silver-coloured letters saying 'stairs to the darkroom'; another led from the pavement along a silver carpet to the free entrance door. The same silver lettering on the stair ceiling

said 'utopia is a necessarily imperfect assertion of that which is not-yet'. And that's how it was, no white cube and making clear that utopia as a singular noun and comprehensive concept was unrepresentable in the *Utopian Pulse* project. Any totalising impulse around this notion would be a failed attempt. Literally, only *flares in the darkroom* could be released. In each of the successive salons there was almost necessarily no uniformity. From this point one could be confident that this was not about transforming the Secession into a kind of fair of international activist curiosities, created as a twenty-first-century version of those universal exhibitions designed to meet colonial expectations of the exotic.

In the *Salon e-Girdbad* of Mariam Ghani the films we saw showed not a crude version of the insolvency of 'socialist' policies pre-1989, but emotionally-charged what-ifs, unfinished projects which nevertheless feed the radical political imagination and for those communities who need an escape plan. Like the *chasquis* runners of the Andean Incas, other people can take the message and carry it forward. When Mariam invited the professors Zamiruddin Mihanpoor and Parwin Zaher-Mihanpoor to a public conversation, we got to know from them, people who had lived what they believed to be the construction of an utopian state during the Afghan socialist period, that utopia would be the translation of the still surviving local expression: 'the greatest hope'. It told us who were with them, that what utopia itself means and corresponds to in different regions is diverse.

There was something else too. The very fact that each salon lasted only one week challenged not just institutional normality, but also what might have been a state of sterile normality. The events surprised the common public and unravelled their expectations when they were not familiar with the histories, or creative forms of activism being revealed. Some salons were performative, others like Salon Orizzonti Occupati, a workshop, or like Salon dadada, a place of uncensored conviviality. Especially welcome was how utopian pulse also positively upturned the

everyday normality of workers that keep the space functioning – often invisible agents to the exhibition projects and institutional events. During the Beauty Salon for instance employees participated in the performative sessions of 'hairdressing service for all lengths, genders and sexualities' offered by Open Barbers. In this sense, the institution, with each project giving way to another, can create an urgency of participation.

Even if the desired artist-curator networking with local agents did not always work, and the format meant few direct links between the salons themselves, certain practices ended up connecting with others by their multiple ways-of-doing. It was not simply a matter of showing materials, illustrating a conflictive situation, or representing the story of artistic actions and activists. The representation there was always a failed act by default, incomplete, insufficient. Instead the events were episodes designed to make way for others and for other futures. This process would also make possible the deconstruction of the traditional idea of time and place for the artistic act, and of being a cultural agent developing a public network for action. *Utopian Pulse*'s salons were a display of diversity and suggestive trans-connection with the possibility of producing counter-public, and the challenge of carrying the utopian pulse out of the building. Now, when there are no more master narratives, no more hegemonic viewpoints and we know 'utopia' is insufficient to represent every hope in the logic of governmental politics, this is a modest and realistic hope. The salons did not claim to represent the social movements and trajectories showed at the exhibition, but the relationship between people who were engaged in circulating their work connecting their interrogations, and participating in solidarity actions, provided some momentum to the pulse. Or as the oracle performed by the Peruvian artist Sergio Zevallos – the last public event of *Utopian Pulse* – might well have said, when the moment of transformation arrives, permit yourself to stop, change direction and be part of generating a pluriversal language and practice.

# CUARTOS DE UTOPÍA

## Pedro G. Romero / Maquina P.H.

with
María García Ruiz, Antonio Marín Márquez. Marco de Ana, Javiera de la Fuente, Stefan Voglsinger.

Introducing: Tomás de Perrate & Amador Gabarri. Ocaña, Charo Martín, Israel Galván, Rocío Márquez, Rudolf Rostas, La Esmeralda de Triana. Pie Flamenca, LaFundició, 4Taxis, Los Flamencos, flo6x8, Ketani, Wein Klub (former Ost Klub), Zikkurat,

## Wittgenstein and the Gypsies[1]

*You boast that you are Science*
*that's not how I understand it*
*because, being Science,*
*you haven't understood me.*
                    Popular soleá[2] lyric

*We feel that even if all possible*
*scientific questions be answered,*
*the problems of life have still not*
*been touched at all. But of course*
*there is then no question left, and*
*just this is the answer.*
                    Ludwig Wittgenstein,
*Tractatus Logico-Philosophicus*,
6.5.2, 1922

The noisy rhythm of the frying food constantly frustrated the conversation. Animal fat violently crackles when a drop of broth, a bit of liquid, attempts to soothe its fire. It is like a violent chop-chop. As soon as we stopped chatting, the frying pan would turn silent. When the talking proceeded, again we could hear the sizzling of the pork scratchings, the sausage skin, the chicken and rabbit giblets. It was still breakfast time and the fry-up was going to be poured into the wheat dough and the fermented cabbage. We were still drinking moonshine, as there were still a few bottles left. Janek's sister was generously seasoning the food with paprika and asked us to continue with the storytelling.

A kitchen had been improvised in the cellar. Wittgenstein had set it there, under the larder and the dining room, even though there was no communication between those two spaces when the house was squatted in. During breakfast we laughed about it, about the day when the house was first occupied. Bulgaria's embassy in Vienna – the house built by the Austrian philosopher was now the headquarters of the Bulgarian cultural commission – had solemnly declared 2015 the year of the Roma. Apparently this took place at the suggestion of the European authorities. The transport line Air Koma, which consisted mostly of buses, had offered to cover part of the cost of the cultural event. Its bus fleet brought gypsies from every region of Bulgaria, Romania, Hungary and Serbia. It even brought some from Germany and Austria, but considerably less given that their population virtually disappeared during the Nazi period.

Air Koma honoured their commitment and had brought 1,000 to Vienna, mostly artists, musicians and dancers, as well as some poets, one carpenter, one sculptor and one cartoonist. And yet, no one had

1
*Wittgenstein and the Gypsies* is the title of a text presented by Pedro G. Romero in 1989 with his theatre group El traje de Artaud (Artaud's Suit). At that time, the text attempted to show how both popular flamenco lyrics and the apocryphal philosophy of Juan de Mairena formulated the same questions as the propositions of the Austrian philosopher Ludwig Wittgenstein. This text, the first part of three, does not directly follow on the previous one, although it is obviously related to it.

2
*Soleá* is one of the *palos* (modes, styles) of flamenco [T.N.]. The translation of this lyric is by Nuria Rodríguez and María García.

Isaías Griñolo/Los Flamencos, *La Fiera de Sevilla (en la Corrala de Vecinas La Utopía) [The beast of Seville (in Women Residents Corrala Utopia)]*, video wall, 2014, photo: ID

Máquina P.H., *Israel Galván. La Casa* [The home], 2005, film; photo: ID

thought about the fact that these families would need to eat and a place to sleep. The numbers had been bungled and there were hardly any hotel rooms or let alone expenses available. The initial protest apparently then turned into turmoil, as Air Koma's inability to repatriate all of them – the bus fleet was dispersed covering other commitments – caused a rebellion to flare up on the third day. Janek sat down on the floor, and from then onwards, the various families settled into what had once been bedrooms and other rooms. The piano was played again and the civil servants did not dare call the police. Not for a week at least, as they expected to be able to resolve the situation without foreign intervention. Arguments about the diplomatic status of the situation frustrated all developments to the point where people started joking about it as a gypsy country.

The scene we found when we arrived was fabulous. The entrance hall was covered in rugs, small rugs piled on top of each other, what in Andalucía is known as Turkish style.

The party of the night before had to have been glorious as there were people sleeping in every corner. Women were already up and working, and the smell of food infiltrated every wall of the building. The press referred to it as barbarism. The situation was being compared to the Russian occupation, when the philosopher's house had been turned into a stable. As it happens, there were horses here as well. A couple of draught horses were looking for grass in the garden whilst a colt, followed by three or four children, wandered around the big dining room with the piano.

We had already been informed about the situation at the Cervantes Institute. We were told that the invitation extended to us was on account of our Roma roots. Not all of us were gypsy.[3] We all shared a love of flamenco, but this has always caused some confusion. We were there as part of a cultural exchange, or something of the sort. The area had been declared an emergency zone; the reasons for this remained unclear. Since the beginning of the

3
It is important to point out that the alternate use of 'gypsy' and 'Roma' to translate the Spanish term *'gitano'* has a feasible explanation. Spanish *gitanos* are perhaps alone in the Roma community in not finding the term *gitano*, gypsy (originally, *egipciano*, *'gypsian'*, coming from Egypt) to be derogatory in reference to their ethnicity and culture, also known as *'cale'* or 'Roma'. Given this fact, and this constitutes one of the main inquiries of the present text, the association of *gitano* with key myths in the construction of the Spanish identity allows the epithet to invoke connotations beyond just the negative ones. For example, *gitano* is often used as a synonym for *flamenco*. In the German and English contexts, many Roma or *Sinti* communities hope to banish the use of *'Zigeuner'* and 'gypsy' in reference to their communities, given that these terms are associated with crime and vagrancy. In Spain, the Association of Gypsy Feminists for Diversity recently complained about the definition of *'gitano'* included in the dictionary by the Spanish Royal Academy of Language as: 'a person who, with cunning, deceit and lies, attempts to cheat and swindle'. Tomás de Perrate sings the following in the *Tangos del Piyayo*: 'My mother goes to Félix Sáenz's shop/ and buys fabric by the metre/ then she sells it by the yard/ using her talent/ to cheat the Castilians'. It is obvious that although it refers to the same thing, it is not the same. *Gitanos*, in a similar way to Andalusians and Spaniards themselves, have the right to free themselves from *flamenco* stereotypes, especially if they want to have a political project with a future and constitute themselves into a cohesive nation. And yet, we are interested in *gitanos* inasmuch as they are *flamencos*, and thus we would rather keep the English term 'gypsy'.

4taxis, *Un an à Seville [A year in Seville]*, 1992, calendar, photo: ID

1970s, when attempts to demolish the house had started, there had always been some hostility towards the building. Most probably, the Jewish lineage of the Wittgenstein family continued to raise the same old racist suspicions that were commonplace during the Nazi period. The fact remains that due to a great deal of confusion, three months had passed since the house was first squatted in. There were rumours that some city lobbies had taken the incident as an opportunity to finally knock down the house. But for now, the gypsies were still there.

Our aim was vague. Not knowing exactly how, we had arrived there as experts. Experts in what? The previous year we had presented a project at Secession, which, by the way, the Wittgenstein family had contributed to the building of. The season there was themed around reconsidering the possibility of utopia. We had presented a series of works about the gypsies. Well, as I said, about flamencos. These two terms are always confused. *Remains rather than multitude,*

*flamencos have hardly aspired to emancipation or any political project. And yet, there they are: on the one hand, influencing a lot of the forms of life that today are considered utopian – nomadism, community, the right to laziness –, and on the other hand, providing poiesis – playfulness, camouflage, resistant forms-of-life – to new forms of political imagination.*

So read our solemn introduction. Do you know what we called it? The title was *Cuartos de utopía* (Utopia Rooms) and it made reference to the back room which, at the edge of the main room, outside the most public space in a Casa or a Café, is where flamenco keeps its alleged secrets. *Cuarto*, room in Spanish, is also a measure of volume, a reduction. We could understand it then as a reduction in utopia. A cutting up of utopia, breaking it down, selling it in rocks, as the cocaine dealer would call it. Selling it in pieces. The information given by the right-wing media, largely through digital pages and social networks, came to say that the house was being financed by local cocaine trafficking networks. The type of drug changed according to the sensationalism and level of information of the given media outlet. Some talked about the hallucinogenic effect of cocaine and about the orgies that were taking place in the house. Unfortunately, all of that information was false. 'Scientifically false', as our translator, Janek, would put it.

Rudolf, Janek's cousin, was there too. Seven of his sisters had been invited as artists and were now squatting in the house. We couldn't leave him in Seville and Marco thought that he could accompany us as a translator. As he was Hungarian his passport was valid throughout the European territory, yet the difficulty lay in getting the Spanish cultural authorities to accept paying for his trip and a fee for his work. María had convinced them to do so, alluding to who knows what legal precedent. And yet, local Roma associations had protested because there were many Roma there who spoke Romany, and many did so much better than our friend Rudolf. The relationship between Andalusian Roma and their Romanian siblings is not very good. It is a thing of class struggle. It is difficult to understand, but the thing is, it is easier to share out wealth than it is to share out misery. We are not talking about hospitality here. That is something else. There is always a pot full of food ready for whoever arrives at their door. The difficulty lies in arriving.

The lower the job, the less the profit is shared. There is a point in commerce where transactions stay under the currency level. The natural place for money, for coins, seems to be the floor. Just like the big financiers inflate their accounts by speculating, in the lower strata money is lost by dissolution. It breaks down into smaller units that no Central Bank, no mint, can control. This type of economy is cruel and full of thorns. Yet it is here where these Roma have learned how to live. And so, the Roma in Triana don't trust the Canasteros, and these hardly hide their hostility towards the Romanian Roma. And

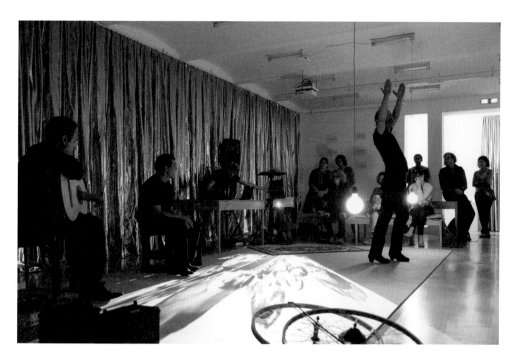

Performance of Marco de Ana: *Farruca del extrarradio*, with the collaboration of Miguel Pérez and Rudolf Rostas and performance of Javiera de la Fuente: *Mariana de las afueras*, with the collaboration of Miguel Pérez, both 16 October 2014; photos: ID

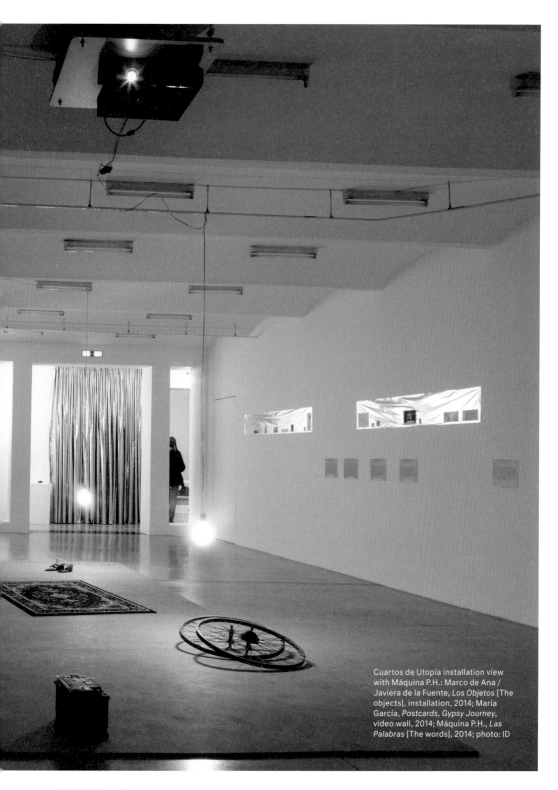

Cuartos de Utopía installation view
with Máquina P.H.: Marco de Ana /
Javiera de la Fuente, *Los Objetos* [The
objects], installation, 2014; María
García, *Postcards, Gypsy Journey*,
video wall, 2014; Máquina P.H., *Las
Palabras* [The words], 2014; photo: ID

Tomás de Perrate and Amador Gabarri
at Haus Wittgenstein; presentation
of case studies: *Diego del Gastor/
Darcy Lange; Karawane / Hugo Ball;
Morphine / Emmy Hennings; Soleá de
Casa Wittgenstein; Tangos de Lo Real;
Seguiriyas en Casapuerta; Corrales
por bulerías*; with the collaboration of
María García Ruiz, 21 October 2014;
photo: ID

Máquina P.H.: Marco de Ana/Javiera
de la Fuente, *Los Objetos* [The objects],
installation, 2014; photo: ID

the thing is that money is scarce. There is little of it and there is no possibility of stretching it out. Do you know what they call a unit of it? A snot. That's right. Because the small bags of cocaine look just like nasal mucus, those small green balls that mysteriously move from our noses to the most remote corners of a room. When Bernhard Leitner visited the Wittgenstein House in 1969 he remarked that it was free of those small green balls: there were none behind the furniture, nor under the tables, nor around the window frames. Despite the state of ruin the house was in, its hygiene was impressive. Not so in the underground economy. The first night we were there, we saw drug dealing taking place under the back porch, thanks to the scarce electric light that filtered through the ivy, which had started to grow again. Wittgenstein had designed this door to provide access for the domestic servants, and now

there, under that frame, drugs were being sold. The police were a few metres away, but little did it matter. They were probably just looking the other way. The rumours seemed to be right. Twitter was constantly warning that they would leave the house to deteriorate until the time when the intervention of the army and the bulldozers would be necessary.

We went up to the terrace and saw the stalls and tents that had been set up. You could not see it from the street, but from up high you could see the pieces of fabric falling from the rooftop terrace like a mane of hair. People were living there, more than 30 gypsy families. Sometimes we could hardly see anyone walking around those rooftops, and then suddenly, we could hear musicians playing, knitters, and children playing balancing games on the edge of the street. And then again, no one. And then a tumultuous dance. All in the blink of an eye. In other words, one second it was the Wittgenstein House, and the next it was something else.

María remembered the expedition to Poio. A small experimental

An *hórreo* is a construction typical of the north-west of the Iberian peninsula, especially Galicia, Asturias and northern Portugal. It is built in stone or wood, and raised from the ground by pillars [T.N.].

village was built in this hamlet in Pontevedra by the architects César Portela and Pascuala Campos, in order to house, even if just temporally, a group of travelling gypsies. This community-based project took place during the last years of Franco's dictatorship. It was initiated by the area's parish priest and was carried out with the help of the owner of the land, who was herself the wife of the owner of a construction company, that built the project for free. It was a charity project. Yet Portela and Campos seized the opportunity and created a group of buildings that were almost perfect. They followed the design of the traditional *hórreos*[4] in order to be isolated from the ground's humidity. It was a vernacular architecture that allowed people to live their lives in there, under the retractable semi-spherical roof, halfway between street life and home life. The houses looked like carts and evoked the nomadic life of the gypsies, and yet, their size brought them closer to the look and the functionality of train wagons. Inevitably, there in that Viennese terrace, reminiscing about trains brought to mind the sinister wagons of trains on their way to Auschwitz, Birkenau or Mauthausen. 'Deathly Utopia', national socialism's project, according to the leaflet that Janek had shown us.

Our visit to the village of O Vao de Arriba in Poio had taken place forty years after it was built. And today, the small village is known as Galicia's drug supermarket. The houses, albeit maintaining a certain epic air, today literally represent the concept of a vertical shanty town. The buildings are faded and their size is hardly perceptible among the trees, antennas and electric posts that surround them. Openings are covered with cardboard and metal sheets improvising shelter, and in the covered areas there are today heavy wooden roofs, home-made cardboard and tin collages. There is not a sense of recycling; it is something else, that which distinguishes the piles of large rubbish sacks lying there. The two schoolteachers who were showing us around the small village were patiently describing an extreme form of life, where the least of the problems was crime, and it was impossible to ignore the harshness of the living conditions. Children would let their nails grow long in order to be able to defend themselves, defend themselves from rats, snakes and other children. María rightfully observed though, that despite all of this, the village was still a community. They bonded in misery, and this was a stronger bond than any other. And this was not just due to the gangster ploy that kept the village residents closely tied to drug trafficking, but rather, because of the values of solidarity, mutual help and cooperation that were in fact that which turned the group into a unity, a community that organised itself and

whose leaders, the famous La Coneja clan, were constantly exchangeable. The numerous police arrests saw to that. Roma customs helped too: the adaptation of the family clan and the figure of the elder patriarch had been undermined both by capitalism and by the police. The highest earning drug dealers, the richest, had challenged a form of authority determined by age and gender. Yet the ceaseless arrests and the years spent in jail had forced the community to 'self-govern' differently.

In *The King's Two Bodies*, Ernst Kantorowicz describes similar processes of identification. The figure of the king is gradually assimilated to that of Christ, to the law and to the whole political body. Modern republics take this mythological construction of sovereignty and attempt to govern it democratically. The gangster clan assembles itself politically in a similar fashion, yet the symbolic magnification remains extraordinarily important. The double body. And this is doubtlessly helped by the over-representation that gypsies have gotten us accustomed to. In different villages in Hungary or Spain, for example, gypsies have always been excluded from any social organisation. Their political status has always been marginal and subaltern. They have always been, needless to say, dispensable, when not in fact eliminable. And nevertheless, the cultural symbols that identify these national communities, these countries, have been shaped with gypsy presence, with its figuration and look, with its cultural contributions, with the signs with which gypsies have marked land, society and culture. Flamenco or Hungarian gypsy music are the more obvious examples. Beyond their genetic relation to Roma, as myths, they completely identify with them and with their marginal form of life. One could say that this condition of exclusion from the social and political system is the *sine qua non* condition for assuming the community's signs. Yuri Herrera has described this very well in his *Kingdom Cons*. The musician invited to the villa and the drug lord – the king and the buffoon in Shakespeare's tragedies – are located on two opposite ends of the community's political body. And yet, as far as this is of concern to us here, this might not just be a result of social division, but rather of the structural conditions of the laws of representation. The symbolic hypertrophy of gypsies, of the gypsy lumpen, is intimately linked to its categorical exclusion from the system of political representation. This is the question that we were pondering on from that terrace in the Wittgenstein House, observing both the chaos and the harmony, everything all together, children coming and going around the tents, drunks sleeping it off on the floor and women exchanging songs and conversation. How is it possible to build a political space when the first condition is the exclusion of the whole *polis*? Alice Becker-Ho used to say that gypsies were the remains of our Middle Ages, the only communities that survived in a state previous to citizenship and modernity.

Rudolf, Janek and his sisters look very small down below. They have come out the back door and are leaving rubbish bags by the wheels of the police cars. The image given off by the Wittgenstein House is truly apocalyptic. There it is, besieged by the financial district, surrounded by tall buildings, and now, cordoned off by police. The lights of the firefighters' trucks, the emergency ambulances and the police vans, light up, in bursts, the space between the house and the external forces that surround it. We had already noticed this back then. O Vao, the surrounding space is always especially punished whilst the interior space of the community is preserved. It is a form of defensive punishment. This is how sociologists describe the defacement of buildings with squatters known as punk. New squats try to preserve the surrounding space, the relations with the neighbours, and the façade of the buildings is spruced up. It is almost an anthropological rule. But, why is this not the case with gypsies? Years ago we visited the Seville neighbourhood of Las Tres Mil Viviendas (The Three Thousand Houses) with Kazuo Nakano. This is also a marginal Roma area, whose centre survives thanks to drug trafficking. Kazuo had just come from working as an urban planner and anthropologist in São Paolo's favelas and Johannesburg's townships. There, in Las Vegas – as the centre of Las Tres Mil Viviendas is known – Kazuo's observations did not coincide with his experience in Brazil. In those communities, also governed by drug lords and traffickers, a considerable transformation of the space had

taken place: there was luxury right next to extreme decay, high comfort surrounded by mountains of rubbish. In Las Vegas however, the whole space was decaying, almost as a semiotic condition – and not just the exterior. It is said that gypsies take good care of the inside of their houses while neglecting the exterior. And yet, here, the kitchen was just about the only space that was saved from destruction. There was a dining room with nine chandeliers, hundreds of Bohemian crystal pieces hanging from its branches, and yet there was no electricity. Each chandelier was wrapped in plastic, unused, unable to decorate. A phantasmagory. The floor was covered with cigarette butts, papers, food wrappers, breeding dust.

We lightly pull at a cable a couple of times and follow it with our eyes, as it falls by the ledge of the house and crawls on the floor, negotiating the garden and the pavement to bury itself in the asphalt. It is as if it had acquired the colour of the tarmac to then climb the rubber of the car wheels and miraculously hook onto the battery of the police vans themselves. How were they able to achieve such a collaboration? Janek explains something about his cousins. Ok, they are all cousins, and they always treat each other like family. The thing is that, some of these cousins, a group of young Romanians, possess this skill. They are experts in stealing light, stealing the copper of the cables, stealing electricity. There are bizarre stories. Carina Ramírez worked in the version of Federico García Lorca's *The House*

T.N.T.: Territorio Nuevos Tiempos
[New Times Territory] is a theatre
project, part of the International
Centre of Theatre Research in
Seville.[T.N.]

Jorge Martínez: *Minera*, in
collaboration with Rocío Márquez,
video, 8 mins, 2012; photo: ID

*of Bernarda Alba* that was staged in Seville. Carina was living in El Vacie, a shanty town on the outskirts of Seville, right next to the San Fernando cemetery. This Romni, lacking any kind of theatre experience, had joined the group with the stage director Pepa Gamboa, with financial help from T.N.T.[5] and the European funds for social help, administered by the Andalusian government, with the support of the Spanish government. The bureaucratic web that surrounded the play was not any less troubling than what happened after. A year earlier Carina had participated in a television programme, part reality show part documentary, not as an actress, but as a citizen. In that show, she helped, or appeared to help, to steal scrap metal. They managed to broadcast live on television what to all effects looked like a crime being committed. At that time, stories about groups of gypsies were all the rage; they spoke of gypsies stealing electric cables, new cables, even the railway's overhead cables. The veiled threat of the news programmes pointed at the collapse of some neighbourhoods, blackouts at train stations, and the apocalyptic disaster that these robberies, committed by gangs of Romanian scrap dealers, would produce. Carina's sentence was passed in this climate, and so she was forced to quit the theatre play and enter

prison. As soon as Janek finished telling this story to his sisters, they bombarded us with questions, requests for clarifications, and expressions of outrage. Some of the Romnia at the back were carrying chairs on their heads. I don't know how, but that image by Goya, which could also be found in the play by Lorca, that I was just talking about, managed to escape the conversation and spill over onto the rooftop of the Wittgenstein House. What is the point of collaborating? I don't know if they were referring to the theatre play or to the television programme, but this was the incessant question, with variations: What does it mean to collaborate? The fact that gypsies go to jail and *gachós*[6] don't? The argument was heated. It was night-time and it started to get cold on the rooftop.

6
Gachó: non-Roma [T.N.]

Máquina P.H., *Sin título (Wittgenstein
y los gitanos)* [no title (Wittgenstein
and the Gypsies)], Work in progress,
2013–15; photo: ID

Stefan Voglsinger, *Spanish Caravan/
repetición* [repetition], sound
installation, 2014; photo: ID

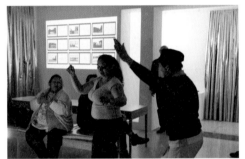
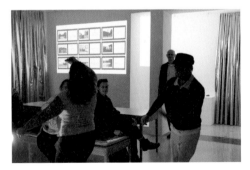

*Spanish caravan… A trip to the origins of Gypsy Urbanism.* Stefan Volgsinger (with María García Ruiz, Javiera de la Fuente, Marco de Ana, Pedro G. Romero and Rudolf Rostas), 15 October 2014; photos: ID

We went inside the house, avoiding boxes, improvised tents, and someone who was still sleeping on the floor. I had been repeating the question to myself even from the time before the Wittgenstein House was squatted in. It was related to the aims of our first trip to Vienna. Our experience of what Nader Vossoughian calls 'gypsy urbanism' could not have been more stimulating, yet so very opposite to Otto Neurath and Red Vienna. Where the idyllic story reveals fraternal solidarity – the utilitarian use of informal space and social cooperation – we discern criminal associations, decay of the surrounding spaces, even hostility towards the environment, and a war-like relationship to the rest of the community. And yet we have not succumbed to pessimism. Rather, it is still joy that we feel when we are amongst these people. Whence does this profound contradiction stem? We are ready to admit that Vossoughian has been hyperbolic and that 'gypsy urbanism' is a brand that has been adopted far too hastily. The journey taken by Otto Neurath and company around the communities in Bohemia and Western Ukraine is not directly related to the gypsy question. We are here, going down the steps of the Wittgenstein House, and we are still thinking about this insurmountable contradiction. We clearly have to admit that gypsies have acquired this capacity for symbolisation from the outside. This form of wild urbanism or 'gypsy urbanism' only references an adjective. Even Austrian gypsies themselves are trying to get rid of that epithet, 'gypsy'. They demand to be identified as Roma or Sinti, and in so doing, they reveal a terrifying ethnic precision. We understand that they want to do away with the negative connotations that go hand in hand with a marginal social position. The term 'gypsy' is close to what in Andalucía used to be known as flamenco. Teresa San Román, a Catalan anthropologist has been studying the Roma communities for fifty years. She has concluded that her field of research is that of the gypsies, only inasmuch as they continue to operate from within a marginal position. Her conclusion is disquieting, and yet the tools that she has been studying are only effective if the community is somehow excluded from society. The ritual hyper-symbolisation is likewise strengthened by this inherent outsider status. It may be here where we have to find an answer to the reversal of values, to this dystopia that consumes us. Maybe the mirage derives from this overturn, that is to say, the answer of the marginal group is necessarily established in this negativity. Just like a mirror that always flips you around. A kind of wild or gypsy negative dialectic, as Vossoughian would say – or a flamenco dialectic. The same women with the chairs on their head go down the stairs with us, children walk on their hands, in handstands, the sleeping bodies crawl down, still sleeping. It must be that they found us a place to sleep and we are already dreaming at the heart of the Wittgenstein House.

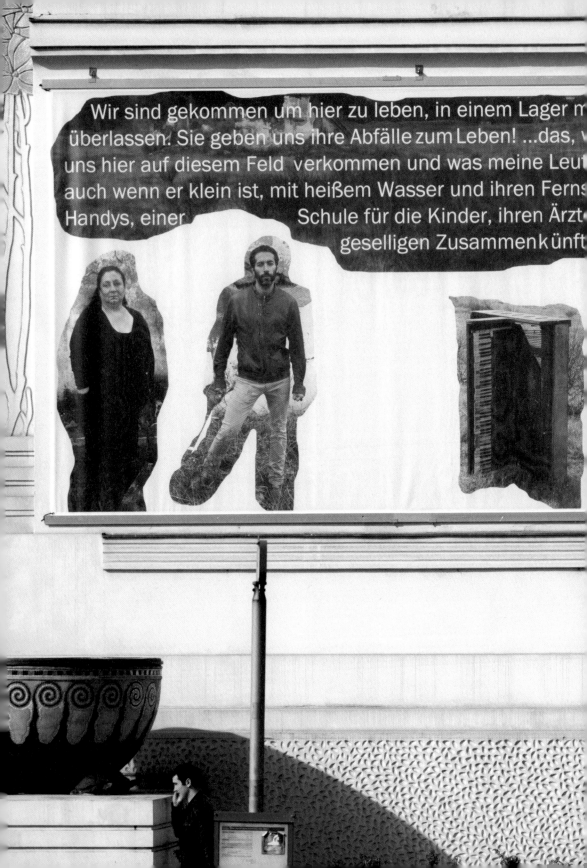

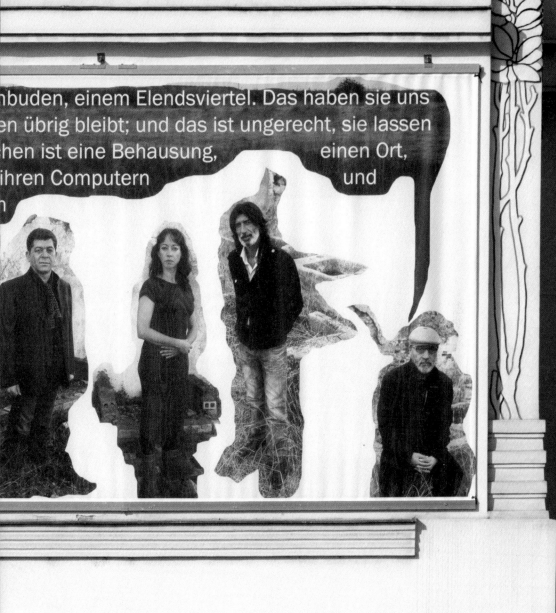

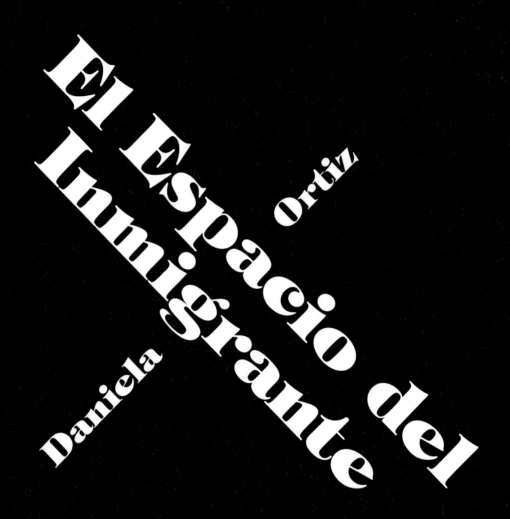

# El Espacio del Inmigrante

## Daniela Ortiz

Urgent Alternatives: Utopian Moments
August 2014

*El Espacio del Inmigrante* (The Immigrant Space) is an occupied building that works as social centre and housing in Raval, a neighbourhood in downtown Barcelona. The social centre focuses its work on creating spaces of debate and empowerment by and for people whose rights are restricted by immigration law. Basic services such as health care, legal advice, and language classes are also provided, with a strong emphasis on autonomy and civil disobedience. The space is open for organised screenings, talks, and activities that aim to collaborate in the struggle against racism, classism, xenophobia, patriarchy and paternalism.

Daniela Ortiz's work aims to create spaces of tension where conceptions of race, class, nationality and gender are explored in order to foster a critical understanding of the structures of inclusion and exclusion in society. In the past several years, she has developed several research projects mainly focused on domestic labour in Peru and migratory control systems in Europe and the United States.

www.espaciodelinmigrante.wordpress.com

*Banner design: Manuel Radde*

# SALON DE BELLEZA

## MIGUEL A. LÓPEZ

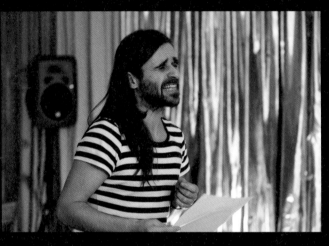

Jaume 'Mal' Ferrete Vazquez,
*Voz Files / Voz Mal*, archive and
performance, variable duration,
2011–14, listening performance,
22 October 2014; photo: ID

## with
**Carlos Motta, Sandra Monterroso, Giuseppe Campuzano, André Masseno, Sergio Zevallos, Virginia de Medeiros, Jaume Ferrete, Open Barbers (Greygory Vass and Felix Lane).**

Salón de Belleza presents various pieces that explore techniques of intervention of the body, cosmetic rituals, and spaces where the body (or certain parts of it) get a 'treatment', associated with colonial history, indigenous memory, affectivity, and queer beauty. This salon explores personal and collective fantasies of the self, questioning dichotomous conceptualisation of gender and imagining a diversity of possible identities through the transformation of the personal appearance and/or of the destabilisation of the visual memory of the so-called normal body. The works included are seeking to intensify the desire to be other, the need to change, the urgency of proposing fictions and utopian representations that shape in a different way the perspective of what bodies should look like.

This process of reconstruction and transformation of one's own body is approached in Salón de Belleza in two ways. On the one hand, through works that explore the body's memory and its ability to rewrite the past, recovering non-normative gestures, movements and behaviour erased by the violence of colonial history. In this group we included the video The Defeated (2013) by Carlos Motta; the installation Life's timeline – Transvestite Museum of Peru (2009–2013) by Giuseppe Campuzano; the photo series The Confetti of India (2012) by André Masseno (in collaboration with Nilmar Lage); and the video The Devolution of the Vucub Caquix Penacho (2014) by Sandra Monterroso. On the other hand, through works that modify the physical appearance of the body and/or create spaces for exchange and conversation about beauty, affection and love, fostering personal and social processes of self-fashioning that go beyond the norms. Among these we include the performance Oracle by Default (2014) by Sergio Zevallos; the video-installation Studio Butterfly (2003–2006) by Virginia de Medeiros; the pop-up shop by Greygory Vass and Felix Lane (Open Barbers); and the performance Voz Mal (2014) by Jaume Ferrete. All these projects attempt to build new understandings of bodies that question and disturb the politics of desire.

Carlos Motta's The Defeated, as well as Giuseppe Campuzano's Life's timeline – Transvestite Museum of Peru, are counter-narratives of history, collecting images and oral chronicles that fracture the dominant models of producing gender and sexuality. These works are examinations of homoerotic rites, drag practices and dissident sexualities, and their persecution since Europe's colonisation of the Americas. As Motta states in the video The Defeated, an indigenous slave, who is guiding a group of Spanish conquistadores up the jungle, describes the moment in which an army commander witnesses an indigenous homoerotic ritual, angrily condemns the act as 'abominable and unnatural' and orders the immediate execution of the men.

The artist combines footages recorded in Northern Colombia with spoken text based on an

Sergio Zevallos, *Oracle by Default*,
Performance, 1 November 2014;
photos: OR

undocumented story passed on from generation to generation by oral transmission, contrasting the beauty of nature with the aggression associated with colonisation itself. Motta speculates about the possibilities of bringing into present time queer indigenous histories that were largely excluded and repressed by European traditional epistemologies. In a similar way, *The Transvestite Museum of Peru* founded by Giuseppe Campuzano in 2004, proposes a critical reviewing of so-called 'History' from the strategic perspective of a fictional figure he calls the 'androgynous indigenous/mixed-race transvestite'. The installation deployed photocopies, photographs, crafts and objects from various fields of transvestism that were overlooked, discarded or persecuted, which ridicule brave masculinity, pervert patriarchal representations of heroism and challenge the colonised dimension of nation-state histories. His work, halfway between performance and historical research, parodies the rigidity and the clearly defined borders of the nationalist identitarian organisation of bodies, emphasising the ways in which these queer representations interfere in the dynamics that produce social narratives and subjectivity.

The photo series *The Confetti of India* by André Masseno in collaboration with Nilmar Lage, also explores a discontinuous queer and transgender narrative. This work creates a dialogue with countercultural attitudes of the early 1970s, inspired by the behaviour of aboriginal cannibals (*Tupi nambas*).

Masseno creates a choreography that explores the gestures and physical experiences of ecstasy that disorganise the body amidst tropical landscapes. The photos explore ideas about what it is to be human and alterity, enacting other forms of being and alternative conceptions of the self, the body and nature. From a different position, *The Devolution of the Vucub Caquix Penacho* by Sandra Monterroso explores mythical-historical accounts from Mayan culture. In the video a woman is standing with her closed eyes inside an acrylic container full of floating black feathers. She can't get out. Her body is stained black, while the transparent case becomes opaque. The action is based on Moctezuma's headdress (a featherwork crown that belonged to the Aztec emperor at the time of the Spanish Conquest) which is currently held in the Museum of Ethnology in Vienna.

Greygory Vass and Felix Lane (Open Barbers) transformed the exhibition space into a beauty salon for a weekend, offering a haircut experience with a queer and trans-friendly attitude. The haircut act is a way to promote and celebrate the diversity of people's appearances, but also offers the possibility of creating close spaces of exchange that involve reciprocity, differences of opinion, implication and affection. The aim of creating gender respectful spaces also appears in *Studio Butterfly* by Virginia de Medeiros. Studio Butterfly was conceived as a photographic studio and meeting place for transvestites that the artist established in a small room of a

downtown commercial building in Salvador de Bahia, Brazil, for about a year and half. In this space, the artist recorded conversations with local transvestites, who introduced her to their personal and affective universe. Beyond just testimony, the work grasps the capacity of individuals to imagine and reinvent themselves, recalling stories of friends, relatives and lovers, building a collective memory that diverges from traditional patterns of life.

In the performance *Oracle by Default* (*Oráculo Por Defecto*), the artist Sergio Zevallos appears transformed into an oracle that responds in a spontaneous way to various interrogations and demands that visitors were invited to ask freely. During the performance the oracle changes the mask it wears which also modifies his language and the response given, exploring the possibilities of shaping desire and perceptions through eccentric thinking against social expectations. This examination of non-normative behaviour is also present in Jaume Ferrete's work, which works with the potentiality of language and sound in a listening performance about the uses, functions and accidents of voice. In the performance *Voz Mal* the artist confronts the hegemony of the masculine voice and deconstructs the role of the voice in the processes of negotiating identity and the assigned meanings of gender and sexuality in the public sphere. Mixing music, political statements, and fragments of interviews with activists, feminist scholars, and cultural workers, Ferrete presents

voice as an open technology that could be misused and turned in order to provoke other ways of producing subjectivity and political intervention. All these works are practices of estrangement that overlap politics, history, the body, and personal fantasies of the self, fostering queer forms of knowing and producing knowledge. All of them evoke bodies and movements that fracture the privileged site of heterosexual subjectivity, and bring into the present alternative modes of inhabiting the world. *Salón de Belleza* explores digressive maps, de-normalised representations, utopian moments, and the developments of strategies to contravene heteronormative processes that construct exclusionary systems of meaning.

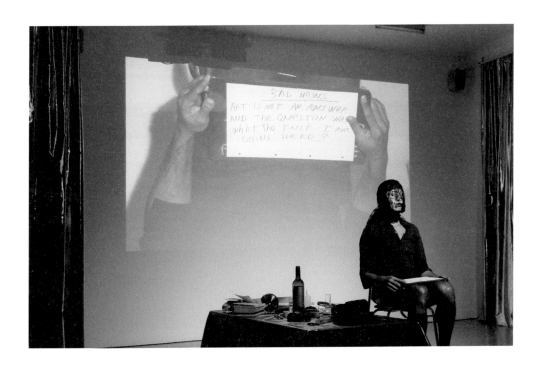

FAGGOTY. Character dre
dance of the LITTLE BL
MAN, dances between tw
couplets in corners of the
local authority or an unusu
diccionario folclórico plura

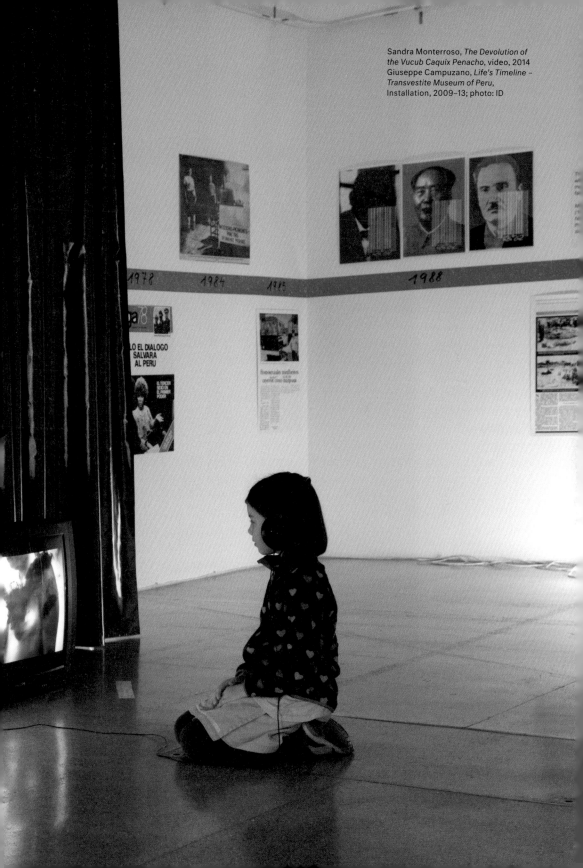

Sandra Monterroso, *The Devolution of the Vucub Caquix Penacho*, video, 2014
Giuseppe Campuzano, *Life's Timeline – Transvestite Museum of Peru*, Installation, 2009–13; photo: ID

## Sandra Monterroso

*The Devolution of the Vucub Caquix Penacho* video is based on the Pop Wuj (Mythical-Historical Poem from Mayan culture), in which Vucub Caquix is a very proud warrior, who has in his skin seven shames: pride, anger, vanity, lust, envy, greed and arrogance. In the video there is a woman who is in a trance; she is not in this reality, and is trapped: she has feathers but cannot fly, is a warrior but cannot fight, has the power of the feathers while at the same time she is locked inside a museum object.

Utopia can also be found in the myths and 'other' knowledges[1] that arise from art practices and non-normative thinking, which attempt to decolonise thought, the gaze and the body. The writer Zulma Palermo reflects on the difficulty of accepting *'other ways of knowing'* such as magic, cosmology and spirituality; she calls this an epistemological problem. I like to work on the 'sacred' as *other knowledge*; it creates a semantic utopian short circuit. I specifically like to use 'the Najt', the Mayan sacred space-time that in the Western understanding would be a non-linear time and therefore not 'real'. These myths and cosmologies are *'knowledge others'* that place us in a frontier where utopia is possible. In the video *The Devolution of the Vucub Caquix Penacho* there is no specific time-space, time is rather an altered state, where hope is linked to the future that looks at the past but does not get caught up in it.

## Jaume Ferrete

I wouldn't know how to relate to the word utopia unless it acts as a synonym of saying 'everything could have been / could be different'. A 'utopian pulse' may be thought of as an expression of our craving for a diverging present, past or future.

I've learned that the voice sits at the crossroads of several narratives – bodily, social, identitary – a good position from which to interrogate them. I've also learned that 'The Voice' is always masculine, unless it sings. That you have to control your body, normalise your voice, or risk being subjected to violence. A fag voice is not a voice, as a flaccid cock is not sex, and has no place in pornography.

The voice is not essentially as is, yet we often identify ourselves or others with it.

Technology is used as a supposedly neutral agent to verify how appropriate your voice is. Sorry, Siri didn't understand you. Text-To-Speech voices are gender binary, emotionally 'neutral', nationally identified and generally, accent-less. Just like yourself? Your father asks you

---

1 Border thinking 'emerges from colonial subordination,' as Walter Mignolo describes it and 'is a thought that cannot ignore the thought of modernity but also cannot be subjugated to it,' in the words of Juan Blanco. See Juan Blanco, *Cartografía del pensamiento latinoamericano contemporáneo*. Guatemala: Cuadernos Winaq, Universidad Rafael Landivar, 2009; see also Zulma Palermo, *La Opción Decolonial*. Buenos Aires: Cecies, 2014, at: www.cecies.org/articulo.asp?id=227 (accessed 7 January 2015).

over the phone 'what's wrong with your voice?'. They tell you that you sound like the women who sells fish at the market. Plug that hole. It may well be that you should be dwelling in the bushes, outside of the city: politics can't be embodied by that sound.

I present recorded conversations on the subject of voice that I had with crip[2] and LGBTQ activists, feminist scholars and singers, somatic practitioners, dubbing actresses, cultural workers ... They stimulate my political imagination, and this is why I want to put them into circulation, and this is why I perform them. But I cannot claim that when I perform I am temporarily giving divergence a physical form. The work is joyful but pathetic, and I am angry.

Yes, it does seem important to ask ourselves: What else could have happened? How can I hack this? Can we build something differently? What will we make out of it tomorrow? But I think we also need to understand and denounce how oppression occurs in our everyday lives; and ask how did it become like this. I would not want to see the work just as an artistic device for the production of imaginaries. People can reflect on how they fit in these dynamics; they are able to incorporate these ideas. So let's fill any relevant spaces, play or talk anywhere it matters; let's remain available.

2
'Crip' is short for 'crippled', a political appropriation of the word used to substitute the term 'disabled'; as it implies a normal (able) body, to which other bodies are compared. In Spanish we talk about 'diversidad funcional' (functional diversity).

## Sergio Zevallos

*Oracle By Default* is the attempt to materialise a disfunction of normative knowledge. By way of a dialogue composed of questions and answers that never coincide, an exchange of knowledges is created. These are knowledges which serve no function under any anticipated circumstances. The oracle thus becomes an institution that produces and multiplies forms of thinking incompatible with social norms.

The oracle is an institution inasmuch as it is a public space where a group of people carry out practical and recognised tasks at the users' service. The whole apparatus is reduced to questions and answers. It is not determined when and why a specific statement is a question or an answer. It is not known whether the question precedes the answer or the other way around. Neither is it known if words necessarily constitute a logical sequence. It is most likely that their meaning is invented by the user at the time of the enquiry or later.

The oracle is a multicellular organism. Users constitute the basic units of this living being. Each one on their own does not know or understand anything of that which is being tackled. However, the fact that they are gathered together and that they are doing it implies that the organism is working and alive. When user-cells disperse, they take a synthesis of the oracle's irregular knowledge with them. Similarly to DNA, that knowledge will be activated and will evolve with each sensual and sensorial exchange with other

Giuseppe Campuzano, *Life's Timeline –*
*Transvestite Museum of Peru,*
Installation, 2009–13; photo: ID

people. The oracle thus affects individual behaviour not by regulation, but by default, without so much as a specific aim.

In order to create an oracle, the following need to converge in one or more people whilst they converse: a state of sexual excitation, a clouded reasoning capacity and an unstable identity.

### Open Barbers

Open Barbers is a hair salon based in London, UK, led by Felix Lane and Greygory Vass. Their service is for any hair length, welcoming people of all genders and sexualities. As part of *Salón de Belleza* at *Utopian Pulse – Flares in the Darkroom* at Secession, Open Barbers ran a pop-up shop for two days in the gallery.

Open Barbers started in 2011 in response to the lack of hairdressing services for people who identify themselves outside of masculine or feminine stereotypes. Full-time since 2014, it's becoming a thriving

environment for socialising and sharing knowledge and ideas.

We look for moments of utopia in the form of a reprieve from the capitalist, binary, and heteronormative ideologies and agendas that most hairdressing spaces are built on. As hairdressers, our role is to shape the image clients have in their mind, of how they see themselves, and how they wish to appear. We understand that a haircut is a form of communication of identity, which sometimes needs to transgress and sometimes needs to assimilate in order to ensure comfort/safety.

Every time someone books a haircut, they can tell us what pronoun they use. This gesture of agency is integral to the welcome and they can change their pronoun from one haircut to the next. The space is full of home-made things, our wall photos are our own clients, our hairstyle 'look-book' is hand made, and we have a library of fanzines. We aim to make the welcome, the conversation, and the interactions full of potential and free from judgement.

Operating in a capitalist world requires us to be efficient, productive, swift and decisive. Things are categorised, we are given limited gender options. This has led to the hair and beauty industry judging us narrowly for the choices we make, if those choices are not deemed appropriate or attractive in a conformist world. We see this manifest physically; sometimes people shut their eyes during a haircut, sometimes people are so nervous that they shake. How can it be acceptable that this ideology makes them feel so far

Giuseppe Campuzano, *Life's Timeline –*
*Transvestite Museum of Peru,*
Installation, 2009–13; photo: ID

Salón de Belleza installation view with
Carlos Motta, *La visión de los vencidos*
[The Defeated], 6:46 mins, 2013;
photo: ID

away from what they want and need?
Our appointments are lengthy and
include room for consultation/
reinvention each time. We create
space for individuals' decisions using
kindness and compassion as acts of
resistance, of movement towards a
utopia in the here and now, not just
as an abstract and impossible
dream, but as a hopeful reality.

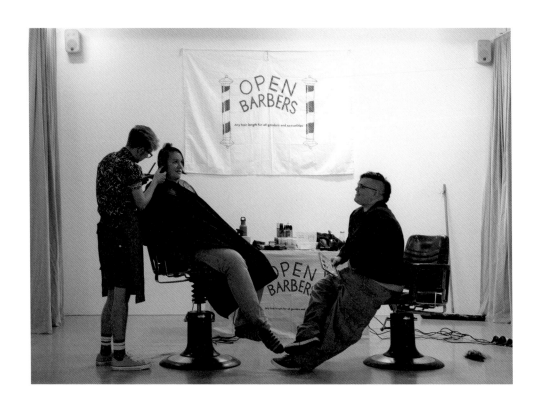

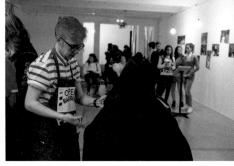

Open barbers, Pop-up Shop by
Greygory Vass and Felix Lane,
Performance, 2014; photos: ID

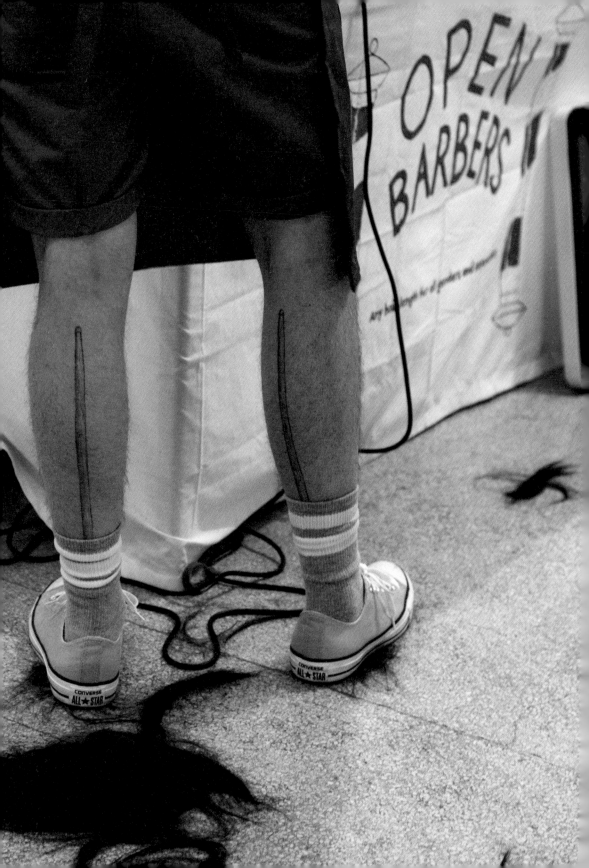

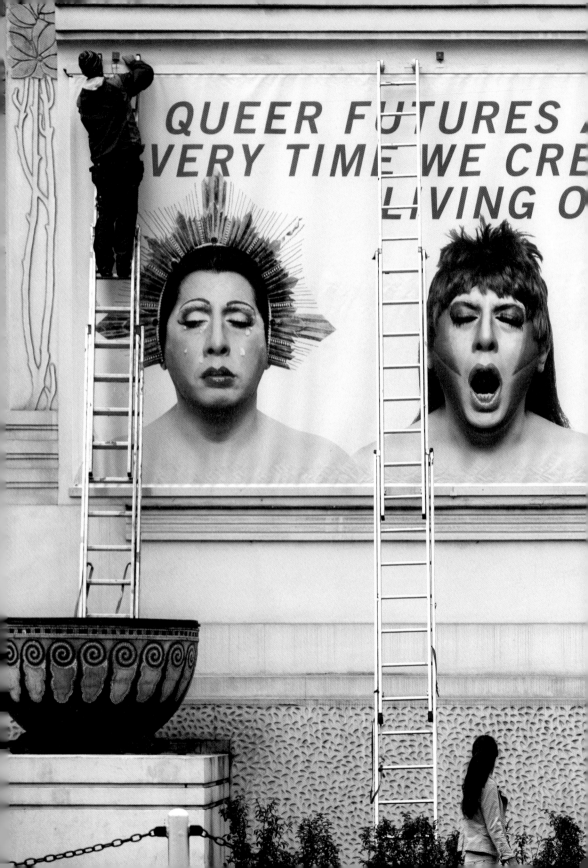

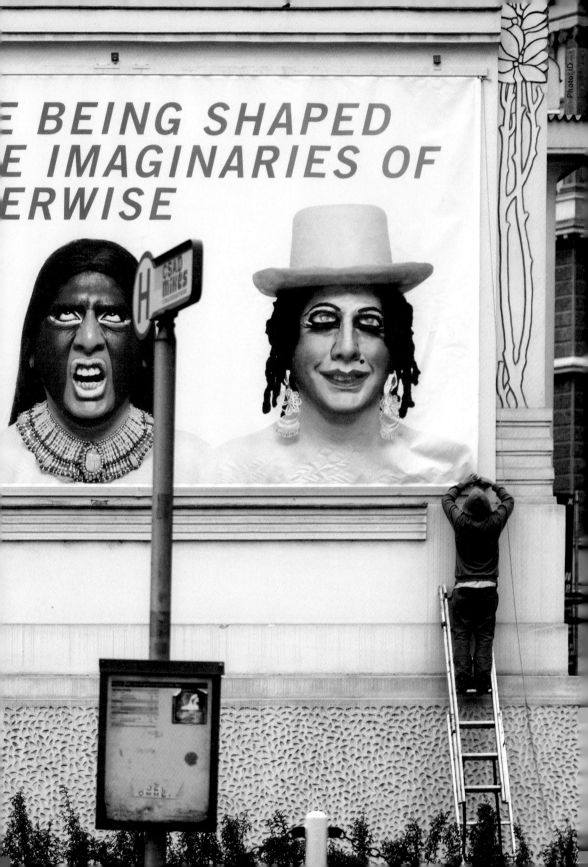

# A MASK IS ALWAYS ACTIVE

## Ines Doujak and John Barker

1
The argument most famously made by Guy Debord in *The Society of the Spectacle*, Paris: Buchet-Chastel, 1967; trans. Donald Nicholson-Smith, New York: Zone Books, 1994.

2
For the deceptiveness of its technological promise, see Richard Barbrook, *Imaginary Futures: From Thinking Machines to the Global Village*. London: Pluto Press, 2007.

3
Mary Russo, *The Female Grotesque: Risk, excess and modernity*. New York and London: Routledge, 1994, p. 101.

Contemporary capitalism, it has been said, makes and needs the conditions for life lived in a perpetual present.[1] Certainly it has reason to be anxious about the past, both revelations of its own violence, and frightened of those dangerous moments of history when something else was possible and so, is instead, strategically forgetful. True also of its possessive monopoly claim to the future when the pleasures of its 'perpetual present' consists so much of anticipations and expectations and, longer term, which has always needed to be one worth waiting for, something more substantial than life after death.[2] It has been the necessary location of what Herbert Marcuse called 'a goal-oriented teleological present', as a place of promise always there to make up for a disappointing present. What does this look like now, when the reproduction of selective scarcity on which the capitalist mode of production is based, has had to come out from behind the curtain, to claim for itself not an abstract present but as Reality-for-Adults, as What Is. In the film *A Mask is Always Active*, two figures with giant heads, in motion on swings, whisper that 'there is no deal done for ever', and then, 'no done deal forever'. In the present climate, when the global elite's slogan, 'There Is No Alternative' no longer even promises Jam Tomorrow but is dependent on the fear that any radical change will mean the supermarket shelves will empty, it is not just defiant but realistic. Watching the film – a musical in five scenes – Bakhtin's thesis on Rabelais and Carnival is not required to know the giants as friendly Rabelaisian grotesques or that they tell of how Kings, Queens and corporate moguls shit and will die the same as the rest of us. What Bakhtin does tell us is that the 'grotesque' body turns away 'from mirror images of itself and towards transformation and possible futures. Like history, the body is shown to be a recyclable *trompe l'oeil*.'[3]

Specific knowledge of the history of Disruptive Pattern – a 'camouflage' of hyper-visibility used by British warships in World War I – is also not needed to recognise that the body and heads of the giants

4
Elias Canetti, *Crowds and Power*, trans Carol Stewart. New York: Farrar, Straus and Giroux, 1984, p. 378.

5
Rachel E. Harding, *A Refuge in Thunder: Candomblé and Alternative Spaces of Blackness*. Bloomington, IN: Indiana University Press, 2000, pp. 32–33.

masked in this pattern are, like all masks individually liberating, but are the same for all the characters and indeed the background of the whole film. The mask is essentially playful, speaking of the joy of transformation, the violation of boundaries and the distinctions of organised society. In the film it is a collective mask, just as carnival is inherently collective, with no time for inequality or the cult of personality so crucial to a sickly 'consumer capitalism', resistant also to the surveillance marked in the film by the sound of the helicopter. Historically such liberating 'disguise' has taken other subversive forms, as when nineteenth-century Afro-Americans made a space for themselves in the New Orleans Mardi Gras by wearing ornate headdresses of indigenous North Americans; the Orisha masks of Afro-Brazilians; or the thousands of masks in four colours distributed at the start of the Reclaim the Streets J18 mass action in London in 1998. From the helicopter point of view,

*A ruler wages continuous warfare against spontaneous and uncontrolled transformation. The weapon he uses in this fight is the process of unmasking, the exact opposite of transformation ... If it is practised often, the whole world shrinks.*[4]

In eighteenth- and nineteenth-century Brazilian-African slaves would often escape, aiming for free settlements – *quilombos* – they might have heard of, knowing that they might not succeed, that their freedom might last just a few days and that they would be severely punished when captured, and do it just for the experience of that freedom.[5] Such must be the wish now of many people in the world, although success is not guaranteed. While it's true that there is no utopian blueprint, these have caused enough trouble for the hope itself, just repeating it can sound smug when for many in the world the utopian moment is likely to be the guarantee of enough to eat today and a secure place to sleep tonight. Thoughts as to how an egalitarian political economy might

work, possible loose-fitting structures, believable counters to the supermarket shelves threat, do not stink of the Gulag, and are needed in the *There-Is-No-Alternative* world. But for this there has to be the *desire* for a world different to the mean and stingy, the highly selective scarcities of What Is, desire without which there are no flares in the darkroom. It is acutely felt in the experience of carnival (not reducible to the Christian calendar) which abolishes everyday distances between people and for its duration, establishes those free, intimate contacts with friends and strangers alike where such desire flourishes, knowing in your whole being that this is how life should be. In this situation people have the freedom to rehearse identities, stances and social relations not permissible by the dominant culture with its smug pessimism and monopoly claims, to go beyond it, having a good inkling of that beyond in its duration.

Carnival stands in comprehensive opposition to the ruling political culture. It challenges its profound fear of abundance so unashamedly expressed by Thomas Carlyle's hatred of the pumpkin, 'Where a black man, by working about half an hour a day … can supply himself, by aid of sun and soil, with as much pumpkin as will suffice' – which allowed people to survive with little need to work and thus to live without anxiety.[6] Such fear and downright hostility is applied in similar manner to the communal as being inherently stultifying if not downright savage. Thus the nineteenth-century missionary John Mackenzie sent to southern Africa by the London Missionary Society wrote enthusiastically of his work in 'weakening the communistic relations of a tribe among one another and letting in the fresh, stimulating breath of healthy, individualistic competition.' Now, when the rational individual of neoclassical economics is king, Carnival is essentially collective and hostility to it reflects the constant elite fear of this characteristic; of 'the masses', especially when they are on the streets, when the standard portrayal is as a 'mindless mob', made

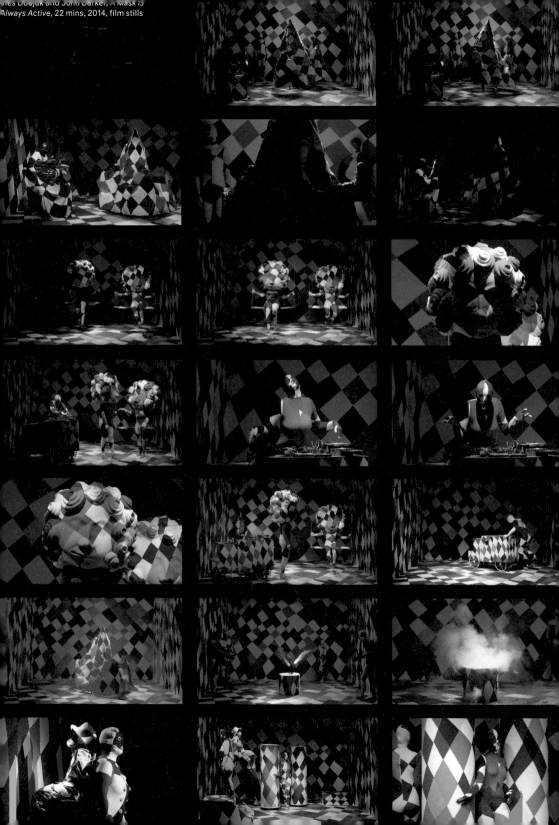

les Deajuk and John Barker, *A Mask is Always Active*, 22 mins, 2014, film stills

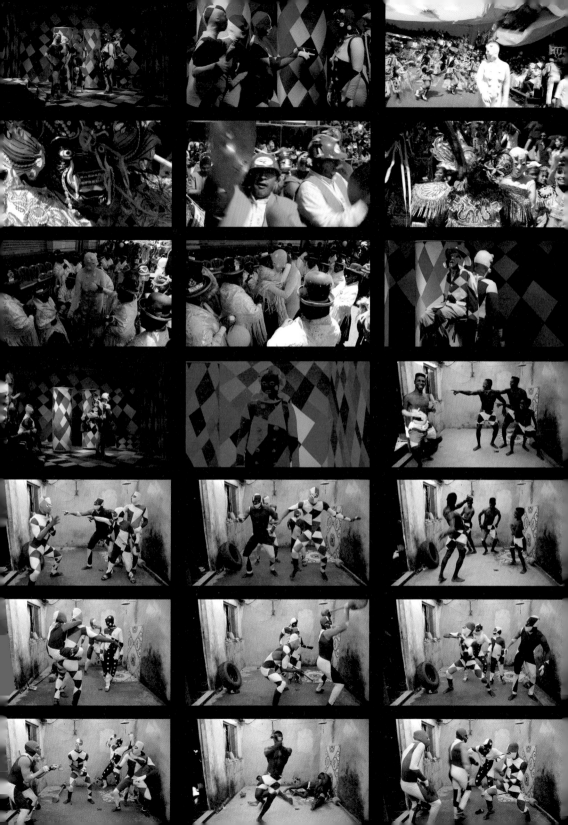

7
Russo, *The Female Grotesque*,
p. 60.

mainstream and 'scientific' by Sigmund Freud in *Civilization and Its Discontents*. The book based itself on the 'evidence' provided by Gustav Le Bon's 1895 *The Crowd* in which he described the 'hysteria' of French crowd he had not actually seen, and which he compared to that of a women. In earlier times as described by Natalie Zemon Davis and then by Victor Turner, this fear of the crowd was especially related to the 'wild woman', the epitome of the irrational: 'the marginal position of women in the "indicative" world makes their presence in the "subjunctive" or possible world of the topsy-turvy carnival "quintessentially dangerous."'[7] Finally, in the corporate age of financialisation, carnival is free of charge, an affront in itself.

The very heavyweight thud of Freud's grandiose title is a giveaway. In the present climate, the playful aspect of carnival is not to be underestimated. It is not carnival that is a safety valve but the heavy, soggy satire of consumer comedy whose main function is in fact, the task of 'unmasking' for the ruler. The playful is by nature subversive when the ruling elite insists not only that it has a monopoly on seriousness, despite its real recklessness, but insists that we get caught up in its version of what is serious. The deficit! The deficit! Which turns out to mean government budget deficits, which have existed for years but are now dramatised as potentially catastrophic. It is the global elite hogging the footlights – the ones carnival does not require – with their latest version of the 'pending collapse' of life as we know it, 'on the brink of the abyss' and so on, and thus the need for their hierarchical authority. The overbearing weight of What Is turns out, in its wholly unreliable narrative, to simultaneously be a fragile craft in constant need of the Commander at the wheel, experienced as he is in crisis management.

Carnival was fearful for the ruling class of medieval Europe and then the colonialists of the New World. The structuralist argument, that carnival has always been a 'letting off steam' safety valve was present too in fifteenth-century

8
Christopher Hill, *Society and Puritanism in pre-Revolutionary England*, New York: Schlocken Books Inc 1964, p. 121. A modern touch of 'we are all in it together' in that it is the 'nation' it is costing.

9
Jane Schneider, 'Rumpelstilt-skin's Bargain: Folklore and the Merchant Capital Intensification of Linen Manufacture in Early Modern Europe', in Annette B. Weimer and Jane Schneider (eds), *Cloth And Human Experience*. Washington, DC: Smithsonian Institute Scholarly Press, 1989. She cites the English landlord in Ireland, Sir Richard Cox, and how he transformed May Day into 'the joyous day of Determining the Premiums. Then a full assembly gathered for the applauses and demerits that each deserved.' The vent involved distribution of a dozen monetary prizes to those tenants who raised and dressed the most flax, spun the best and the most yarn diligently for two years in a row, wove the most and best cloth, and kept the most looms in operation. 'It is,' Cox wrote, 'a Natural Vanity to desire to be distinguished ... And surely ought to be indulged, since it is productive to much good.' He went to describe how 'a generous and useful Emulation between the new comers which of them shall first become rich. I foresaw that these good effects ... would make others ashamed of their indolence, and stir up a Spirit of Industry.'

Europe but was made at the very time it was being steadily foreclosed in the name of authority's need for a mystique of gravitas and its fear of things getting out of hand, of mass cross-dressing, of the representations of 'uncrowning' role-reversal creating the desire for a real uncrowning of the hierarchical world. More pressing at the time were the requirements of labour discipline for proto-capitalism and the realigning of the calendar that required, the flattening out of time required by repetition and the economic 'law' of capital accumulation. A perhaps distinctively English bourgeois economist of the seventeenth century estimated that each holiday 'cost the nation' £50,000 in lost labour.[8] At the same time the May Day holiday with its subversive Maypole, and other yearly festivals were manhandled into prize-giving occasions for the best workers.[9] Now, while 'immaterial labour' carries the bulk of social analysis, the body-battering labour discipline of Taylorism, as in Foxconn making Apple Macs in China, or a Bangladeshi clothing sweatshop, rules the world's manufacturing. The 'real' world became and is one of *Time is Money,* past-present-and-future all eaten up, while carnival stood and stands out as a true feast of time, the work clock suspended, hostile to all that was immortalised and sewn up. In the now-present, without the future's promise, the question posed by Matthew Hyland has especial resonance. It is no longer simply: '"why must Carnival end, why doesn't all life look like this?" but: "what latent power, which in Carnival/utopia we *prove* is real, is so unbearable to see shut down."'

It was to the invaded 'New World', including modern-day Bolivia, that carnival was exported just as it was being curtailed in Europe itself, the paraphernalia of the Catholic Church needed by the invader to feel at home in a foreign land. Here however, the same concern was quickly expressed by a Judge Maldonado in 1625 Guatemala who put a ban on indigenous dances that had attached themselves to the Saints Days of the invaders because the Indians 'squandered' money on

10
Eduardo Galeano, *Genesis*: Volume 1 of *Centuries of Fire*, trans. Cedric Belfrage. New York: Pantheon Books, 1985.

11
Eduardo Galeano, *Faces and Masks*, Volume 2 of *Centuries of Fire*, trans. Cedric Belfrage. New York: Nation Books, 2010, p. 98.

12
Ibid., p. 151.

13
There were such folk at the time, like the early twentieth-century Anarchist European immigrants to Brazil and Argentina who saw carnival in exactly this way. It was a distraction for the poor and 'a decadent display of drinking and other unseemly behaviour.' wrote one in La Terra Livre. https://lib-com.org/history/organized-labor-brazil-1900-1937-anar-chist-origins-government-con-trol-colin-everett

feathers and masks but also because they 'lose too much time in rehearsals and drinking bouts which keep them from reporting for work at the hacienda, paying their tribute and maintaining their households.'[10] It could be the elite's view of the 'feckless' working class in almost any period, and in this case a distaste for its aesthetics, those feathers and masks which in this case would be active in a special sense: that of direct communication with other species or spirits of the natural world; experience outside the ken of the coloniser and exploitation, and so a source of anxiety.

In the Brazilian sector of the New World, Afro-Brazilians appropriated carnival bringing music, dance and the drum. In 1808 the traditional burning of the Judas figure during Holy Week was banned as he appeared to take the form of 'the marshal, and the archbishop, the rich merchant, the big landlord and the chief of police.'[11] The downpressor-man downed, and who is to say that the sound of the crackling of the flames at that moment might not have ignited the slave's desire for freedom whatever the risk. Some years later on the eve of emancipation in Trinidad, Afro-Caribbeans participated for the first time in carnival bringing their own music, African symbolic imagery and doing a wickedly funny parody of the white militia. By 1845 carnival had escaped the confines of 'defeating' Lent, on the Christmas Eve a European visitor reported that 'it seemed as if under the guise of religion, all Pandemonium had been let loose with the sound of drumming, the women being of the lowest class: and all dancing and clapping their hands like so many demons.' Women, low class, demons and worst of all the drums: just a few years earlier on the plantations of Cuba strict instructions were given about how drum dances there were to be strictly controlled by foremen[12] as they could so easily speak of and incite rebellion.

That was then, say the weary of heart, fussy progressives, what of now, even if carnival wasn't just always a safety valve – bread and circuses,[13] look at it now, commercialised, institutionalised

and so forth, Rio de Janeiro, Notting Hill, same story. There is a whiff of snobbery here aimed at its mass nature. Sure, they sell tourist holidays and tickets for a carnival spectacle in Rio, but up in Cidade Alta's tropical tenement blocks, Saturday night's Funk Balls are free, wild and where spectators and performers are one and the same; there are no tourists but there a certain level of self-organisation of bars and sound systems allows for the spontaneity of party: two deceptive binaries reassuring to the masters' universe down the tube, and thus attracting a heavy police surround; under constant persecution as being 'obscene' and violent. Cidade Alta, home to the dancers of our film's finale. There they played with masks on and off and improvised with playful and subversive wit as they danced, smug and then derisive with a mimic World Cup; dramatising the War Against the Poor with a derisive touch, they were hysterical but undefeated by a spray like that of tear gas.

Carnival and its many forms is not ahistorical; it would be a source of oppression if it were so. Notting Hill, a non-Lenten late August carnival, started life as a reverse travel, the Trinidadian descendants of the 1845 revellers settled in early 1960s London bringing carnival back again to Europe and not bothering with the Christian calendar. Heroic at the time in a then racialised London and faced with the overt hostility of the police and the media oligopoly. It then changed itself, the Jamaican culture of fixed-spot street sound-systems added to the circulating carnival procession and costumes and masks of the Trinidadian tradition. It was from then, coinciding with the working class making of a multi-racial London, that it started to become a mass event, institutional to a degree but still fearful enough to be controlled by police instructed to put a smile on their faces and grimacing; and the media reporting only any crimes that may have happened. More recently a fussy progressive with a familiar fear of the sound of slave drums at night used the Trojan Horse rationale of the safety of children, to remove the most authentic, safe and local part of carnival –

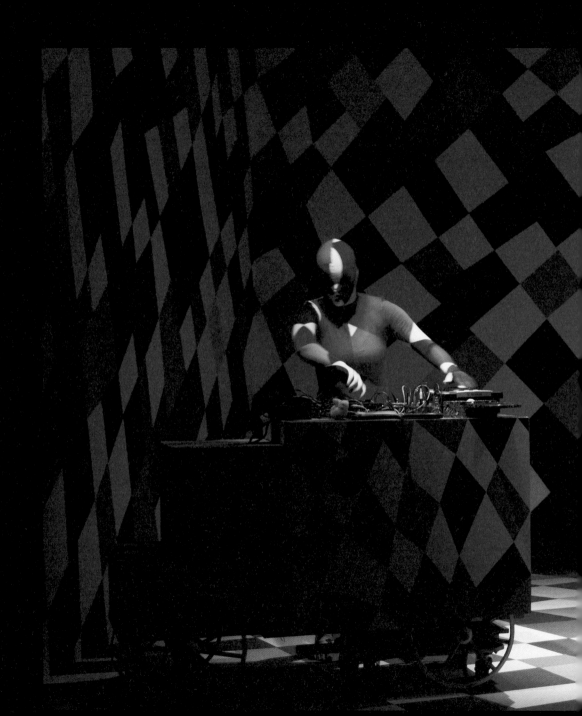

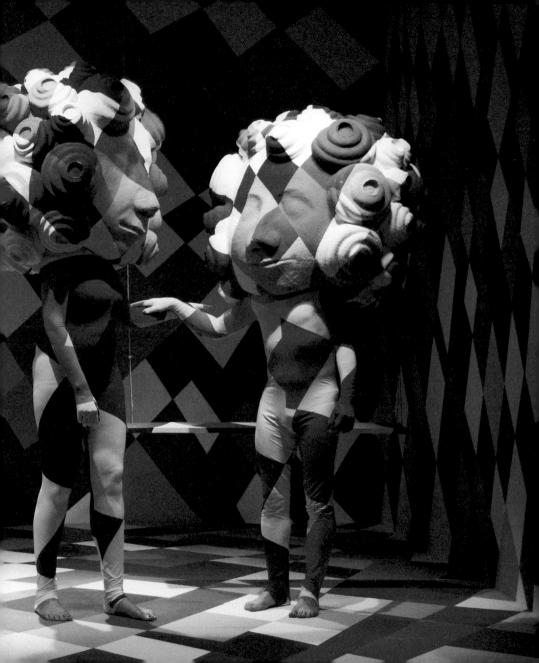

14
For an account of this day, see John Barker in *Adbusters*, 18 June 1999, at: www.vanguard-online.co.uk/archive/politicsand-culture/1103.htm

15
The parking of trucks in capitalist underground car parks overnight to be used both as barriers and for sound systems was crucial to J18 as Carnival, a modern version of the bourgeois selling the rope to hang the bourgeoisie.

Saturday night's steel drum band show from the streets to Hyde Park in the afternoon.

Notting Hill, like any moment of carnival is not there to be fetishised and is exceptional precisely because of its longevity, when mass expressions of joy are not immune to history and the balance of class forces. The comprehensive violence used to smash the Windsor Free Festival of 1974 happened at the very same time capital began its attack on the Western working class and its culture of mass audacity. The desire expressed then was not extinguished and in Britain re-emerged with the illegal Rave movement of the late 1980s. The utopian moment of the Exodus Collective from working-class Luton coming out of this, fed into a larger political manifestation, the Reclaim the Streets movement. Years later this experience was instrumental in making the J18 mass-scale Carnival of the Oppressed that surrounded and partied round London's Liffe building where the trillions that back the dominant culture's monopoly whizz around the globe.[14]

This is not a matter of nostalgia – the very reverse of the utopian – but an inspiring history in the present, which is one of constant police attacks on collective life on the streets, aided by mass surveillance at a time when it is 'scarcity' which is fetishised. These 'flares in the darkroom' in the recent history of two countries are characterised not just by a generic 'self-organisation', but also by working-class groupings that disregarded the rules. They have required not necessarily the individualism of crime but the criminal shrewdness and imagination that can think and act beyond those rules. The utopian pulse is by definition Breaking the Law which is what controls the quantity and quality of pleasure in life. It means practically breaking some specific laws or getting round them or grabbing opportunities from its own logic to subvert them.[15] It is the pragmatic version of what Ernst Bloch says to Theodor Adorno, that if 'we had not already gone beyond the barriers, we could not even conceive them as barriers.' The 'spontaneous' requires space being made for it,

16
Jacques Attali, *Noise: The Political Economy of Music*. Minneapolis, MN: University of Minnesota Press, 1985, p. 142.

crucially with no ownership claims from those who organised the basics for it to happen, but once created, the streets reclaimed in one form or another, carnival can be that pace for a collective rehearsal of being someone(s) else. It is possible precisely because the spectator–participant division breaks down while giving the courage to be and do something *other*. It is the reverse of what Marcuse called the 'performance principle', which he defined as a repressive social order set in place by limiting the form and quantity of pleasure the human is allowed. In the modern age of work, performance has become obligatory, and is constantly measured. At carnival one performs without judgement.

The film's scenes are performed with different music(s) and dances on which judgement is not made, for it is these joyous art forms which are open to all, and which along with costume and mask are the essentials of carnival. Music makes not just the rhythm but the excitement and collective courage, drumming especially. Nowadays political demonstrations everywhere from Brazil to Europe get their buzz from the sound of samba schools. In an age of muzak, muzak everywhere and a fear of silence, the utopian moment comes when music 'extricates itself from the codes of sacrifice and representation' and instead, 'plugs into the noise of life and the body, whose movement it fuels. It is thus laden with risk, disquieting, an unstable challenging, an anarchic and ominous festival, like a carnival with unpredictable outcomes.'[16] At carnival, on the street, in the park, in the squatted warehouse, music does these things, inextricable from the body, made for dance. In turn, dance breaks the boundaries of the dominant defining of space. In places where entry tickets are not required, not just boundaries but the functions of *What Is*, are subverted. It was always drumming and dancing that most unnerved the white invaders both of the New World and Africa. Its missionaries consistently hostile and a language of 'frenzy', 'hysteria' developed and crucially of 'possession'; the outrage being that for

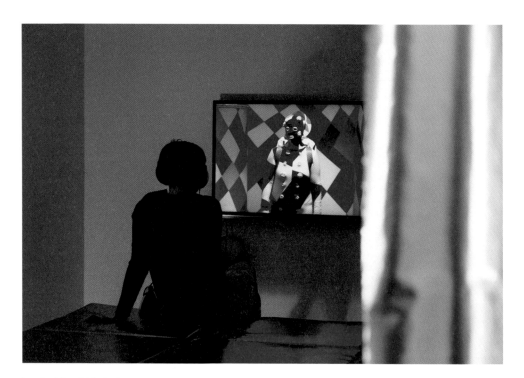

Ines Doujak and John Barker, *A Mask Is Always Active*, 22 mins, 2014, installation view; photo: ID

17
Hermann Melville describing the 'Lory Lory' dance, cited in Alan Moorehead, *The Fatal Impact: An Account of the Invasion of the South Pacific, 1767–1840*. New York: Harper and Row, 1966, p. 94.

18
The history of colonialism is littered with grotesque triumphalism but Thomas Edison's *Sioux Ghost Dance* movie for Buffalo Bill's Wild West Show, made for his Kinetoscope in 1894, just four years after the massacre, is truly gross. Describing itself as a carnival, it celebrates white pioneers conquering the land, and made him a lot of money.

the time of the dance, they were not possessed by the coloniser or his judgmental God. For others the dance was essentially 'degrading' and 'barbaric'. The undercurrent here, sometimes explicit as in colonial descriptions of Voudou dance, is sexiness. It was left as so often to Herman Melville to see the beauty.

*Presently, raising a strange chant, they swiftly sway themselves, gradually quickening the movement, until at length, for a few passionate moments with throbbing bosoms, and glowing cheeks, they abandon themselves to all the spirit of the dance, apparently lost to everything around. But soon subsiding again into the same languid measure as before, the eyes swimming in their heads, join in one wild chorus, and sink into each other's arms.*[17]

Not many years later, the colonial mindset and policies he had written against was in full swing against Native Americans, treaties broken, and land snatched. In this context the Ghost Dance developed, a dance which came from a Lakota ideology of peaceful co-existence and of re-uniting past, present and future. In the eyes of vicious paranoia of the Bureau of Indian Affairs the dance was dangerous and its practice and the refusal to stop at a certain moment lead directly to the death of Sitting Bull and consequently the massacre at Wounded Knee.[18]

To 'abandon' oneself is not the morbid hysteria, the irrationality of the Guru and the spellbound crowd of chosen people, but in the collective space of the dance it is to leave behind the self jealously guarded by the beneficiaries and regulation-makers of What Is and its seemingly endless repetition of content and limits, its dead weight.

The utopian pulse resides with masterless voices singing songs in the dark.

# SALON KLIMBIM

Ines Doujak and Fahim Amir
in correspondence
with Oliver Ressler

with
Ayreen Anastas / Rene Gabri, Elke
Auer / Esther Straganz, Zanny
Begg, Mariam Ghani, Miguel A.
López: Guiseppe Campuzano,
Die Schefin, Alexander Nikolic,
Bert Theis, Schon-Schön-Girls,
Tanz durch den Tag, Ines Doujak/
John Barker: Vitalie Lesan, Maja
Osojnik, Sexy Deutsch, BAM of
the Jungle Brothers, Christoph
Schäfer, Susiklub, Franz Kapfer,
Krõõt Juurak, Oliver Ressler,
ProllPositions, Maja Osojnik,
Hermann Seiwald / gabarage,
GOLEM, Pedro G. Romero /
Archivo F.X.: Marco de Ana, Niño
de Elche, Martín Acosta / Chiara
Cirillo, Zsófi Pirók, Laia Fabre,
Stephan Voglsinger, Brigitte
Langer, et.al.

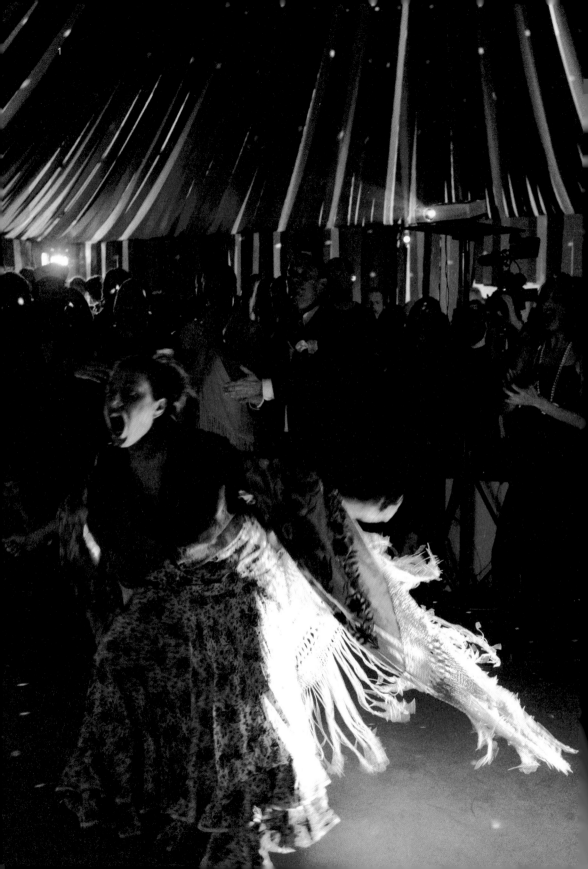

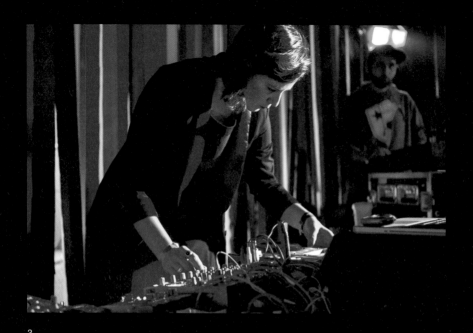

3

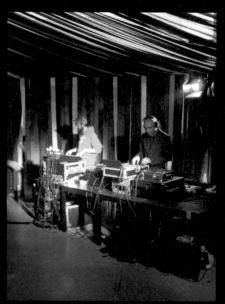

6

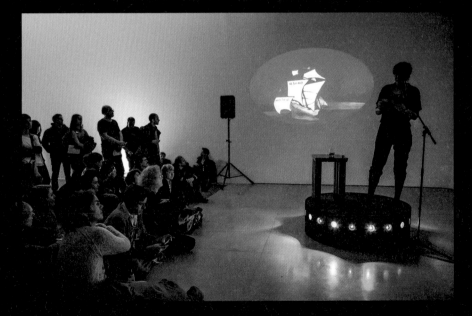

7

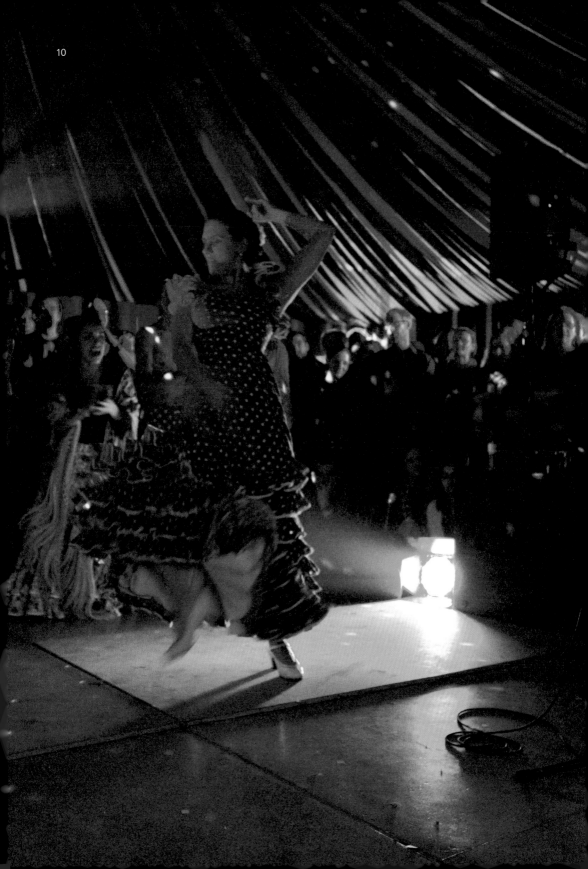

11

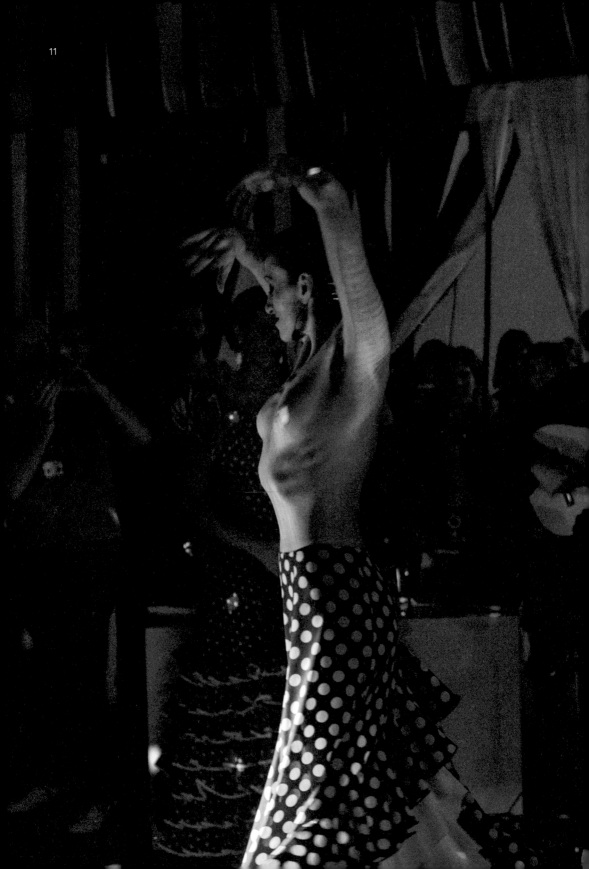

14

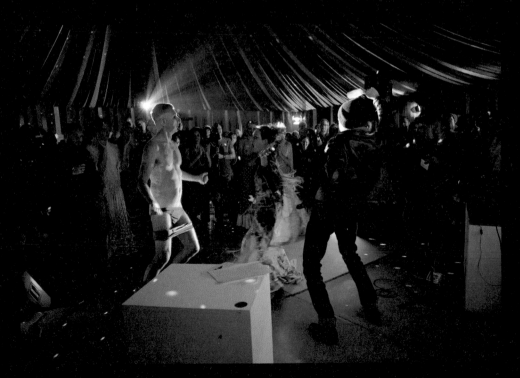

15

16

17

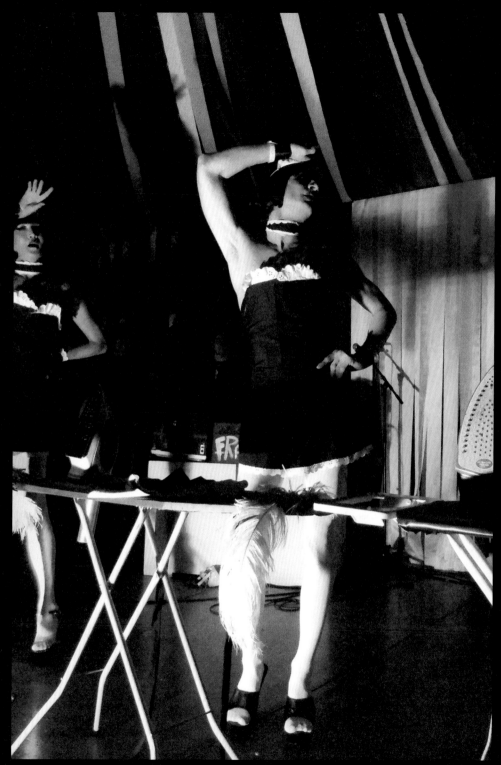

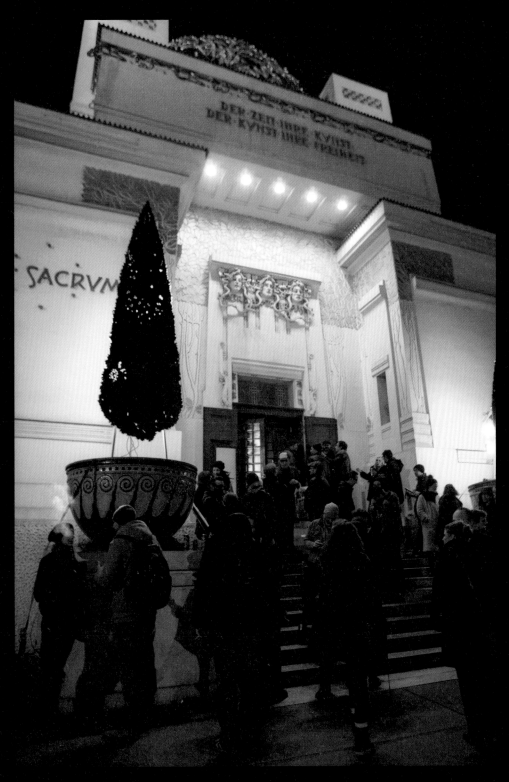

1
Pedro G. Romero/Archivo F.X.,
*Entradas: Hugo Ball; Vicente
Escudero; Emmy Hennings; La
Criolla; La Galerie des Monsters*;
here Laia Fabre performing;
photo: VMW

2
Christoph Schäfer, *A Talk
Illustrated by Hand*; photo: LE

3
Maja Osojnik, *Adjusting the
Bleach for an Utopian Rich*, short
concert, 2014; photo: LE

4
Bert Theis, *Utopia Has Just
Left the Building*, video and
performance; photo: LE

5
BAM, DJ/MC-Set; photo: LE

6
GOLEM, *Bar Performances*;
photo: LE

7
Zanny Begg, *Utopia Backwards*,
lecture, 2014; photo: LE

8
Ines Doujak, John Barker and
Maja Osojnik, *Song in the Dark*,
song and dance routine, 2014;
photo: VMW

9
Miguel A. López, *Die Schefin
performing the Transvestite
Manifesto by Giuseppe
Campuzano*; photos: LE

10
Pedro G. Romero/Archivo F.X.,
*Entradas: Hugo Ball; Vicente
Escudero; Emmy Hennings; La
Criolla; La Galerie des Monsters*,
here Chiara Cirillo performing;
photo: LE

11
Pedro G. Romero/Archivo F.X., *La
Criolla*, Martin Acosta and Chiara
Cirillo performing; photo: LE

12
Krõõt Juurak, *A Stand-Up Routine
for Animals*, performance;
photo: LE

13
Alexander Nikolic, *Reconstructing
a Memorial Plaque*, inauguration
speech; photo: VMW

14
BAM, DJ/MC-Set; photo: LE

15
Pedro G. Romero/Archivo F.X.,
*Entradas: Hugo Ball; Vicente
Escudero; Emmy Hennings; La
Criolla; La Galerie des Monsters*;
photo: LE

16
GOLEM, *Bar Performances*;
photo: VMW

17
Schon-Schön-Girls, *Synchronic
Ironing*, performance; photo: LE

18
Schon-Schön-Girls, *Synchronic
Ironing*, performance; photo: LE

19
Photo: LE

20
Franz Kapfer, *Sieh-Dich-Für/
See-For-Yourself*, 2010,
installation; photo: VMW

21
Melodien für Millionen, DJ-Set;
photo: LE

22
Franz Kapfer, *Sieh-Dich-Für /
See-For-Yourself*, 2010,
installation; photo: VMW

23
Florine Stettheimer: *Spring Sale
at Bendel's*, Philadelphia Museum
of Art

Florine Stettheimer, together
with her sisters Ettie and Carrie,
hosted a modernist salon in
Manhattan from 1915 to 1935;
she was a painter, designer and
poet and often depicted her
salon in her works.

# Biographies

**4Taxis**, the 'Magazine of International Boondocks', founded by Michel Aphesbero and Danielle Colomine, explores arts and culture from the perspective of a different city in each publication.

**Khan Adalat** is a refugee and activist.

**Latif Ahmadi** spent the 1990s in exile in Moscow. From 2001–2013 he was head of Afghan Films. He is currently making a series for Afghan TV and starting a new film academy.

**Halil Altındere** is an artist focusing on the resistance to repressive structures and marginalization within official systems of representation. www.pilotgaleri.com/en/artists/detail/30

**Fahim Amir** is a Vienna-based philosopher with Afghan origins. Amir is involved with art-based research, curatorial practices and performance art.

**Marco de Ana** is a flamenco dancer and choreographer. He is assistant choreographer of Israel Galván. His works have been presented in festivals such as Dance Montreal and ImPulsTanz Vienna. www.marcodeana.com

**AND... AND... AND...** is a series of conjunctions and relays which animate and sometimes put into play emergent positions, concerns, and potential points of encounter between art, politics, thought and life. Contributors share a desire to conjoin aesthetic and political imaginaries toward a horizon of common(s), revocation, and non-capitalist life.
Animators for the Vienna edition included: Ben Morea, Emilio Fantin, Sherry Millner, Ernie Larsen, Ayreen Anastas, Rene Gabri, Harout Simonian, Karen Hakobian, Giulia Gabrielli, Andrea Fabbro, Luca Musacchio, Mattia Pellegrini, Annette Krauss, Miklos Erhardt, Elske Rosenfeld, Keiko Uenishi, Virag Major and guests.
http://andandand.org

**Luca Andreolli** is an activist who is part of the new student movement in Luxembourg and a videomaker.

**Architectural & Urban Forum** is a research agency based in Milan, whose aim is the investigation of urbanity through actions. The work teams are directed by Lorenzo Degli Esposti. www.aufo.it

**Oreet Ashery** is a London-based, interdisciplinary visual artist. Her practice is socially and politically engaged and often takes place in public spaces. http://oreetashery.net

**Sherko Jahani Asl** is a political refugee from Mahabad, Iranian Kurdistan. He is a journalist, writer, human rights activist, Kurdish language teacher and a photographer.

**Ilker Ataç** is a political scientist, researching on migration policy and self-organised, anti-racist movements. He was involved in Kanak Attak and the 1st March Transnational Migrant strike.

**Elke Auer and Esther Straganz** have been working together since the turn of the millennium. They use found and bought things, language and bodies to create performative sculptures, photographs, paintings, posters, videos and installations.

**Dario Azzellini**, assistant professor, Johannes Kepler University in Linz, Austria, has published several books and films. www.azzellini.net

**Emanuel Balbinot** is a film-maker, photographer and activist. He studied cinema and art in Venice, San Francisco and Milan, where he lives and works. http://emanuelbalbi.wordpress.com

**Katherine Ball's** artistic practice is founded on a physically immersive, experiential and solutions-oriented approach to ecological activism and pluriversal counter-hegemony. www.katherineball.com

**Roberto Balletti** is passionate about flying. He is the author of the video *Ape che vola* and **Claudio Tancetti** is an Italian manufacturer of wooden propellers. He is the inventor of the flying Piaggio Ape vehicle. www.propellers.it

**Open Barbers** is a hairdressing project run by Greygory Vass and Felix Lane, built on an ethos of equality, affordability and kindness, challenging normative ideas around gender and sexuality. http://openbarbers.tumblr.com/

**John Barker** is a fiction writer and essayist from London. As an artist he has participated in the Busan and São Paulo Biennale, and in the Potosí Principle exhibition.

**Barat Ali Batoor** was born in Pakistan into a family that was driven out of Afghanistan by the civil war. Batoor started photographing in 2002 and launched his first solo exhibition in 2007.

**Svenja Baumgardt** aka elektrosafari works as a documentary film-maker on public events like demonstrations, art and democratic processes in Hamburg.

**Zanny Begg** is a Sydney-based artist, writer and organiser. She uses humour, understated drawings and found cultural artefacts to explore ways in which we can live in the world differently. www.zannybegg.com

**Kristina Borg** (Malta) is a visual arts educator and artist. Since 2012 she has been based in Milan, reading for an MA in visual arts, and has been part of Isola Art Center since 2014.

**Antonio Brizioli** is an art historian living between Perugia and Milan, Italy. He has been an active member of Isola Art Center since 2011. He funded the independent art journal *Emergenze*.

**Tania Bruguera** (Havana, Cuba) is an interdisciplinary artist working primarily in behavioural art, performance, installation and video. www.taniabruguera.com

**Irene Bude** and **Steffen Jörg** are doing social and political work in Hamburg St.Pauli. Active in groups like 'Initiative ESSO-Houses', 'SOS St.Pauli' and the 'Right to the City Network'. They have made two films about local conflicts: *Empire St.Pauli* (2009) and *buy buy st.pauli* (2014).

**Imayna Caceres** is an artist, researcher and activist working on the role of coloniality in the construction of 'othered' subjectivities and the criminalisation of migration in Europe. www.imaynacaceres.com

**Giuseppe Campuzano** (1969–2013) was a transvestite philosopher. In 2004, Campuzano created *The Transvestite Museum of Peru*, a bodily counter-narrative to make-up voids and de-makeup boundaries.

**Libia Castro** and Ólafur Ólafsson are based in Rotterdam and Berlin. They have been collaborating since 1997 with a conceptual and multidisciplinary approach and site related practice. www.libia-olafur.com

**Angelo Castucci** is an architect, artist, curator and activist. He lives in Milan, dividing his activities between Isola Art Center and Macao, the new centre for arts, culture and research.

**Özge Çelikaslan** is doing her PhD on political aesthetics of video art. She is a member of video artist/activist collectives in Turkey and works on an open digital media archive of political movements: http://bak.ma

**Antonio Cipriani** is a journalist and writer living in the Isola district, Milan. He is the art director of Globalist Syndication and an active member of Isola Art Center. www.globalist.it

**Irene Coppola**, born in Palermo, is an artist based in Milan. She joined Isola Art Center in 2014 for the project Wild De-Construction. www.isolartcenter.org

**CreativeOlive** is a group from San Mauro Cilento, a village overlooking *Italy's Cilento* coast. Founded in 2013 by Francesco Citro to create opportunities for local youths to participate in international exchange and research projects: www.creativeolive.it It is in collaboration with **Cooperativa Nuovo Cilento** (www.cilentoverde.com) and the **Comune di San Mauro Cilento**'s city administration.

**Alice Creischer** is an artist and lives in Berlin.

**Margit Czenki** is a film-maker and artist, living in St. Pauli, Hamburg, and teaching Cultural Planning at the Zeppelin University in Friedrichshafen. http://margitczenki.net

**Paola Di Bello** was born in Naples, Italy, lives and works in Milan. She is Lecturer in Photography and Head of the MA Photography at the Brera Academy of Fine Art. www.paoladibello.com

**Ines Doujak** is a feminist artist who participated in exhibitions like the Biennial in São Paulo (2014) and the documenta 12 in Kassel (2007). www.inesdoujak.net

**Pilar Mata Dupont** is an artist based between Australia and the Netherlands. In her work she is investigating ideas of national identity, mythology, parable and the triggers of nostalgia.

**Katharina Duve** is a film-maker, video and performance artist and **Timo Schierhorn** is a film-maker and video artist; both are based in Hamburg. www.katharinaduve.de   www.timoschierhorn.de

**Frank Egel** is a people photographer for magazines and agencies. Frank lives and works out of Hamburg city. www.frankegelfoto.de

**Antke Engel** is director of the Institute for Queer Theory, Berlin and works on queer visual culture, feminist philosophy, and cultural politics. www.queer-institut.de

**Etcétera**, an Argentine artist collective, which founded the International Errorista in 1997, is an organisation that supports the error as a philosophy of life and social action. http://grupoetcetera.wordpress.com

**Clifford Erinmwionghae** is a migrant and activist who has been living in Austria for over a decade.

**Escape From Woomera** was developed ten years ago as a prototype for a computer game where participants stage a virtual break out from Woomera Detention Centre (now closed).

**Noory Fakhry (Rebwar)** is an asylum seeker from Iranian Kurdistan. He received his masters degree in International Human Rights at Lund University.

**Los Flamencos** are the flamenco singer Niño de Elche, the poet Antonio Orihuela and the artist Isaías Griñolo. They use the hybridation of flamenco, poetry and audiovisual archives to pick up the disaffection of social body.

**Flo6x8**, an activist-artistic collective of common people with common concerns: flamenco and financial system. They practise civil disobedience by singing and dancing flamenco in banks. www.flo6x8.com

**Fluchthilfe & Du** is a campaign platform against the criminalisation of migrant knowledge and self-organisation. www.fluchthilfe.at

**Fornace Falcone** is a family-run terracotta factory (kiln) in the province of Salerno. The furnace produces hand-made *artistic terracotta*. www.fornacefalcone.it

**Maddalena Fragnito** lives and works between Milan and Macao. Her artistic work follows and promotes processes of self-government and self-production of groups of people around Europe.

**Javiera de la Fuente**, a flamenco dancer, began her career in Seville. She was part of José Galván flamenco dance company (2013) and the show ¡Viva el Café cantante! by José Luis Navarro (2014).

**LaFundició** is a cooperative whose work is situated between art, culture and education, as controversial activities. They develop open collaborative processes. http://lafundicio.net

**Amador Gabarri**, a young and multi-faceted flamenco guitarist. He has been inspired by Diego del Gastor and Pedro Bacán, and also by Maurice Ohana.

**Israel Galván**, a flamenco dancer; with works such as *Los zapatos rojos* (1998) and *Fla.Co.Men* (2013), he has changed the history of flamenco dance. www.israelgalvan.com

**María García** is an architect, who has developed her work through collective art projects dealing with physical and symbolic dimensions of the city. Currently she explores relationships between architecture and flamenco.

**Edna Gee** is a South African artist based in Milan, Italy. She works with Isola Art Center and the collective Cherimus Sardegna. She draws to explore the world she lives in. http://ednagee.blogspot.it

**Mariam Ghani** is an artist, writer and film-maker. She also co-curated the travelling film programme, *History of Histories: 50 Years of Afghan Films*. www.kabul-reconstructions.net/mariam

**Golem**, a place for serious drinking and serious conversation. http://golem.kr/

**Emil Gross**, based in Vienna, is part of the 1724 trio, plays in the Kindred Blues Trio, modern jazz with Oliver Lake, and in GSCHREAMS. www.kindredbluestrio.com

**Igor Gross**, based in Vienna. He is a member of Klangforum, Ensemble Phidias, Ensemble Platypus, plays with the Wiener Philharmoniker. http://4stsssss.limmitationes.com

**Marina Gržinic** is professor at the Academy of Fine Arts in Vienna; she is an artist, philosopher and a writer. http://grzinic-smid.si

**Yusuf Said Haibeh** is a refugee activist from the Somali community based in Vienna; he is a journalist and vice-president of *JEF for Africa*, a platform reporting about refugee rights movements, structural violence and institutional racism in Austria.

**Juwansher Haidary** is currently the head of the Filmmakers Union of Afghanistan. He co-founded Ariana Films, Afghanistan's first private film production company.

**Abdul Khalek Halil** directed features for Afghan Films over several decades and under several different regimes. He now lives in Europe.

**Nathaniel Hall** aka BAM is a US-American hip-hop artist. He was part of the group Jungle Brothers and is now working solo and in various collaborations. www.officialbam.com

**Matthew Hyland** is an anathematician and distranslator, gainlessly employed at a London press cuttings agency. Occasional pseudonymous outbursts at www.metamute.org.

**Njideka Stephanie Iroh** is a poet, performer, writer, artist and activist in Vienna. Her political work is part of PAMOJA – The Movement of the young African Diaspora.

**Isola Art's Club Band** (Naima Faraò, Igor Francia, Denis C. Novello, Walter Novello, Vincenzo Onida, Steve Piccolo, Gak Sato ...) is an open structure that includes musicians and singers, experienced and/or inexperienced, linked to Isola Art Center.

**Heinz-Norbert Jocks** is a German art critic, curator, essayist and journalist. He lives in Düsseldorf, Paris and Beijing. Since 1979 he has been a regular editor for the magazine *Kunstforum International*.

**Krõõt Juurak** is an artist who works with performance. Recent projects include *Animal Jokes* (for *Animals*), *Animal Performances* and *Animal Show* with Alex Bailey. http://kr66t.com

**Franz Kapfer**'s work has been shown in Austria, France, Germany, Italy, South Korea, Mexico, Poland, Serbia, Russia and the United States.
https://franzkapfer.wordpress.com

**Ketani** is an association based in Austria whose goals are to keep culture and language, and also to ameliorate social, economic and legal situation of Sinti and Roma.
www.sinti-roma.at

**Luca Kezdy**, based in Budapest, is part of the 1724 and Santa Diver trios, and also performs frequently as a solo artist.
http://santadiver.bandcamp.com

**Sylvi Kretzschmar** engages in the fields of electronic music, live art and choreography.
http://we-are-the-skills.de
http://schwabinggrad-ballett.org
www.versammlung-und-teilhabe.de

**Ernie Larsen** and **Sherry Millner** are anarchist artists who collaborate on video, photo, book and curatorial projects, not to mention everyday life. Millner is also an obsessive photomonteur and occasional installation artist; Larsen is a fiction writer and media critic.

**Vitali Lesan** lives in Vienna and works in sculpting, painting and interior design. He likes superficiality and can express it easily in his work.

**Marissa Lôbo** is an artist and activist who works for and in Maiz, an independent organisation by and for migrant women.

**Miguel A. López** is a writer and curator. His work focuses on queer re-articulations of history from a Southern perspective and the transforming engagement with politics in Latin America in recent decades.

**Isabell Lorey** is a political theorist at the European Institute for Progressive Cultural Policies, and an editor of transversal texts based in Berlin, Germany.
http://eipcp.net

**Ines Mahmoud** is a political activist/poet and has written her bachelor thesis about reproductions of white supremacy within the Refugee Protest Camp Vienna.

**Antonio Marín**, a scenographer, who was part of the theatre group El traje de Artaud. Since 1990 he has collaborated with Pepa Gamboa. One of his works was *La Casa de Bernarda Alba* (2011).

**Rocío Márquez**, a flamenco singer, won the Lámpara Minera prize at the La Union Flamenco Festival in 2008. Her recent works include *Claridad* (2012) and *El Niño* (2014).
www.rociomarquez.com

**Charo Martín** teaches flamenco singing at the Conservatorio Superior de Música in Córdoba, Spain. Currently she is working on her performance 'Visceras y otros cantes'.
www.charomartin.es

**André Masseno** (Rio de Janeiro, Brazil) is a choreographer and performer. He combines dance, theatre and literature, dealing with contemporary art, gender and sexuality.
www.andremasseno.wordpress.com

**Virginia de Medeiros**, born in 1973, is based in São Paulo. Her recent exhibitions include: 31st São Paulo Biennial; *Rainbow in the Dark*, SALT Galata, Istanbul; and La Chambre Blanche, Quebec.
http://virginiademedeiros.com.br

**Melodien für Millionen**, the DJ duo combines 1950s–1980s *Schlager* with 1970s disco and 1980s pop. They have a fetish for German versions of Italian and French hit music.
www.melodienfuermillionen.com

**Mindj Panther** rap to combat discrimination and populist incitement. They sabotage racist election speeches and encourage young migrants to protest.
www.romanosvato.at/rapattack

**Sandra Monterroso** lives and works between Vienna and Guatemala. She engages with public space through different media.

**Gianfranco Marelli**, based on the island of Ischia, is an Italian anarchist and author of several books covering the history of the Situationist International.

**Orestis Mavroudis** is a visual artist based in Milan and Berlin. His work investigates the narrative potentialities of familiar images and materials from the everyday life.

**Dr Zamiruddin Mihanpoor** was a member of the Parcham faction of the People's Democratic Party of Afghanistan. He now lives in the UK with his wife, Dr Parwin Zaher-Mihanpoor.

**Dr Parwin Zaher-Mihanpoor** was the first director of the Afghan Progressive Women's Association. Until the end of Dr Najib's regime, she was the director of Noor Hospital.

**Valentina Montisci** (Milan, Italy) is a journalist at *Globalist*. She is the author of several interactive webdocs investigating the Isola Neighbourhood.
www.globalist.it

**Ben Morea** has been one of the protagonists of Black Mask and Up Against the Wall Motherfucker. Ben and 'the Family' were among the key proponents of anarchist thought, action and art as embodied in the 1960s counter-culture and political radicalism.

**Carlos Motta** is a multidisciplinary artist, educator and organiser. His work draws upon political history to create counter-narratives that recognise suppressed histories and identities. http://carlosmotta.com

**Gin Müller**, a theatre scholar and dramatic advisor, teaches at the University of Vienna and implements his own theatre projects. He was active in the refugee protest movement in Vienna.

**Faqir Nabi** trained as an actor at the Pune Institute in India, and starred in a number of films in the late 1970s and early 1980s. He spent the 1990s in exile in Canada and now lives in Kabul.

**Philippe Nathan** is an independent architect based in Luxembourg. He founded the research-based office 2001. In 2012, he curated the project *Post-City* at the Venice Architecture Biennale. www.2001.lu

**Abassin Nessar** is a political scientist who grew up in the Netherlands after his family was exiled from Afghanistan in 1991. He was the programme coordinator of dOCUMENTA 13 in Afghanistan.

**Alexander Nikolic** is an artist, activist and researcher. His works deal with questions of class, migration, urban-rural conflict zones, participation, etc. http://malcolmxs.postism.org/

**Nobodycorp. Internationale Unlimited** was founded in 1993 by Alit Ambara, artist and activist of Cultural Network (Jaringan Kerja Budaya) in Jakarta. http://nobodycorp.org

**Fernanda Nogueira** born in São Paulo, in 1982, is an art historian, translator and literary critic. S/he is member of the Southern Conceptualisms Network and a PhD-in-practice fellow at the Academy of Fine Arts Vienna.

**Ocaña**, an artist, libertarian and queer (Cantillana, Seville, 1973–1983). His works in Barcelona in the 1970s have the category of myth. He presented *La primavera* as total artwork in 1980.

**Nikolay Oleynikov** is a Moscow-based artist, activist and active member of the Chto Delat? group. http://nikolayoleynikov.wordpress.com

**Daniela Ortiz's** work aims to create spaces of tension where conceptions of race, class, nationality and gender are critically explored. www.daniela-ortiz.com

**Maja Osojnik** works as a singer, composer and improvising musician, mostly using paetzold bass recorders, tapes, electronic devices, toys, trash and found objects. http://maja.klingt.org

**Maria Papadimitriou** is working in the context of relational art form, political imagination, community co-existence, gender and artistic research. http://mariapapadimitriou.blogspot.it

**Dan Perjovschi** is an artist who draws. Commentator of his time, attentive to the social and political life, his works are a synthesis of comics, art brut and graffiti. www.perjovschi.ro

**Tomás de Perrate**, the son of Perrate de Utrera, belongs to a traditional dynasty of flamenco families. He founded the group *Sistema Tango* in 2012; his recordings include: *Perraterías* (2005) and *Infundio* (2011).

**Steve Piccolo**. Since the mid-1970s he has worked on music, theatre, performance, sound projects, installations, film scores and fiction. www.stevepiccolo.undo.net

**PIE Flamenca**, Independent Platform of Modern and Contemporary Flamenco Studies. Editorial board: Patricia Molins, Georges Didi-Huberman, José Luis Ortiz Nuevo, José Manuel Gamboa and Pedro G. Romero. www.pieflamenco.com

**Edith Poirier** is an artist from Montreal based in Milan. Her work narrates the city and the layers of information that are hidden underneath the visuals of the media. www.edithpoirier.com

**Prozess.report** is a collective of media activists and critical journalists monitoring and reporting from trials against politically engaged persons and groups in Austria. www.prozess.report

**Gerald Raunig** is a philosopher and art theorist. He works at the Züricher Hochschule der Künste and at the European Institute for Progressive Cultural Policies. www.eipcp.net

**Refugee Protest Vienna** started with an uprising of asylum seekers against the conditions in the asylum centre Traiskirchen in 2012. www.refugeecampvienna.noblogs.org

**Oliver Ressler** works as an artist and film-maker on issues such as economics, democracy, forms of resistance and social alternatives. He is co-editor of *It's the Political Economy, Stupid: The Global Financial Crisis in Art and Theory* (Pluto Press, 2013). www.ressler.at

**Pedro G. Romero**, an artist and curator, works mainly through two devices/projects: Archivo F.X., about iconoclasm and avant-garde; and Máquina P.H., about popular culture and flamenco. http://fxysudoble.com

**Daniele Rossi** lives in Milan; he is a graphic designer focused on identities of public services, cultural institutions and editorial design about art and lifestyle. www.dnlrsss.com

**Rudolf Rostas** is the grandson of Vig Rudolf, a singer and dancer of popular Hungarian music. He was awarded the Soros Price in 1992 and founded the Folk Kalyijag Company.

**belit sağ**, an artist, activist, currently a resident in Rijksakademie in Amsterdam and working on http://bak.ma, an open digital media archive of political movements in Turkey.

**Gak Sato**, a musician, Thereminist and sound artist, born in Tokyo, where he founded the band 'Diet Music' in 1994. Since 1996 he has been living in Milan, Italy.
www.gaksato.com

**Christoph Schäfer** lives in Hamburg and is decisively involved in *Gezi Park Fiction*, which was also part of Documenta 11 in Kassel (2002).
http://christophschaefer.net

**Sophie Schasiepen** is based in Vienna, and works and lives between activism, art and theory.

**Die Schefin** is co-founder of the Viennese Tunthatlon.
http://www.tuntathlon.at/

**Mariette Schiltz** lives in Milan and Luxembourg. Since 2001 she has been active in the Isola Art Center. She has made several videos about the Isola Art project.
www.isolartcenter.org

**Schon-Schön-Girls** are synchronic ironing artists – winners of the 2011 and 2012 World Tuntathlon Association competitions.

**Serio Collective** is a collaboration between Edith Poirier, Daniele Rossi and other artists. They experiment with screen-printing in a contemporary art context.
www.seriocollective.com

**Sexy Deutsch** is the voice of the emerging underground music and the culture that surrounds it. We are always in tune and on time.

**Firas Shehadeh** is a visual artist. His work explores his relationship with space and the influence of authority on the alteration of collective consciousness and identity.
www.firasshehadeh.com

**The Silent University** is an autonomous knowledge exchange platform by and for refugees, asylum seekers and migrants. It is led by a group of lecturers, consultants and research fellows.

**Milena Steinmetzer** studies architecture at the Technical University Vienna and is member of the National Union of Students, Luxembourg, co-leading the new student movement in Luxembourg.

**solidarityagainstrepression** is a support group standing in solidarity with eight refugees accused/convicted of human smuggling and organised crime in Austria.
www.solidarityagainstrepression.noblogs.org.

**Superstudio** was an architecture firm founded in Florence in 1966, and a major part of the radical architecture movement of the late 1960s. They abandoned working as a collective in 1978, but members continue to develop their ideas independently.

**Susiklub** is a DJ collective based in Vienna.
www.susiklub.com

**Tanz durch den Tag** is a young collective of artists and cultural workers, enriching the city of Vienna with marvellous open-air events.
http://tddt.info

**Peter Taylor** is a film curator and programmer for the International Film Festival Rotterdam, DEAF, and WORM.
www.kinokino.me

**Bert Theis** lives and works in Luxembourg and Milan. He is involved in the Isola Art Center, where the practice of a 'fight-specific art' in an urban conflict has been developed.

**Camilla Topuntoli** is an artist and film-maker based in Gothenburg, Sweden, currently studying film. Recently she had a solo exhibition at Kunstnernes Hus in Oslo.

**Transdisziplinäres Planungsteam Milliardenstadt** is a project by students of the Technical University Vienna. They created the model for a vast city that could be built for the amount of cash the government had used to bail out a bank.
http://milliardenstadt.at/hypotopia

**La Esmeralda de Triana**, also known as Esmeralda de Sevilla, is a transvestite, comedian, actress, singer and performer. Works include *Esmeralda de Sevilla y sus flamencas* (1980) and *Chistes* (1980–1990).

**Renée Tribble** is an architect based in Hamburg, where she teaches at the HafenCity University. She is part of PlanBude, developing participatory methods for urban planning.
http://planbude.de

**Undrawing the Line** includes key artists: Mona Moradveisi, Safdar Ahmed, Zanny Begg and Murtaza Ali Jafari with the participation of Bashir Ahmed, Mansoora Gulzari, Parastoo Bahrami, Neda Bahrami, Mohammad, Madina Sayer, Farnaz Yegan, Kamaleshwaran Selladurai, Susie Egg, Daminda Ehsan and Tabarak (some names have been changed for participant's security). Undrawing the Line is an artistic collective that challenges current thinking about borders.

**Utopia Urbis** is a project by four architectural firms based in Salerno: Laboratorio di Progettazione Ferrara, Amor Vacui Studio, Ghelo Studio Architettura and Project 2.0 www.amorvacui.org

**Nikola Uzunovski** is a Macedonian artist working on utopian projects suspended between art and science, visionary ideas and social issues, poetry and hyper-technology.

**Flora Vannini** is a solo dancer based in Milan. Since 2004 she has worked freelance on various dance projects. Flora is an actor in Isola Art's Club Band's video-clip *Culture don't grow on trees*.

**Jaume 'Mal' Ferrete Vazquez** works with the voice and its peripheries, uses and meanings; through formats as CD, concert, performance, workshop or website. http://jaumeferrete.net

**Stefan Voglsinger**, based in Vienna, does research in sound on stage, in the studio and on the road; he does improvisation and composition for music, film and dance projects.
http://voglsinger.klingt.org

**Marina Vishmidt** works on the relationship between art and value; author of *Speculation as a Mode of Production* (2016) and *A for Autonomy* (with Kerstin Stakemeier) (2014). She writes and lectures widely.

**Wealth of Negations.** SELF-ESTEEM = consent to the conditions that compose the self. Dictionary and Curses at www.wealthofnegations.org

**WienTV** is a non-profit online media collective, founded during the student protests in 2009. Since then they have been publishing grassroots news regularly.
www.wientv.org

**Katarzyna Winiecka** is an activist, artist and educator, focusing on questions of border politics, migrant resistance and its occupation of (public) space. She co-initiated **Fluchthilfe & Du, Prozess.report** and www.re-emphasis.blogspot.co.at

**Sergio Zevallos**, born in 1962 in Lima, works with photography, performance and art installation. His projects are visual researches about the relation between individuals and power.

**Jiang Zhi** is a multidisciplinary artist based in Beijing and Shenzhen, China.
www.jiangzhi.net

**Maria Zimmermann** studies political science and is a feminist activist working in net politics. She co-organised FemCampWien 2014 and co-founded Prozess.report.
www.mahriah.org

# Imprint

**Editors**
Ines Doujak and Oliver Ressler

**Authors**
Halil Altindere, AND AND AND, Oreet Ashery, Dario Azzellini, John Barker, Zanny Begg, Alice Creischer, Ines Doujak, Antke Engel, Etcétera, Mariam Ghani, Matthew Hyland, Miguel A. López, Nobodycorp. Internationale Unlimited, Fernanda Nogueira, Daniela Ortiz, Oliver Ressler, Pedro G. Romero/Máquina P.H., Christoph Schäfer, Sophie Schasiepen, Bert Theis, Marina Vishmidt, Wealth of Negations, Katarzyna Winiecka

**Translation**
Anja Büchele and Matthew Hyland (*Salon Public Happiness*)
Rosa Nogues (*Wittgenstein and the Gypsies*)

**Copy Editing**
John Barker, Thérèse Wassily Saba

**Proofreading**
Sue Stanford

**Photography**
Ines Doujak (ID)
Lisa Eidenhammer (LE)
Carolina Frank (CF)
Oliver Ottenschläger (OS)
Maximilian Pramatarov (MP)
Oliver Ressler (OR)
Verena Melgarejo Weinandt (VMW)

**Graphic Design**
Atelier Liska Wesle, Wien / Berlin

**Image Editing**
Markus Wörgötter

**Organisational Assistance**
Sophie Schasiepen

**Publisher**
Pluto Press, London

First published 2015 by Pluto Press
345 Archway Road, London N6 5AA

www.plutobooks.com

British Library Cataloguing in Publication Data
A catalogue record for this book is available from the British Library

ISBN 978 0 7453 3596 4 Paperback
ISBN 978 1 7837 1338 7 PDF eBook

10 9 8 7 6 5 4 3 2 1

Printed in the European Union

This book has been published in conjunction with the exhibition *Utopian Pulse – Flares in the Darkroom* at Secession, Vienna, from 10 September to 2 November 2014, and a follow-up exhibition at Württembergischer Kunstverein, Stuttgart, from 29 June to 16 August 2015.

**Exhibition at Secession**

Attendants: Robert Eichhorn, Mario Heuschober, Niklas Hofstetter
Cleaners: Emine Koza and Firma Simacek
Web Design: Christina Goestl
Intern Salon Klimbim: Magdalena Stöger

The Klimbim tent was designed and materialized by Ines Doujak in cooperation with garbarage: Hermann Seiwald, Nicola Brandtmayr and the helpfull hands of Claudio Studer, Andreas Raicher and Linus Duda. Metal work by Roland Finkenstedt. Thanks to Textil Müller.
Sound Salon Klimbim: Michael Jellasitz
Audio-visual documentation Salon Klimbim: Rudolf Gottsberger, Thomas Parb
Lightbox for *Utopian Pulse*: Roland Finkenstedt

**Architecture**
Claudia Cavallar, Lukas Lederer

**Website**
100UND1 media OG

*Utopian Pulse – Flares in the Darkroom* was realized as a PEEK project, funded by the Austrian Science Fund (FWF) AR 183-G21, with the Secession Vienna as research institute partner.

Special thanks to John Barker, Matthew Hyland, András Pálffy, Hermann Seiwald, Bettina Spörr, Sophie Schasiepen and Helga Weber.

**www.utopian-pulse.org**

Der Wissenschaftsfonds.

**secession**